Native American Modernism

Art from North America

THE COLLECTION
OF THE ETHNOLOGISCHES MUSEUM BERLIN

Peter Bolz and Viola König

Native American Modernism

Art from North America

THE COLLECTION
OF THE ETHNOLOGISCHES MUSEUM BERLIN

MICHAEL IMHOF VERLAG

VERÖFFENTLICHUNGEN DES ETHNOLOGISCHEN MUSEUMS BERLIN
NEUE FOLGE 81 · FACHREFERAT AMERIKANISCHE ETHNOLOGIE X

Staatliche Museen zu Berlin – Stiftung Preußischer Kulturbesitz
Ethnologisches Museum
Edited for the Ethnologisches Museum – Staatliche Museen zu Berlin by Viola König

Translated by Sabine Lang

This publication accompanies the exhibition *Native American Modernism. Art from North America*

An exhibition of the Ethnologisches Museum, Staatliche Museen zu Berlin, from March 3 – October 28, 2012

Photographs: Staatliche Museen zu Berlin, Ethnologisches Museum
Dietrich Graf: Figs. 1–3, 6–10, 14–16, 21–22, 25, 27, 29–30, 36–39, 42, 44, 68–74, 76, 82.
Claudia Obrocki: Figs. 4–5, 11–13, 17–20, 23–24, 26, 28, 31–35, 40–41, 43, 45-67, 75, 77–81, 83–84.

Front cover: Fritz Scholder, Luiseño, "Indian Portrait with Tomahawk", 1975. Detail of fig. 72, p. 106.
Back cover and page 124: David Bradley, Chippewa, "Indian Market Manifesto", 1997. See fig. 79, p. 153.
Page 8: Kevin Red Star, Crow, "Walks Long", 1981. See fig. 38, p. 68.

Publications Management Staatliche Museen zu Berlin: Elisabeth Rochau-Shalem
Publications Coordination: Alexia Pooth

Native American Modernism. Art from North America. The Collection of the Ethnologisches Museum Berlin; Michael Imhof Verlag, Petersberg 2012

Bibliographical information of the Deutsche Nationalbibliothek:
The Deutsche Nationalbibliothek holds a record of this publication in the Deutsche Nationalbibliografie; detailed bibliographical data can be found in the internet under http://dnb.d-nb.de.

© 2012
Staatliche Museen zu Berlin – Stiftung Preußischer Kulturbesitz
and Michael Imhof Verlag, Petersberg, as well as the authors.
www.smb.museum
www.imhof-verlag.de

Design and reproduction: Meike Krombholz | Margarita Licht, Michael Imhof Verlag
English copy editing: Brooke Penaloza Patzak
Printed by B.o.s.s Druck und Medien GmbH, Goch

Printed in EU

ISBN 978-3-86568-785-2
ISBN Museumsausgabe 978-3-88609-724-1

CONTENTS

FOREWORD

The Berlin Ethnologisches Museum, containing about 160 paintings, sculptures, and graphics dating from 1970 to the present, hosts one of Europe's largest collections of modern Native American art. The majority of these works of art represent so-called "Native American Modernism." They are part of a collection that comprises altogether almost 30,000 objects of Native American material culture – the largest outside the Americas.

The largest part of the museum's North American collection dates from the 19th century and documents a "traditional" way of life that no longer exists. The 20th century, in which Native American life has undergone fundamental political, social, and cultural changes, is not represented in a comparable way in the collection. In the second half of the 20th century, white society's pressure on Native Americans to assimilate has produced forms of resistance that find expression in not only political action, but also a radical change of Native American art.

From the very beginning, Native American art has been not only a retrospection on an epoch of history, but also an important means of communication (and at times also of struggle) between the indigenous minority and white majority. Contemporary American society is no longer imaginable without the impulses that come from that minority. Successful Native American writers such as N. Scott Momaday and Louise Erdrich, actors such as Graham Greene and Adam Beach, and visual artists such as Allan Houser and Fritz Scholder have contributed to shaping the image of modern America. Today they are role models who have successfully integrated themselves into the multicultural American society without renouncing their ethnic roots.

Thus we find it important to complement the collection of modern Native American art that has been compiled since 1975, and to document these impulses borne by a new Native American self-consciousness. The result is a collection that has developed from modest, locally specific beginnings into a nearly representative overview of late 20th century art. Due to new purchases made between 2008 and 2011 we can now present this collection in its entirety. In doing so, we also hope to awaken the public's interest in this art genre.

The development of "Other Modernisms" outside the sphere of white, "Anglo-American" art in North America is thus at the focus of both this exhibition and publication. Though influenced by Euro-American trends, Native American art has found creative means of its own that lend expression to its specific features. "Native American Modernism" refers to a kind of art that has been created by an ethnic minority within a dominant majority society. Having emerged from the traditional roots of Native American art, this art has continued to develop over the course of one hundred years; little by little, it has detached

itself from its roots and produced new, distinctive offshoots. Rather than linear, this process has given rise to diverse local variations with countless ramifications. Innovative individual artists have constantly given new impulses to this art which, as a result, has taken various directions. Native American Modernism is not a self-contained period of art history, but rather an energetic, vibrant form of Native American creativity that intentionally sets itself apart from "traditional" Native art. They exist simultaneously and there are myriad hybrid forms.

Native American Modernism is like a visual allegory of the changes undergone by Native American cultures during the 20th century. These changes ranged from a phase of forced assimilation to Anglo-American culture and a period of rebellion in the 1960s and '70s to the recognition of Native American self-determination, which, for the time being, has culminated in the establishment of an autonomous museum of American Native cultures – the National Museum of the American Indian in Washington, the U.S. capital.

We wish to express thanks to all those who have contributed to this publication and helped to make the exhibition possible:

To begin, we thank Mr. Walter Larink and his wife, the late Renate Larink, who presented a large part of their excellent collection of Northwest Coast serigraphs to the Ethnologisches Museum as a gift. Ms. Dorothee Peiper-Riegraf has generously added to the collection through gifts of artworks from her collection. Without continuous commitment and sponsorship on the part of these collectors and lovers of Native American art we would not be able to present the exhibition in its present form.

Last but not least, we thank General Directors Peter Klaus Schuster and Michael Eissenhauer, as well as the assembly of directors of the National Museums Berlin, Prussian Heritage Foundation, for their kind agreement to recent purchases of particularly important artworks.

Exhibition designer Renate Sander has put our conceptual ideas into perfect practice. As a co-author, editor, and co-organizer our colleague Claudia Roch has made an essential contribution to the successful realization of both the exhibition and the catalogue ; and Sabine Lang, who is a specialist in anthropological translation, has rendered all texts into excellent English.

Berlin, March 2012
Viola König, Peter Bolz

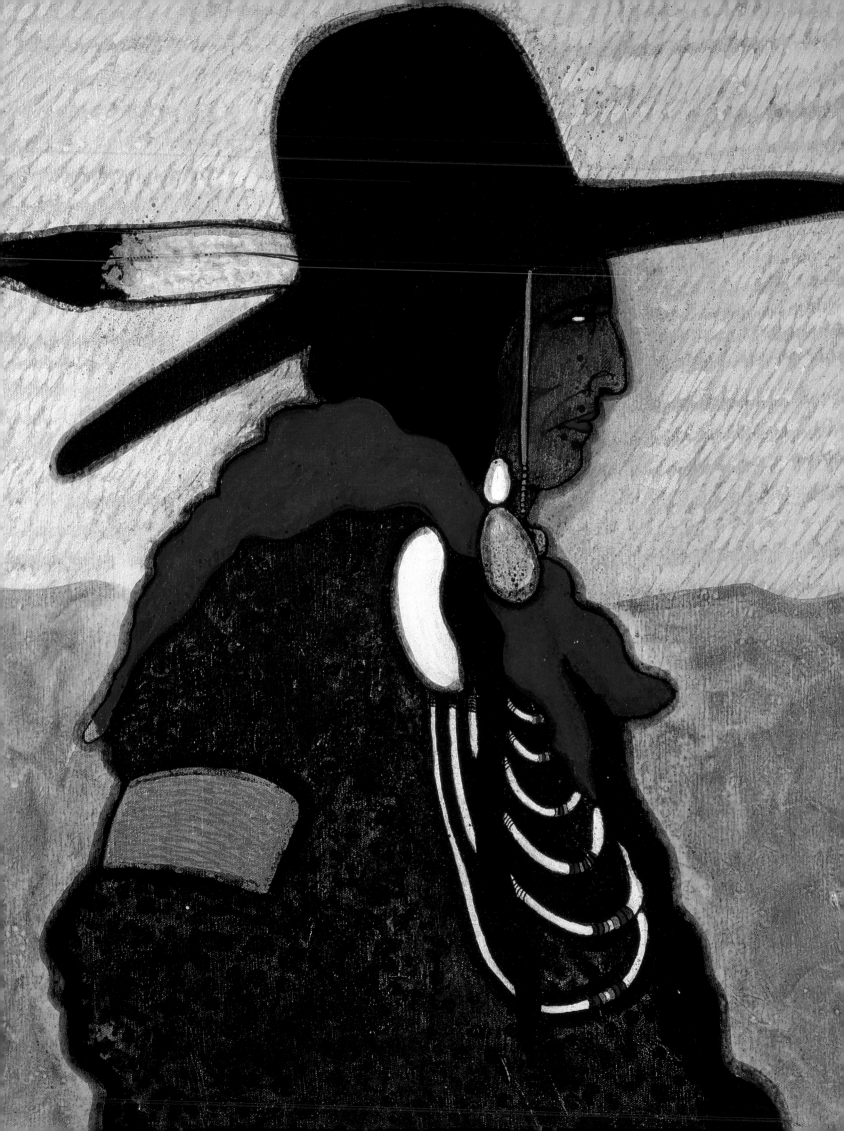

Peter Bolz

NATIVE AMERICAN MODERNISM
Historical Roots and Regional Developments

What is Modern Native American Art?

The modern art of Native North Americans is often classed under the category of "Non-European Art." While this is not wrong in principle, there is nevertheless a hierarchical order within non-European art that goes back to European patterns of thought, and closely resembles the hierarchy between European and non-European art.

In Berlin, the House of World Cultures (*Haus der Kulturen der Welt*) made the laudable attempt to present in 1997 the *Die anderen Modernen. Zeitgenössische Kunst aus Afrika, Asien und Lateinamerika* (The Other Modernisms. Contemporary Art from Africa, Asia, and Latin America) exhibition as an alternative concept to the *Die Epoche der Moderne* (The Epoch of Modernity) exhibition, which exclusively focused on European and (white) North American art. With regard to this, the preface of the catalogue states: "Seen from the Eurocentric perspective, 20th century art is dominated by Europe and North America ... There is general consensus that non-European art, particularly of African and Oceanic provenience, has played a decisive role in the development of our modernism – just think of the cubists and expressionists. In spite of this model character, however, non-European art – neither from the beginning of the century, nor contemporary – has never become accepted and incorporated as an equal partner by the international art scene" (Hug 1997: 7). Exhibition curator Alfons Hug identifies the "administrators of modernism in museums, university institutes, newspaper arts sections and art galleries, all of whom have turned art into a book sealed with seven seals," as well as the "keepers of the Holy Grail in the temples of western art, who still chase the chimera of the uniqueness of Euro-American modernism" (Hug 1997: 7) as the originators of this segregation.

While any anthropologist will likely subscribe to these statements without restriction, a closer look at the "Other Modernisms" reveals deep chasms. Within the concept underlying the exhibition, Africa, Asia, and Latin America are referred to as the "Third World" or "the larger rest of the world;" the artists come from nation-states such as Benin, Nigeria, Brazil, Thailand, Cuba, Mexico, and China. Ethnic minorities that live in these states and have come to be termed "peoples of the Fourth World" since the 1970s are, however, not represented in this concept. That is, within Non-European Art there is also a hierarchical order that

orients itself by European norms. The artists are classified according to nation-states, and the question as to their ethnic origin is not asked. If applied to Native American art in North America, this would mean classifying the artists under the categories of "U.S." or "Canada" without paying any further attention to their ethnic roots, which are a crucial element of their creative work.

This single example alone shows that the issue of Non-European Art needs to be addressed in a much more differentiated manner, and cannot be simply reduced to the catchphrase "Third-World" art.

When talking about "American Indian art" in the present context, we are simultaneously dealing with two unknown entities. There exists neither an authoritative definition for "American Indian," nor for "art;" instead, there are countless interpretations and attempts to grasp both concepts. In the 19th century art was defined in a completely different manner than today; such definitions are subject to the *zeitgeist* of any given epoch. Likewise, the issue of who is regarded as a native in North America and who is not depends on a multitude of regulations. In censuses conducted in the U.S., everyone who calls himself or herself an American Indian or Native American is counted as such. Much stricter rules apply, however, when it comes to the production of arts and crafts. According to the Indian Arts and Crafts Act passed in 1990, only individuals who are enrolled members of federally recognized tribes are permitted to produce "Indian art". The criteria for membership in such tribes are established by the tribes themselves on the basis of descent or "share of blood," and are thus very diverse. Just as is the case with writers and actors, there are occasional instances where visual artists are exposed as "would-be Indians" who have established themselves in an ethnic niche that is not properly theirs. The most recent example from the ranks of Hollywood actors is Iron Eyes Cody, who for more than half a century played the role of the exemplary Indian, including the "typical" aquiline-nosed profile. Only shortly before his death in 1999 was it revealed that he was not of Native American, but of Italian descent.

These examples show that we are dealing with a type of art that is defined in ethnic terms and expected to relate, at least to some extent, to specific "Indian" roots. Even if nothing Indian appears in a given picture, the artist must be able to prove his Native ancestry so that his art is to be accepted as Indian. If he fails to do so, he will be quickly marginalized, and will find himself exposed to massive hostility. This would, as a rule, be the end of his career.

We must assess the collection of modern Native American art purchased by the Ethnologisches Museum over the past decades against this background. For the museum curator in charge of such acquisitions, each purchase is a balancing act between art and ethnology. Whenever he buys a piece of art he faces the question of how it relates to the holdings of the historically grown collection as a whole. This, by the way,

explains the manner in which our Native American modern art collecting activities began in 1975. The first paintings purchased showed either Native American dancers wearing traditional costumes or illustrated religious rituals. These paintings are the only existing images of certain ceremonies, particularly with regard to the Southwestern United States, where there is a strict ban on photography during ceremonial events. At the same time, such paintings represent the dawn of modern Native American art in that region. Ethnologists began to supply Indians with paper, crayons and watercolors as early as around 1900, which were to be used for paintings of dancers in their regalia, with a special emphasis on ethnological detail. Fostered by art schools where white teachers instructed the students, this developed into a "traditionalist" – that is, nostalgic – style of painting which for a long time was considered "typically Indian." It was not until the 1960s that this stylistic orientation, which had been imposed from outside, underwent a radical transformation due to the profound social changes of that time, including the 1962 foundation of the Institute of American Indian Arts in Santa Fe.

In the wake of the protest campaigns in Alcatraz (1969) and at Wounded Knee (1973), the call for Native American self-determination also left its mark on Native American modern art. Such art was no longer a mere illustration of the past, but an expression of Native resistance against the dominant Anglo-American culture and society, from which Native Americans wished to deliberately dissociate themselves (Rader 2011). According to Gerald Vizenor (Chippewa), one of the best-known Native American writers, the mere fact of being an Indian in American society is in and of itself a political act (Kidwell and Velie 2005: 11). Creating Native American art in a world dominated by Anglo-Americans is thus also a political decision. Every Native American, whether living in the U.S. or in Canada, is aware of the fact that he or she is part of an ethnic minority that has been displaced, nearly eradicated, and forcibly "civilized" by European colonists for 500 years. This awareness is reflected directly or indirectly in Native American art, which means that any form of Native American art is, by that same rule, a political statement directed at white society, and the message is: "Look, we are still here, you did not succeed in completely eradicating us! We still try to preserve important parts of our cultures and, most of all, our autonomous ethnic identities." Thanks to the diversity of modern media, it is possible to carry countless variants of this message into white American society. Along with literature and, in more recent times, film, Native American fine arts are one of the most important forms of communication between the Native American world and that of the dominant Anglo-Americans.

In order to understand Native American art, we must constantly keep in mind their suffering as a result of white Americans' racial arrogance and obsession with "civilization," which persisted well into the 20th century. The painting by Ben Buffalo (Cheyenne), which shows a Sun Dancer (Fig. 31), is thus not merely a portrait of such a dancer. It is also a reminder of the fact that in the 1880s, the American government

prohibited the Cheyenne and other Plains nations from performing the Sun Dance, which was their most sacred ceremony. At the same time, however, the painting gives expression to the unexpected revival of that very Sun Dance in the 1970s: as a symbol of ethnicity, a ritual of resistance, and – first and foremost – visible proof of the undiminished vitality of Native American culture. Like many other works by Native American artists, Ben Buffalo's painting expresses the essential feature of the Indians' will to survive: the pride of being Native American.

In the final analysis, the most important message to be conveyed by Native American art to the beholder is: "We are not relics from a remote, mystical past; we are people of the present, people of the 21st century, who lay claim to a life that is self-determined and free of external restraints." Today, Native Americans themselves have the right to define the contents of their respective cultures, and thus also the contents of their art. Outwardly, this art is subject to the laws of the market, just like any other art; inwardly, however, they take the liberty of including passed-down values and formal conventions in their art. This can be a strict design vocabulary, as can be the case in Northwest Coast art, and it is an unwritten law that only members of Northwest Coast cultures are entitled to make use of that design vocabulary; it would never occur to any Native American from some other region to work in the style of the Northwest Coast, and vice versa.

Many Native American artists, however, do not feel committed to any of the local styles, and since the 1950s have thus been developing individualistic styles of their own – often referred to as "Pan-Indian" (Schulze-Thulin 1973: 75–83, 1981: 241–244) – at an increasing rate. Nevertheless, these individualists frequently allude to passed-down elements of their cultures. Harry Fonseca (Maidu), for example, created the unique figure of Coyote who acts the part of the clownish trickster on the stages of the world. In these ways Native American tradition meets Native American modernity, and combine to form a new, contemporary type of Native American art that continues to struggle for a place of its own within the canon of "World Art."

Historical Roots

Like everywhere else in the world, the beginnings of art-making on the American continent are lost in the mists of history. Rock paintings and petroglyphs, which are particularly well preserved in the arid climate of the Southwest in comparison to other regions, are the earliest evidence of creative endeavors. This rock art primarily shows animals and mythical beings using very abstract and symbolic shapes. In addition, there are geometrical patterns such as lines and spirals that once conveyed some specific meaning to the initiated, but today defy a definite interpretation (Wellman 1976, 1979).

Another early form of painting, which was first described by Spanish conquistador Coronado as early as 1540, was done on animal hides. These painted hides did not, however, become widely known until the early 19th century when explorers brought them to the eastern United States and Europe. The Ethnologisches Museum owns no less than nine such bison robes, painted with figurative and abstract designs, which were collected by Maximilian Prinz zu Wied during his travels along the Missouri in 1833/34 (Bolz and Sanner 1999: 74–80). Worn by men as cloaks, such robes were decorated with pictographs that illustrated either their owner's heroic feats in war or the merit he gained by distributing presents. The robes worn by women have much more abstract patterns that symbolize the bison, the most important staple animal on the Plains. Besides the bison robes, the nomadic Native nations of the western Plains painted their tents, clothing, drums, shields, bags, receptacles and many other things; painting on animal skins was thus an integral part of their cultures.

The same use of abstraction is true for the sedentary agrarian groups in the Southwest. In that region, pottery vessels served as the medium for painting; they were predominantly decorated with geometrical designs, a practice that goes back to prehistoric times (Bolz and Sanner 1999: 123–126). In addition there were wall paintings in their *kivas*, subterranean ceremonial rooms. The earliest known of these paintings date from the 13th century, the latest period of prehistoric Anasazi culture. They show supernatural beings, humans, animals, plants, and celestial phenomena. The paintings were applied to the dry plaster of the *kiva* walls in matte colors without foreground or background (Hibben 1975). Another important source of traditional art is the making of sand paintings, a type of dry painting borrowed from the Pueblo by the Navajo in the 14th century; while the Puebloans were long-established residents of the Southwest, the Navajo had only recently migrated there from the north. Sand paintings feature ceremonial motifs that fulfill a special function during curing rituals. They are made of colored sands that are sprinkled on a smoothed, light sand surface. When the ceremony is over these pictures must be destroyed. The Navajo repertoire encompasses about 1,000 different designs, some of which have found their way both into rug weaving and modern painting (Parezo 1983).

Because of this the Southwest and the Plains regions were important centers for the development of Indian painting in North America as early as in prehistoric and early historic times and it was thus a logical step to transfer this type of art onto paper in the late 19th century.

In around 1890 in the Southwest, ethnologist Jesse Walter Fewkes commissioned three Hopi Indians to make color drawings of kachina dances, with a special emphasis on the details of the masks and costumes. The figures were painted on paper with crayons in a naïve, two-dimensional style. Without a background, they seemed to float in the middle of the drawing-paper sheets. These works were intentionally unsigned, as the representation of religious themes was controversial among the Hopi (Fewkes 1900).

By 1880 the bison had become almost extinct on the plains. Tents were no longer made of leather but of canvas, and commercial fabrics, which were available at trading posts on reservations, were used for clothing. Plains Indians turned to passing their heroic war feats down to posterity on cotton fabric or paper. An example from the collection of the Ethnologisches Museum is the depiction of war scenes by Bull Head, a Brulé Sioux, who drew with crayon on a piece of cloth around 1880 (Fig. 1). We see him fighting with enemies and capturing horses; in each scene, he is recognizable as a crescent-shaped name symbol that appears above his head. This symbol does not necessarily relate to his historically documented name, because Plains Indians bore several names over the course of their lives. The style of the work corresponds to that of the bison robes, that is, there is no cohesive overall composition, and individual scenes are strung together. The depicted hero's clothing and equipment are probably not identical to that which he actually wore in battle, rather, they denote his rank as a warrior and social position (Hartmann 1973: 363).

Similar scenes were put on paper by Running Antelope, a Hunkpapa Sioux, around 1880. Using pencils and watercolors he made eleven individual drawings for anthropologist Walter J. Hoffman. The scenes relate to fights with the Arikara during the 1850s (Hartmann 1973: 364–365). It is interesting to note that the artist signed each sheet with his name symbol, a running antelope (Fig. 2).

The illustrations by Bull Head and Running Antelope can be viewed as a transitional stage towards another type of traditional painting that has become known as "ledger drawings". When in 1875 about seventy young Native Americans were deported as prisoners of war from Oklahoma Indian Territory to Fort Marion, Florida, Captain Pratt, the head of the prison, encouraged them to record their experiences on paper with pencils, ink and watercolors. As drawing paper was not widely available, they used the ruled pages of ledgers, which is why these early Native American drawings are commonly referred to as ledger drawings.

Fig. 1 Bull Head, Brulé Sioux, *War Scenes*, ca. 1880. Wyman Collection, 1905. Color pencils on cotton cloth, height 84 cm, width 90 cm. Ethnologisches Museum Berlin, Inv. No. IV B 7623.

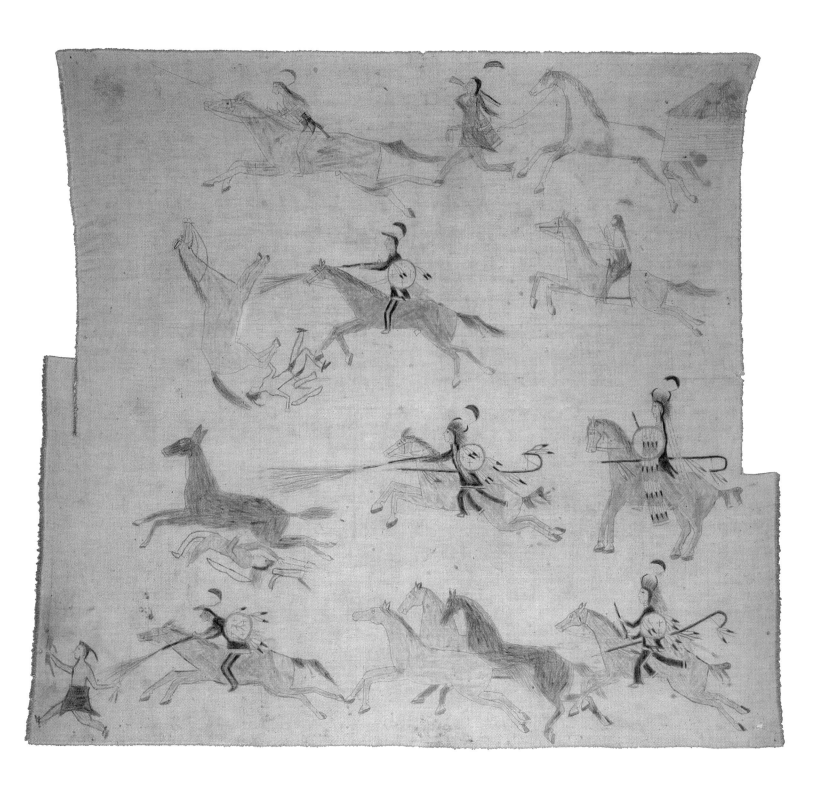

Fig. 2 Running Antelope, Hunkpapa Sioux, *War Scene*, ca. 1880. Hoffman Collection, 1889. Watercolor on paper, height 23 cm, width 31 cm. Ethnologisches Museum Berlin, Inv. No. IV B 1979.

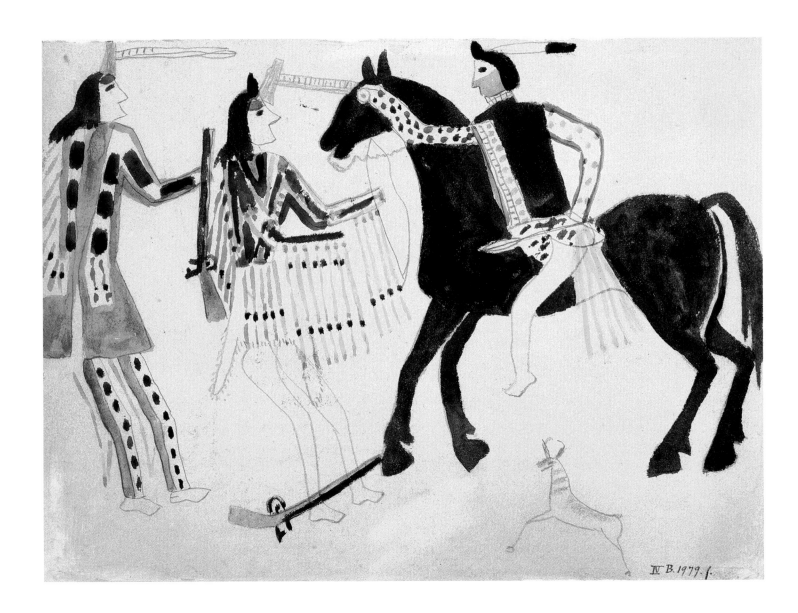

Far from home, the men painted nostalgic, idealized scenes from the past: gorgeous costumes, festivities, experiences on the hunt, and heroic war feats. These images are regarded as the beginning of modern painting on the Plains (Petersen 1971, Berlo 1996). The clear, simple style with its pronounced contour lines continues to intrigue many Plains artists, such as Arthur Amiotte (Lakota) who incorporates elements of ledger art into his collages (Berlo 2006).

The Early 20th Century

The "professionalization" of Plains art began around 1918 when Susie Peters – a field matron at the Kiowa Agency in Oklahoma – "discovered" a group of Kiowa painters who, in an entirely autodidactic manner, had taken to recording events from their traditional lives. When Susie Peters arranged painting classes for them Oscar Jacobson, the director of the School of Art at the University of Oklahoma, took notice. He invited them to live and work at the university and encouraged each one of them to develop a painting style of his own. Common features of all paintings were bright colors, an emphasis on motion, pronounced contour lines and a lack of perspective; consequently, the paintings were characterized as "flat." The group, which later came to be known as the Kiowa Five, combined the technique of ledger art and the illustrative style of Art Deco that was very popular in America at that time (Wade 1986: 56). Their first exhibitions were successful, and in 1928 a selection of their works was shown at an international art exhibition in Prague. In 1929 a portfolio with 30 prints of the Kiowa Artists' works was published in Nice, France, making them known far beyond the borders of the U.S. (Brody 2009: 7). Their painting style became so dominant in the world of Native American art that it prevailed until the 1960s.

Around the same time in 1932, art teacher Dorothy Dunn founded a studio for Native American painting at the Santa Fe Indian School. Fostered by the incipient reform politics of the U.S. government, this experimental art studio soon became the center of "traditionalist" painting in the Southwest. The principles postulated by Dorothy Dunn were: disciplined brushwork, precise contour lines, use of watercolors, omission of any shading and background, and a focus on the portrayal of traditional life styles without allowance for contemporary or controversial themes (Dunn 1968, Tanner 1973, Bernstein and Rushing 1995). The most well known artists who emerged from the Studio include Allan Houser (Apache), Oscar Howe (Yanktonai Sioux), Harrison Begay (Navajo), and Quincy Tahoma (Navajo). Some of the artists rendered their paintings more dynamic by depicting horsemen on the hunt. Others preferred to paint scenes inhabited by large eyed deer. The deer motif, which bore close resemblance to the Bambi drawings made later by Walt Disney, became a particular target of criticism for those who felt that this style of painting was too idyllic and commercial, and thus, this style came to be pejoratively referred to as Bambi art.

In the 1940s the Studio gradually lost its importance, yet its influence on the development of Native American art is still felt today. Many Native American artists continue to orient themselves by the norms established by Dorothy Dunn, which her student Allan Houser pinpointed as follows: "My only objection to Dorothy Dunn was this: she trained us all the same way. 'You either paint like this, Mr Houser, or it's not Indian art'" (Rushing 1999: 66).

The Institute of American Indian Arts

In 1959, a conference was convened at the University of Arizona in Tucson to discuss issues of the status and future of Native American art. Several participants voiced the opinion that Indian art was caught in a state of stagnation and doomed to failure, and that it was therefore necessary to develop new guidelines. As a result of the conference a summer program called Southwestern Indian Art Project was run in 1960 and 1961, with the aims of making each art student aware of his individual creative potential, and of encouraging him to further develop his talent while maintaining his Native American pride (Warner 1997: 72). In 1962, this program was followed by the establishment of the Institute of American Indian Arts (IAIA) in Santa Fe, New Mexico (Gritton 2000).

According to the norms applied up until that time, Indian art belonged to the sphere of "ethnic" or "folk" art. Stirred by the political and cultural developments of the 1960s, individual Native American artists rebelled against these norms and began to search for their own forms of artistic expression. One of the pioneers who tried to abandon the traditionalist style was Oscar Howe, a Yanktonai Sioux. He created a style called Indian Cubism by critics; Howe himself always stressed that he had been inspired by the traditional trickster figure of Iktomi, the Spider, and that the cubist forms in his paintings were nothing but spider webs (Berlo and Philips 1998: 222).

The Santa Fe institute received fresh impetus from Fritz Scholder (Luiseño) who began teaching at the school in 1964. Scholder became the icon of a radical change in Native American art, away from the "Bambi Style" towards a Native American form of expressionism (Breeskin and Turk 1972, Taylor 1982, Sims 2008). Scholder is best known for his "ugly" Indians, distorted images of individuals who are part of the reality of reservation life and differ pronouncedly from the nostalgic images from the "traditional" painters (Figs. 71 and 72). Scholder wanted to shatter stereotypes about Native Americans, and to show that Native Americans are not people of a mystic past, but of the present. Inspired by Scholder's example, students at the IAIA began to put their own ideas of Indian painting into practice. One leading figure was Tom Wayne "T.C." Cannon (Kiowa/Caddo), who died in 1978 and developed a socio-critical, Pop-Art-like style. Other painters who emerged from the IAIA include Kevin Red Star (Crow, Figs. 38–41), David Bradley (Chippewa, Figs. 79–81), Linda Lomahaftewa (Hopi), Billy Soza War Soldier (Cahuilla/Apache), and Dan Namingha (Hopi). They all created individual, non-conformist styles that were markedly different from the traditional styles that had prevailed up until that time.

This novel, unfamiliar style caused some understandable irritation in the Native American art market, which flourished particularly in and around Santa Fe. Gallery owners and art critics, who had become used to the depiction of an idyllic Indian world unaffected by social problems, felt provoked. While modern artists insisted on finally showing the "true" Indian, others claimed that socio-critical and "ugly" portrayals such as those painted by Fritz Scholder were anti-Native American (Silberman 1978: 21). Eventually, however, these new unconventional styles established themselves without displacing more traditional types of painting, and continue to exist alongside each other today.

Pan-Indian Developments

Aside from the Institute of American Indian Arts, the 1970s witnessed the emergence of art movements that were associated with neither the Southwest nor with the Plains. Most of these artists had studied at public art schools where their ethnic background was irrelevant and where they had become acquainted with international art movements and techniques. Still, they were very aware of their Native ancestry and sought contact with each other over large distances for an exchange of ideas and mutual support. As a result, a network of Native American artists began forming in California in 1974. This network was the starting point for the Carl N. Gorman Museum at the University of California, Davis, which organized some remarkable exhibitions featuring works from these artists (Bolz and Peyer 1987: 202).

The most seminal exhibition of that time was shown in 1978 at the Oklahoma Museum of Art in Oklahoma City, and was entitled *One Hundred Years of Native American Painting*. The "one hundred years" referred to the deportation of the Native American prisoners of war from Oklahoma to Florida in 1875 and their "invention" of ledger art. In his foreword, James Reeve, the director of the museum, stressed that the paintings shown in the exhibition were chosen according to aesthetic rather than ethnological considerations: "By removing the art from an ethnological category and simply presenting it as Art, a remarkably brilliant aspect of American culture is revealed" (Silberman 1978: 5). Aside from the "classics" from the painting schools in the Southwest and Oklahoma, this exhibition was the first to include Fritz Scholder, Kevin Red Star, and representatives of the Canadian Woodland School in an art historical trajectory of the development of Native American painting.

To avoid patronization on the part of Anglo-American gallery owners who showed little interest in selling contemporary Native American art, Native artists in the U.S. founded a number of self-managed institutions around 1980. These included the American Indian Community House Gallery in New York and the Sacred Circle Gallery in Seattle. A third institution, American Indian Contemporary Arts (AICA), was established in San Francisco in 1983. These galleries defied the patronizing attitude of white collectors and critics who claimed that only traditional Native American art was "authentic." They wanted to show how alive their contemporary art was. Kenneth Banks, the first director of AICA, comments on this: "Indian people today are a mixture of traditional and contemporary values – they have saved from the past and collected from the present to create their unique lifestyles ... The presence of contemporary art alongside traditional art in the Indian community is simply a manifestation of the coexistence of traditional and contemporary values in the community" (Banks 1986: 3). His successor, Kathryn Stewart, adds: "Feeling confined and stereotyped by galleries and the public who expect to observe traditional Indian images, many native artists have turned to mainstream contemporary art as a source of inspiration. Some critics have gone so far as to declare this new art 'not really Indian.' However, contemporary American Indian art is instilled with symbols and images that somehow reflect the tribal heritage of the artists" (Stewart 1988: 5).

The most recent example of a Native American artists' initiative is an exhibition entitled *Visions for the Future*. Presenting works of young Native talents, it was launched in Boulder, Colorado, by the Native American Rights Fund in 2006. Out of the 130 works submitted, 40 works by 13 artists from all over the U.S. were exhibited. Besides paintings, the works included prints and photographs. The motto of the exhibition is given on the back cover of the catalogue: "Art is a weapon … It's about telling stories that have not been told. It's about reclaiming visual space" (Native American Rights Fund 2007).

The exhibition *Native American Arts '81*, which was shown at the Philbrook Art Center in Tulsa, Oklahoma in 1981 was an important step towards the recognition of contemporary Native American art. The accompanying catalogue with the flowery title *Magic Images: Contemporary Native American Art* (Wade and Strickland 1981) was a milestone in the history of Native American art, and represents the first attempt to establish various categories of art. The artists on exhibit are not classified according to their regional provenience, but according to the following style-related criteria: Historic Expressionism, Traditionalism, Modernism, and Individualism. In their introduction, the authors emphasize that the 37 artists were chosen as "visual speakers" in order to establish alternative definitions of Native American art: "While Indian art has never been a single stylistic world, today, more than ever, gifted young men and women are exploring divergent artistic avenues" (Wade and Strickland 1981: 3). In a critical essay about the ethnic art market, Wade addresses the dilemma faced by innovative Native artists: "The most serious threat to the Indian art market is persistent Anglo domination of Indian aesthetics and creativity. The market is built on a stereotyped, purist vision of traditional Indian art and culture, a vision which has little tolerance for unplanned, potentially disruptive innovation" (Wade 1981: 10).

Many of the 37 artists who were on exhibit have since become classics while some others have vanished into oblivion. The collection of the Ethnologisches Museum Berlin includes works by the following foundational artists of that time: Virginia Stroud, Allan Houser, Jerry Ingram, Fritz Scholder, Frank LaPena, Grey Cohoe, Benjamin Buffalo, George Longfish, Jaune Quick-To-See Smith, Robert (Bob) Haozous, Norval Morrisseau, and Harry Fonseca.

In 1985 *Indianische Kunst im 20. Jahrhundert* (20th Century Indian Art), one of the largest modern Native American art exhibitions which presented 250 works, was shown not in the U.S., but in Germany. Organized by Gerhard Hoffmann, a professor of American Studies at the University of Würzburg, this travelling exhibition was shown with great success in Berlin, Würzburg, Frankfurt, Wuppertal, Mannheim, Hamburg, and Zurich. The accompanying catalogue (Hoffmann 1985) is still a treasury of information about the artists that were exhibited. Several of the works presented there, including the piece on the cover of the catalogue by Jerry Ingram, are today part of the Berlin collection.

In recent years, the National Museum of the American Indian, founded in 1989, has been an institution whose activities have focused particularly on modern Native American art. In 1994 the exhibition *This Path We Travel. Celebrations of Contemporary Native American Creativity*, in which 15 contemporary Native American artists presented a joint installation, was shown at the original New York site of the museum (Hill et al. 1994).

On the occasion of the 2004 opening of the newly built exhibition building in Washington, the museum presented the *Native Modernism* exhibition, which exhibited the lifeworks of George Morrison (Chippewa) and Allan Houser (Chiricahua Apache), both of whom were deceased and regarded as pioneers of Native American modernity (Lowe 2004).

In 2007, the exhibition *Remix. New Modernities in a Post-Indian World* with works by 15 contemporary indigenous artists from the U.S., Canada, and Mexico was presented at two venues: first, once again in New York, and then at the Heard Museum in Phoenix, Arizona. Paintings, sculptures, photos and videos addressed issues of race and ethnicity in an increasingly globalized world (Baker and McMaster 2007). With these exhibitions, all of which were designed by Native American curators, the National Museum of the American Indian has become a leader among institutions that regularly present contemporary Native American art.

In the American west – the former "Wild West" – the Denver Art Museum in Denver, Colorado, is the most important institution with regard to a long-term commitment to traditional North American Indian art. The inclusion of contemporary Native American art in the museum concept was conspicuously demonstrated in 2004 when Edgar Heap of Birds (Cheyenne) built a monumental ten-part steel sculpture entitled *Wheel*. Situated on the lawn in front of the museum, this sculpture is painted in blood red with black inscriptions, and modeled on the circular construction of a Cheyenne Sun Dance lodge (Blomberg 2008, 2010).

The complexity of Native American art and its multitude of traditions and styles have led art historians and anthropologists to create ever new, more or less convincing criteria of classification. With regard to contemporary Native American art as a whole for example, John Anson Warner recently established a typology which he regards as an alternative to the commonly practiced regional classification (Warner 1997). His two basic categories are "Traditionalism" and "Modernism," which are in turn each divided into three subcategories of equal value: Revivalist, Adaptive, Innovative; and Representational, Transitional, Pluralistic. Within that classification, an artist can be represented in several categories at once, depending on the contents of his or her works. A classification such as that proposed by Warner is certainly legiti-

mate from an art-historical point of view, and deserves further serious discussion. With regard to an exhibition that presents a museum collection that has grown irregularly over decades, however, other criteria must be used.

In a collection like that in Berlin, which has been compiled since the 1970s, there are marked differences in regional emphasis due to the diversity of criteria used in collecting. The paintings purchased between 1975 and 1985 are exclusively from the American Southwest. With regard to the majority of artworks, the only reasonable classification is thus one that takes these regional differences into account, and hence, the most significantly represented North American art regions in the Berlin collection will be introduced in the following.

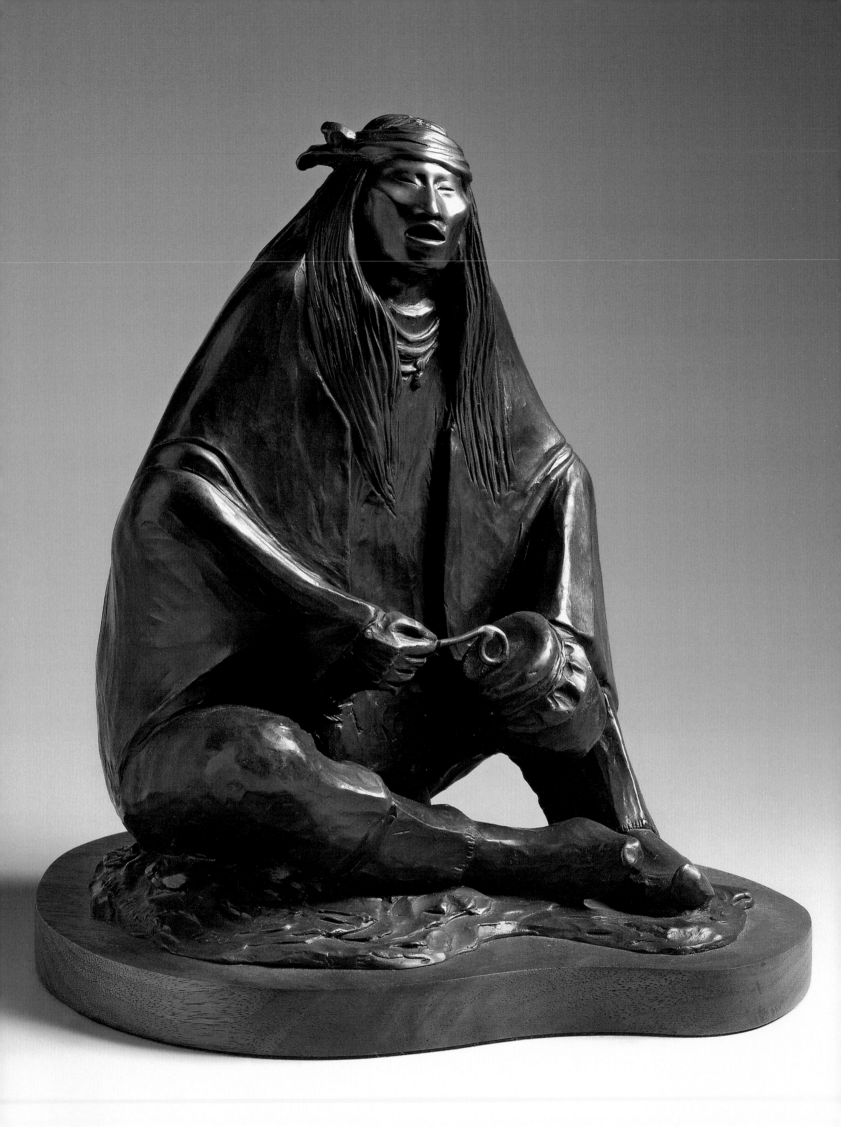

Regional Developments

The Southwest

By the end of the 19th century the Southwest had become a popular destination for American tourists. When the railroad to Santa Fe, New Mexico, opened in 1880, the region began to witness what today is called mass tourism. The arts of pottery, weaving, and silverwork began to flourish due to the influx of tourists. In addition, white artists settled in and around Santa Fe to capture the sun-flooded scenery and colorful culture of the local Native Americans on canvas. It comes as no surprise therefore that the inhabitants of San Ildefonso Pueblo in New Mexico where the first to make a try at painting pictures of traditional Native American activities for sale to the visitors. The earliest artists of this San Ildefonso School included Crescencio Martinez, Awa Tsireh (Alfonso Roybal), Tonita Peña, and Julian Martinez. Other autodidactic artists, such as Fred Kabotie or Otis Polelonema, came from the Hopi pueblos, and Velino Shije, who later called himself Herrera or Ma Pe Wi, was from Zia Pueblo. Edgar L. Hewitt, the director of the American School of Research, had a decisive influence on the development of these artists, commissioning several of them to paint traditional dances and ceremonies. In doing so, he attached more importance to artistic quality than ethnographic detail. With their bright colors and flat, two-dimensional style the works of Awa Tsireh and Fred Kabotie were particularly influential in setting the standard for the future painting style in the Southwest.

The era of institutionalized Native American painting in the Southwest had begun when Dorothy Dunn established the Studio at the Santa Fe Indian School in 1932. The first generation of Pueblo painters, such as Ben Quintana (Cochiti), Joe Herrera (Cochiti), and Pablita Velarde (Santa Clara) were joined by Chiricahua Apache Allan Houser, Yanktonai Sioux Oscar Howe, and Navajos Harrison Begay, Gerald Nailor, Quincy Tahoma, and Andrew Tsinajinnie. The Navajo painters in particular incorporated the element of motion, which had formerly been regarded as a feature typical of Plains Indian art.

Regrettably, the Ethnologisches Museum Berlin does not own any paintings created by that first generation of artists. The collection, however, includes a bronze sculpture made by **Allan Houser** (1914–1994) in 1982 (Fig. 3). Houser (Haozous) was one of the most successful artists spawned by the Santa Fe Studio. As early as 1937 he had his first solo exhibition as a painter at the Museum of Fine Arts in Santa Fe. Around 1940 he turned to sculpture and created works from bronze and stone. From 1962–1975 he taught sculpture at the Institute of American Indian Arts in Santa Fe. His great sculptural works were instrumental in establishing Native American sculpture as a distinct art form. Houser did not exclusively create sculptures in the round; he also used an openwork style that lends his works an air of weightlessness and dematerialization. Being Chiricahua Apache, he devoted much of his work to the bygone culture of his people, bringing it

Fig. 3 Allan Houser (Haozous), Chiricahua Apache, *Chiricahua Medicine Man*, 1982. Hartmann Collection, 1983. Bronze sculpture on wooden base, height 26 cm. Ethnologisches Museum Berlin, Inv. No. IV B 13104.

right: **Fig. 4** Beatien Yazz (Jimmy Toddy), Navajo, *Navajo Couple*, ca. 1970. Hartmann Collection, 1975. Watercolor on cardboard, height 51 cm, width 38 cm. Ethnologisches Museum Berlin, Inv. No. IV B 12905.

Fig. 5 Beatien Yazz (Jimmy Toddy), Navajo, *Two Dancers at a Fire*, ca. 1970. Seybold Collection, 2010. Tempera on black cardboard, height ca. 48 cm, width ca. 58 cm. Ethnologisches Museum Berlin, Inv. No. IV B 13229.

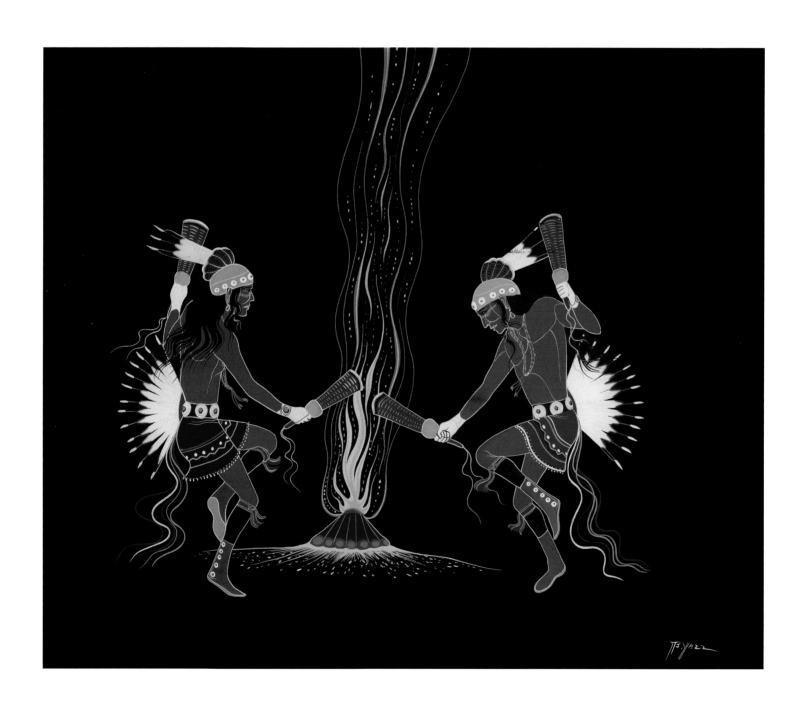

right: **Fig. 6** Beatien Yazz (Jimmy Toddy), Navajo, *Peyote Princess*, ca. 1975. Hartmann Collection, 1980. Casein on canvas cardboard, height 62 cm, width 51.5 cm. Ethnologisches Museum Berlin, Inv. No. IV B 113064.

p. 30–31: Fig. 7 J.D. Roybal, San Indefonso Pueblo, *Corn Dance*, ca. 1970. Hartmann Collection, 1975. Watercolor on paper, height 40 cm, width 57 cm. Ethnologisches Museum Berlin, Inv. No. IV B 12904.

back to life in sculptures of warriors, chanters, and medicine men (Rushing 2004). In 1983, the Amerika Haus Berlin (an institution of the U.S. government) organized a joint traveling exhibit of Houser and Hopi painter Dan Namingha, which was shown first in Berlin and then at various Amerika Haus venues in German cities (Amerika Haus Berlin 1983). The works were for sale, and the Ethnologisches Museum Berlin was thus able to buy a small bronze figure of a seated Chiricahua Apache medicine man who is singing and beating a drum. The decision to purchase this piece was guided by both its artistic message and ethnological content. With this sculpture, which rests in itself and gives the impression of being monumental despite its small size, Houser expresses the essence of Native American spirituality.

From amongst the subsequent, second generation of artists spawned by the Santa Fe Indian School, several are represented in the Berlin collection: Beatien Yazz, José D. (J.D.) Roybal, and Raymond Naha. During his research trip to the Southwest in 1975, Horst Hartmann bought one painting by each of these three artists from trader Rex Arrowsmith in Santa Fe. This was the basis for all further collections of modern Native American art at the Ethnologisches Museum Berlin.

While Navajo Artist **Beatien Yazz** (Jimmy Toddy, *1928) is often compared with Harrison Begay, he was too young to be trained in Dorothy Dunn's Studio. Nevertheless, many of his works still embody the traditionalist style of that school, which becomes particularly apparent in *Navajo Couple* (Fig. 4) and *Dancers at the Fire* (Fig. 5). Being a member of the Native American Church, which uses the hallucinogenic peyote cactus in its religious practice, Yazz has been painting pictures in bright colors, that reflect his experiences with Peyote ingestion, since the 1960s (Brody 1971: 162–173, Chase 1982: 16–19, Seymour 1988: 92–95). *Peyote Princess* (Fig. 6) is one of these pictures. It shows a young female participant of a peyote ritual who is surrounded by color visions that emanate from the peyote cactus she wears in her ear like a piece of jewelry.

Pueblo artist **José D. (J.D.) Roybal** (Oquwa, 1922–1978) from San Ildefonso, who studied painting at the Santa Fe Indian School, continued the Studio style with his works. When his cousin Awa Tsireh died in 1955, he adopted the latter's themes and painting style. Thus, there exists a continuous line between his work and the beginnings of Pueblo painting (Brody 1971: 169). Roybal's *Corn Dance* painting (Fig. 7) is a typical example of the flat, two-dimensional style of the Studio, and lends additional emphasis to the ceremoniousness of the event.

Percy Sandy alias Kai Sa (Red Moon, 1918–1974) was the best-known Zuni artist of his time, and was represented in many exhibitions. The *Longhair and Mate* watercolor (Fig. 8) shows a detail of a rain dance featuring two longhair kachinas. Most of his paintings, however, are more complex depictions of Zuni ceremonies (Tanner 1973: 293–296).

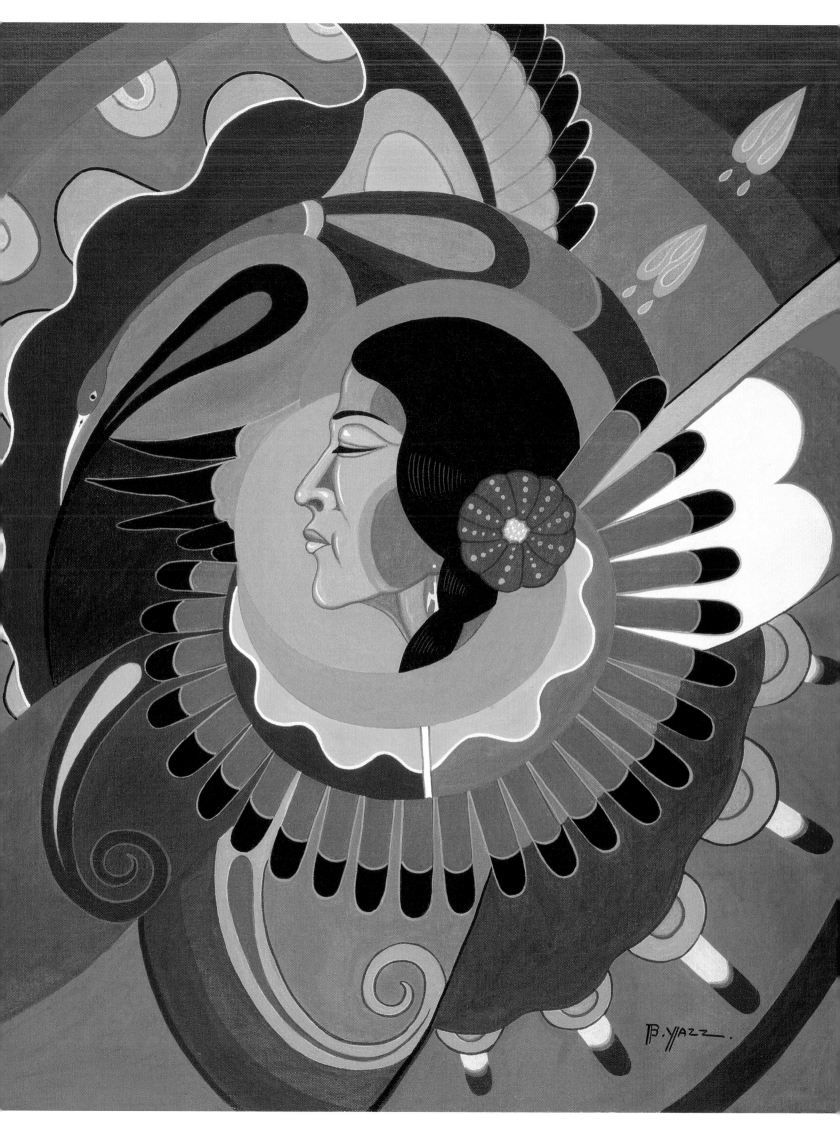

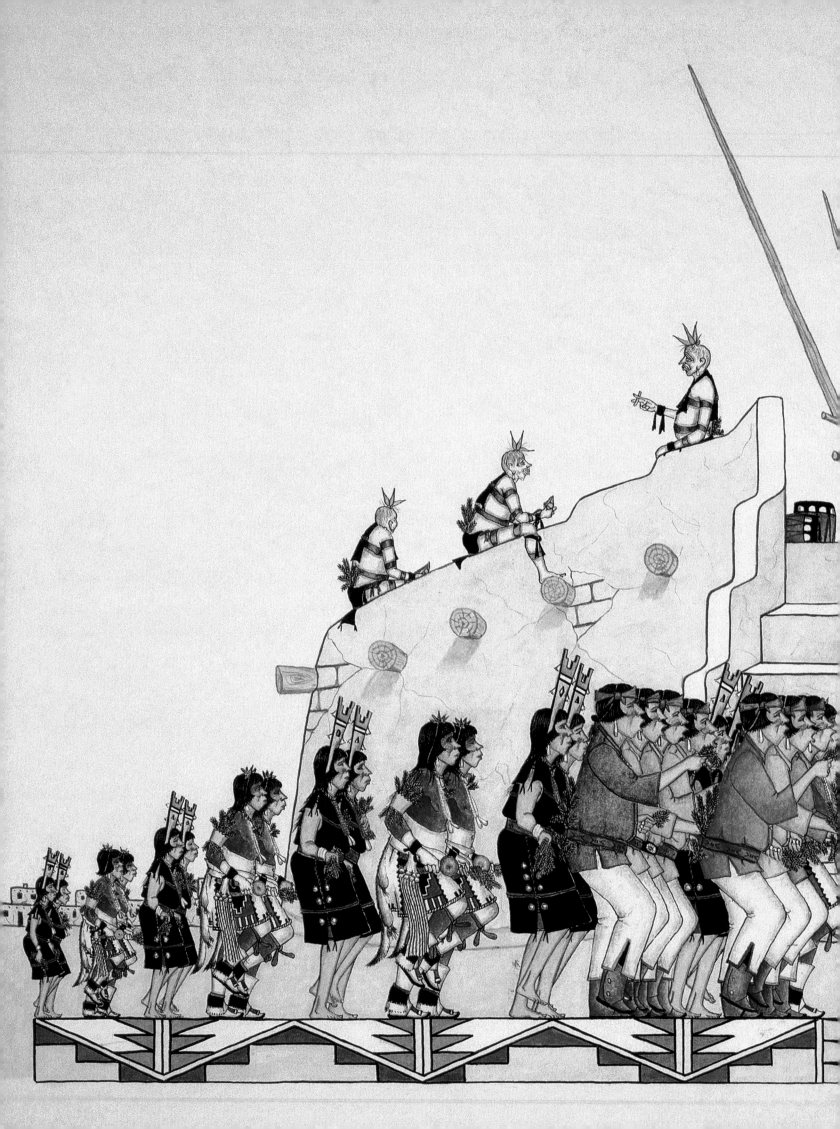

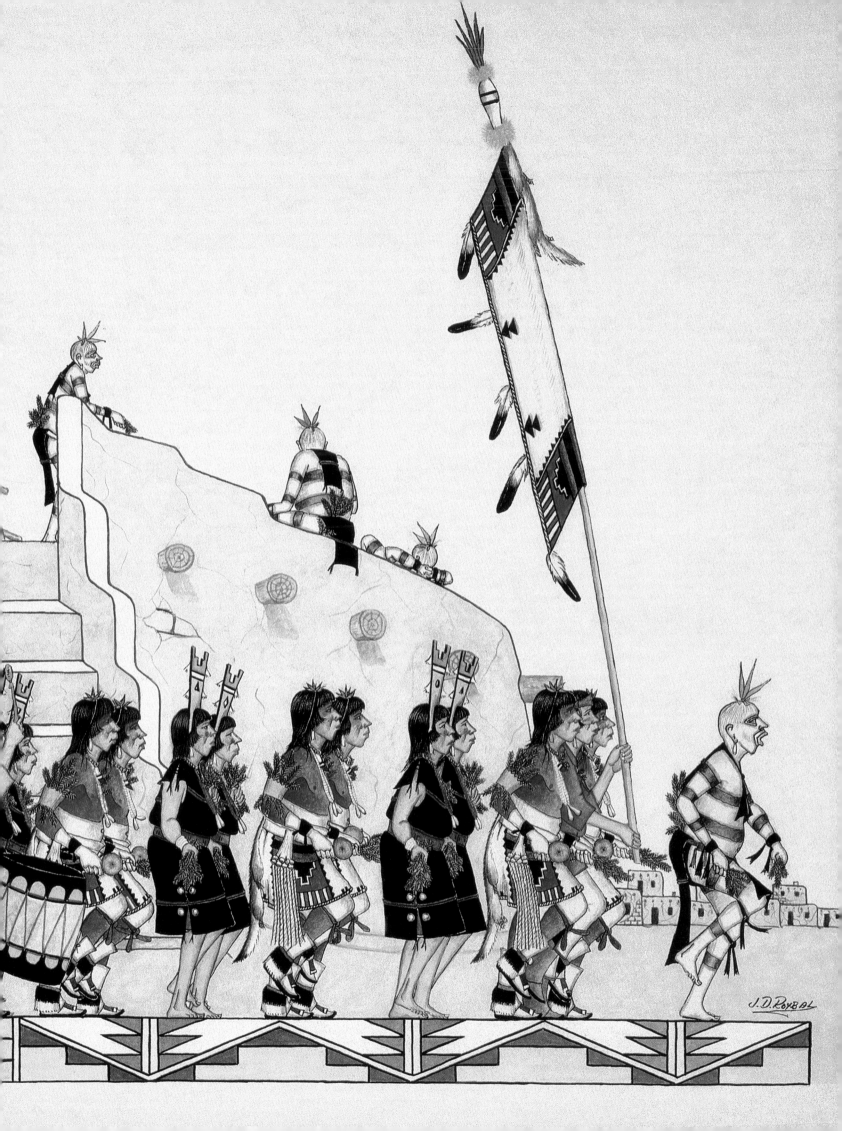

Geronima Cruz Montoya (P'o-tsunu, *1915) from San Juan Pueblo is one of the few female artists represented in the Berlin collection. She was Dorothy Dunn's successor as an art instructor at the Santa Fe Indian School, and her paintings tend to conform to the traditional style (Tanner 1973: 191–193). Against this backdrop, her 1979 image *Ghost of the Underworld* (Fig. 9) is all the more remarkable, as it takes up the tradition of prehistoric rock paintings.

The majority of the paintings collected by Horst Hartmann and – on Hartmann's behalf – Ekkehart Malotki come from the Hopi. This is due to the fact that during the 1970s Horst Hartmann was particularly interested in Hopi culture. As a result, his book *Kachina-Figuren der Hopi-Indianer* (*Kachina Figures of the Hopi Indians*) was published in 1978. He commissioned Ekkehart Malotki, a German-born scholar who specialized in Hopi linguistics, to collect paintings, kachina figures, and other Hopi objects for the Berlin museum. In 2010 three more pictures came to the museum from the Seybold collection.

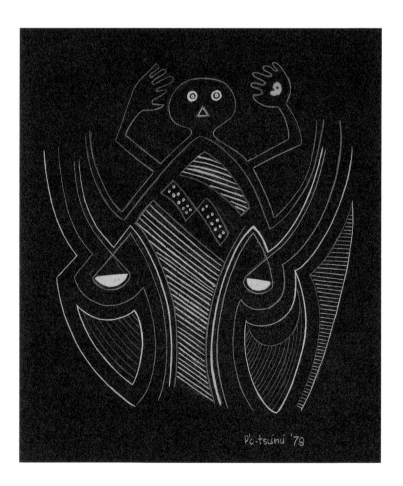

The earliest of these purchases was created by Hopi painter **Raymond Naha** (1933–1975) and shows a *Mixed Kachina Dance* (Fig. 10). Naha was lauded for his complex compositions of dancers moving amongst pueblo buildings (Tanner 1973: 270–275). Featuring a number of different kachina dancers, the picture in the Berlin collection is thus definitely one of the highlights of his creative work. Hartmann (1978: 5) also used it as an illustration in his Kachina book.

The three paintings by Hopi artists **Roy Calnimtewa** (Bevasiviya, Fig. 11), **D. Kopelva** (Fig. 12) and **Cecil Calmingtewa** (Fig. 13) show various types of kachinas. Because none of these painters are mentioned by either Brody (1971) or Tanner (1973), it is likely that these works were collected for the emphasis they placed on the depiction of the costumes rather than for their artistic qualities.

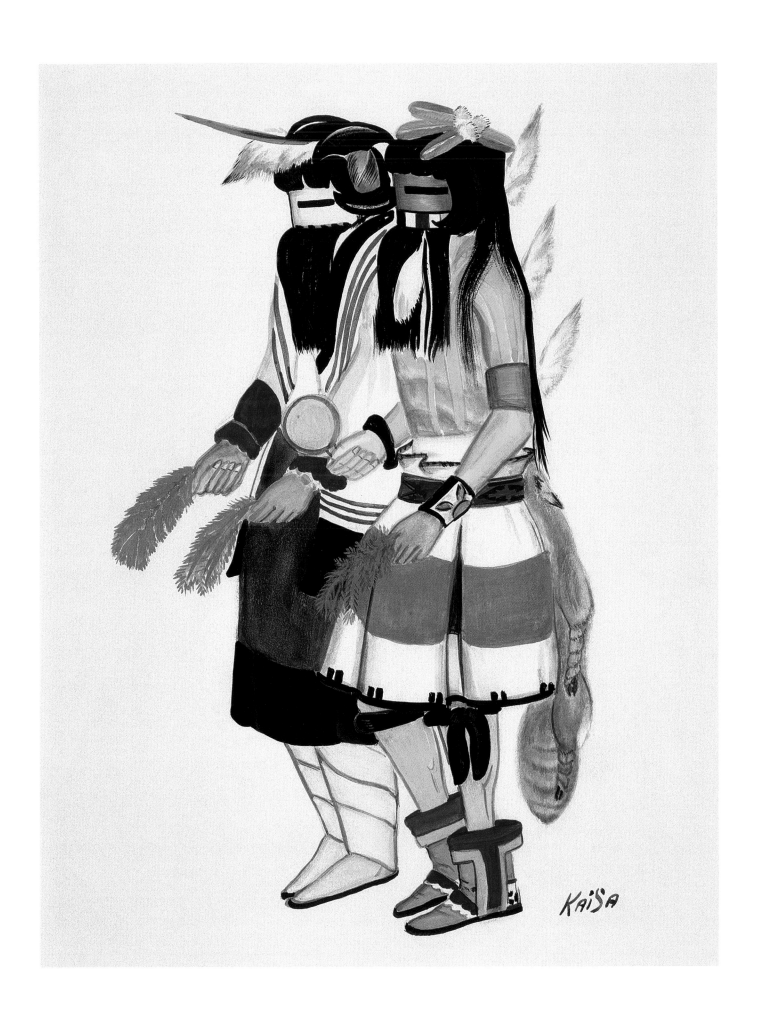

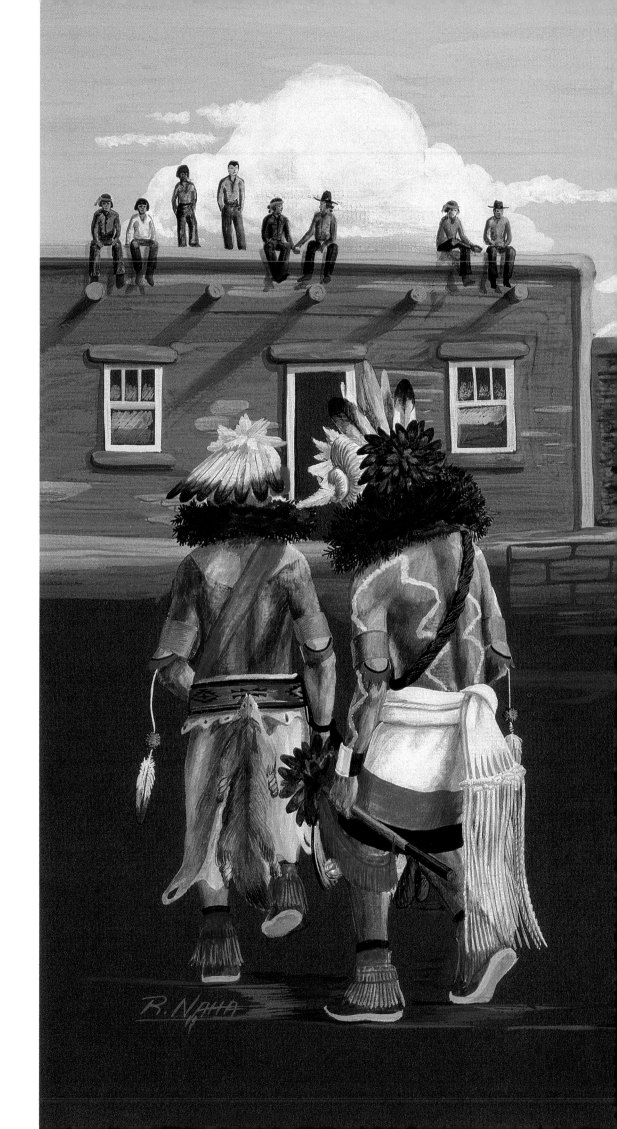

Fig. 10 Raymond Naha, Hopi,
Mixed Kachina Dance, ca. 1970.
Hartmann Collection, 1975.
Gouache on brown cardboard,
height 38.5 cm, width 51.5 cm.
Ethnologisches Museum Berlin,
Inv. No. IV B 12906.

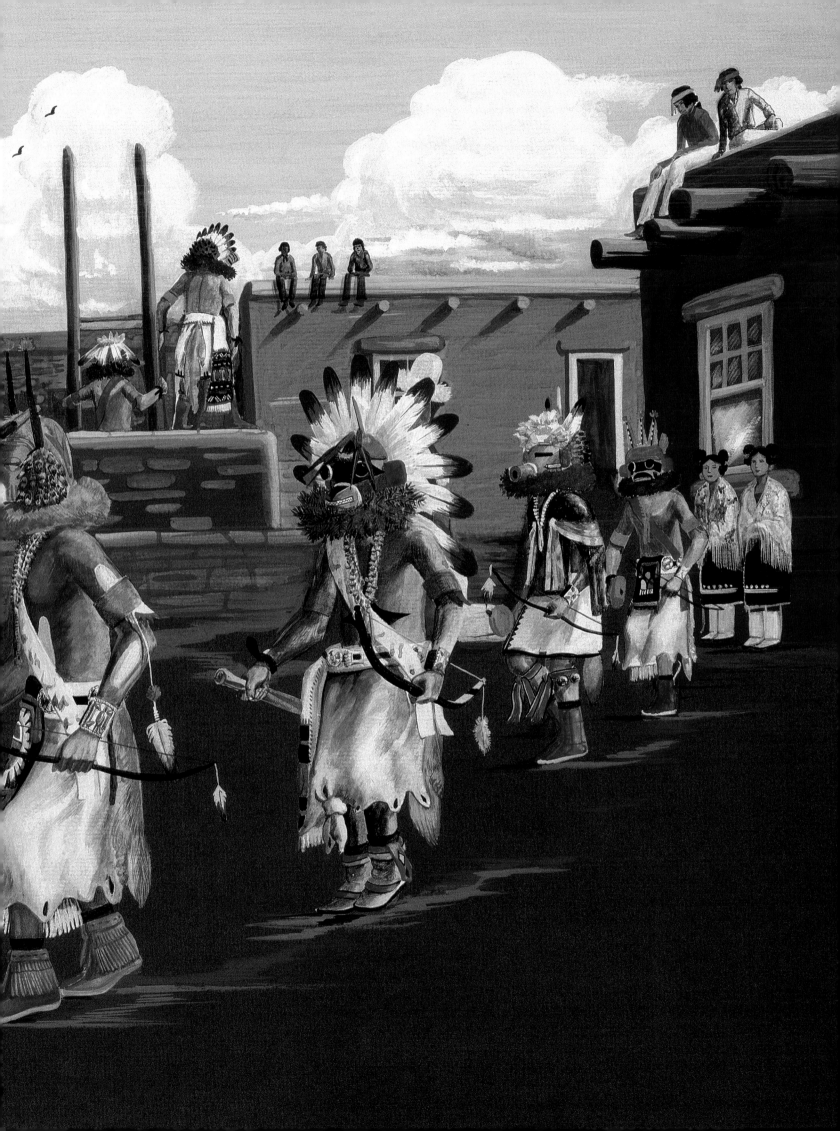

right: **Fig. 13** Cecil Calmingtewa, Hopi, *Hummingbird Kachina*, ca. 1975. Hartmann Collection, 1980. Gouache on brown cardboard, height 51 cm, width 41 cm. Ethnologisches Museum Berlin, Inv. No. IV B 13055.

Fig. 11 Roy Calnimtewa (Bevasiviya), Hopi, *Kooninkatsina*, ca. 1975. Malotki Collection, 1975. Watercolor on cardboard, height 51 cm, width 40.6 cm. Ethnologisches Museum Berlin, Inv. No. IV B 12998.

Fig. 12 Kopelva, Hopi, *Corn Dancer, Ka-e Kachina*, ca. 1975. Hartmann Collection, 1980. Watercolor on cardboard, height 30.6 cm, width 23.3 cm. Ethnologisches Museum Berlin, Inv. No. IV B 13056.

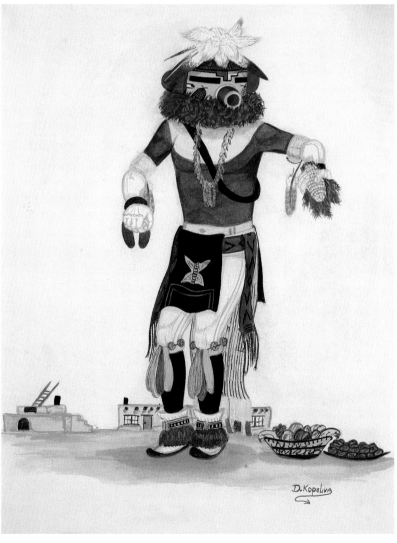

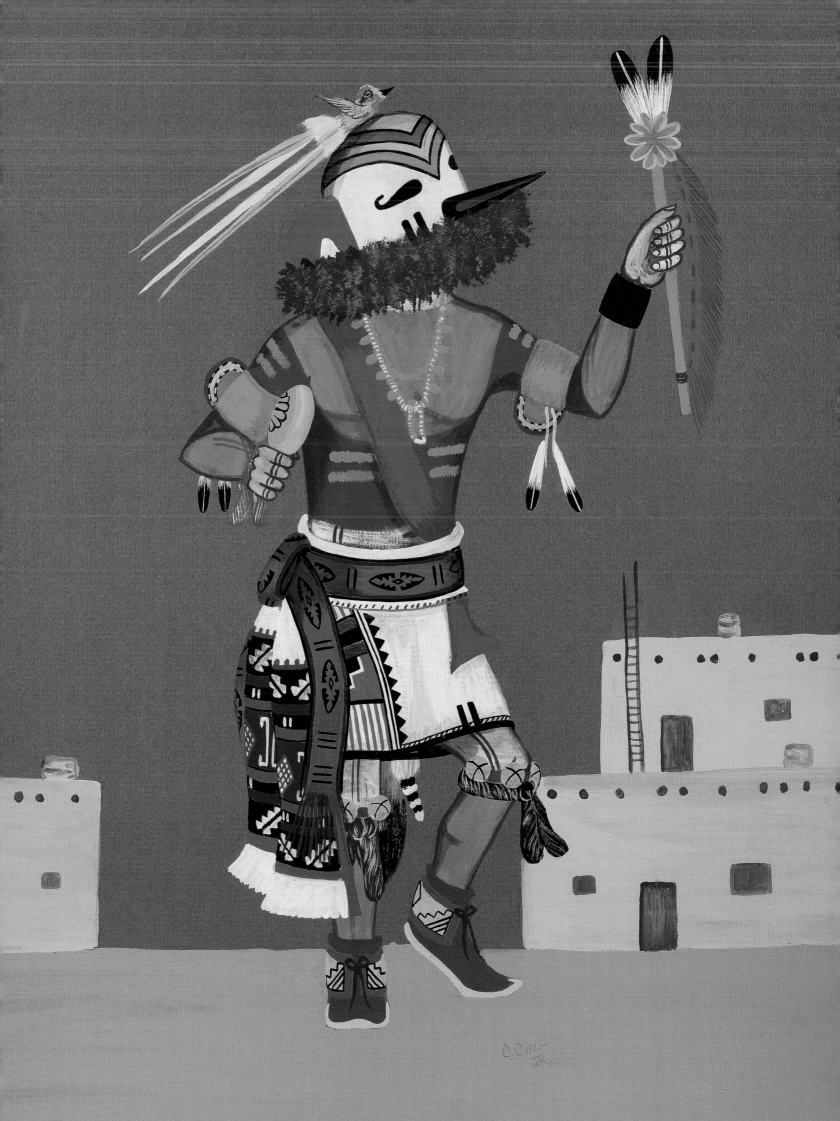

The Artist Hopid Group

In May 1973, Hopi artists Mike Kabotie, Terrance Talaswaima, and Neil David formed a group which they called Artist Hopid. They wrote a manifesto that included the following goals: to use their artistic skills for the purpose of fostering the pride and identity of the Hopi people; to convey Hopi aesthetic and cultural values to both Hopi and non-Hopi people; to develop new artistic ideas on the basis of traditional Hopi

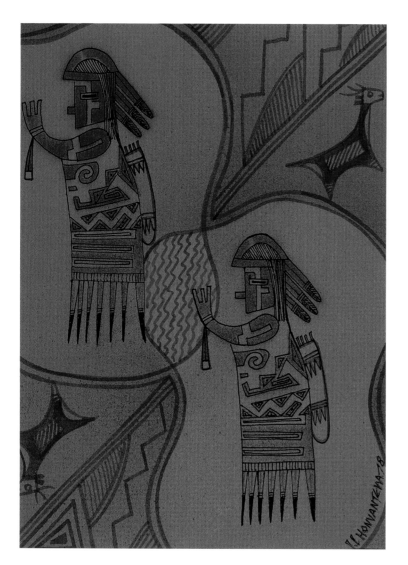

designs; and to use their art to study and document Hopi history (Broder 1978: 299). Shortly afterwards the group was joined by Delbridge Honanie and Milland Lomakema. In 1974, the first exhibition of the group was presented on Second Mesa (Hopi reservation), followed by other exhibitions that same year in Phoenix, Tucson, Riverside, and San Diego. With the help of a public art foundation they were able to send an exhibition of 31 paintings on a tour to seven U.S. cities in 1976. In this context, they also placed an emphasis on lectures and demonstrations in which they pointed to the origins of their art in petroglyphs and *kiva* wall paintings (Broder 1978: 301). The group existed until 1979, after which its members embarked on individual careers. The Berlin collection includes a considerable number of works by this group of artists – 14 paintings and graphics, most of which were created by Neil David, Mike Kabotie, and Milland Lomakema.

While founding member **Terrance Talaswaima** (Honvanteva, *1939) is only represented in the Berlin collection by the small-format *Hunter Spirits* (1978, Fig. 14) painting, there are five paintings by **Neil Randall David** (*1941). His subjects range from realistic depictions of kachinas to humorous scenes featuring Hopi clowns and abstract renderings of *kiva* wall paintings (Figs. 15–19). David is also a much sought after carver of kachina figures (Pearlstone 2001: 34–35), and all of his artwork is dominated by that theme. One of his most impressive works in the Berlin collection is the

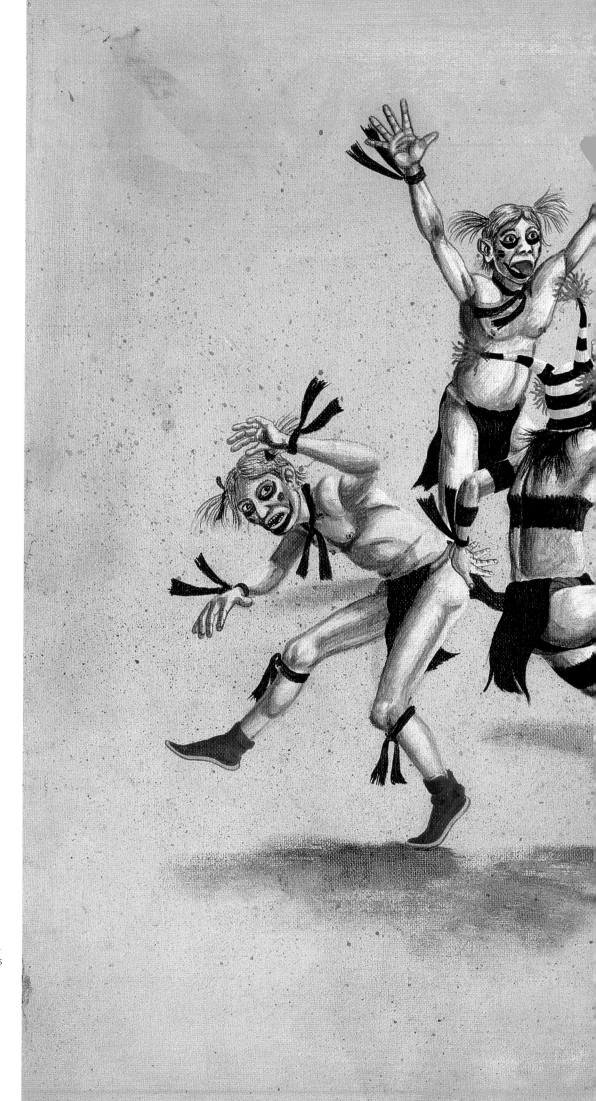

Fig. 16 Neil David, Hopi, *Hopi Clowns*, 1975.
Malotki Collection, 1982. Acrylic on canvas
cardboard, height 45.5 cm,
width 61 cm. Ethnologisches Museum
Berlin, Inv. No. IV B 13085.

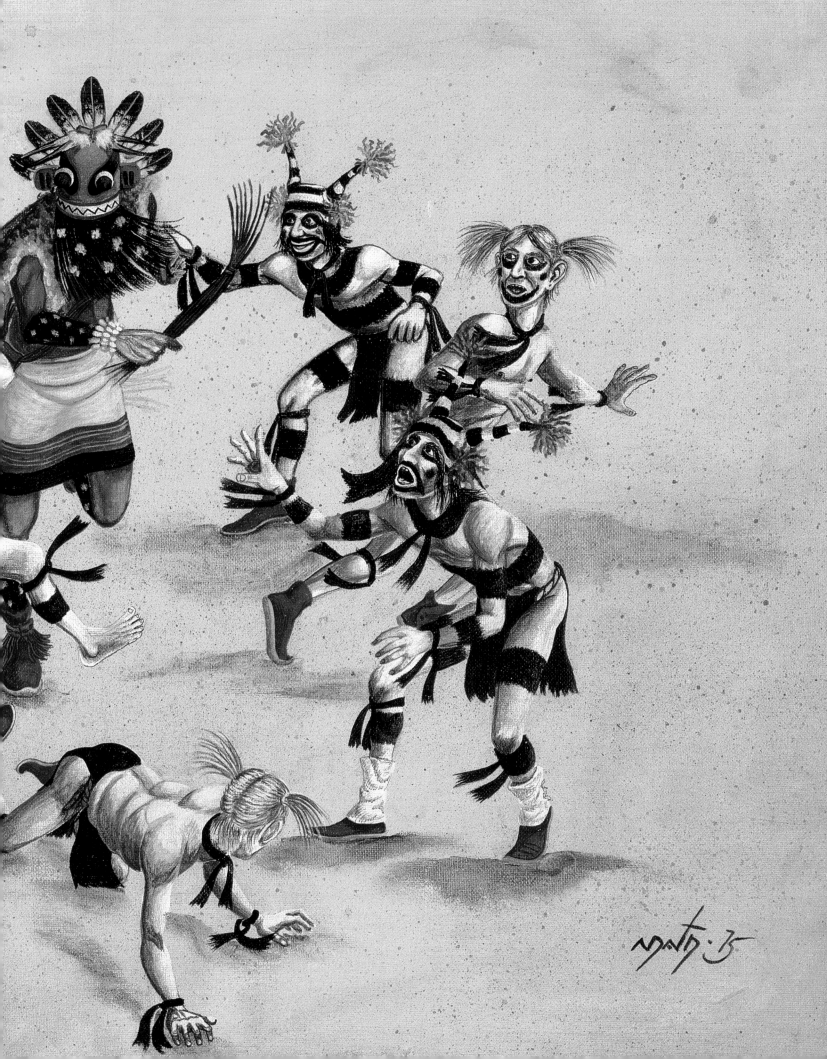

painting *Warrior Maiden Kachina* (Fig. 15), the portrait of a legendary young woman who – with her hair only partly done – immediately seized bow and arrow to defend her village when enemies attacked.

Michael Kabotie (Lomawyweswa, 1942–2009) created the painting *From Zuni They Came* (1978, Fig. 20). In the style of a rock painting, it refers to the mass migration of the Hopi as described in their origin story. *Kachina Coming* (Fig. 21), in contrast, is a Cubist-style rendition of the entry of the kachina dancers, and the lithograph *Kachina Song Blessing* (Fig. 22) combines elements of rock paintings with the portrayal of the rain-bringing Longhair kachinas.

Milland Lomakema (Dawakema, *1941) is represented by very diverse themes: his 1976 painting shows a very stylized *Warrior with Shield* (Fig. 23), in which the contours of the figure shine through the shield like in an x-ray image. *Warrior God* (Fig. 24), in contrast, is reminiscent of a *kiva* wall painting. Two figures – the one to the right being the *War God* – are fighting with two water snakes and in doing so bring forth the rain that makes the corn plant – shown in the center – grow (Kunze 1988: 196). The other three pictures are abstract images from the vast repertoire of Hopi iconography and the kachina dances (Figs. 25–27).

All members of Artist Hopid draw on a multitude of traditional references from both the ceremonial system and the history and mythology of the Hopi, and make creative use of these in new media of art.

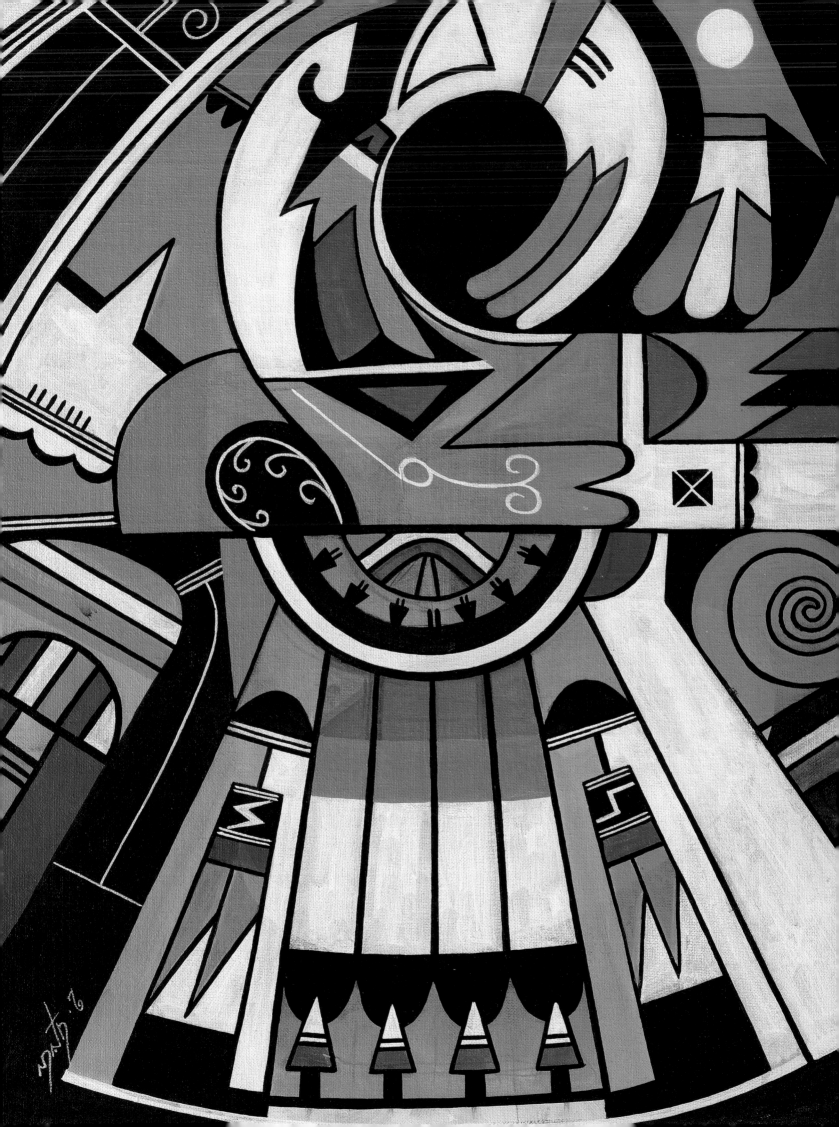

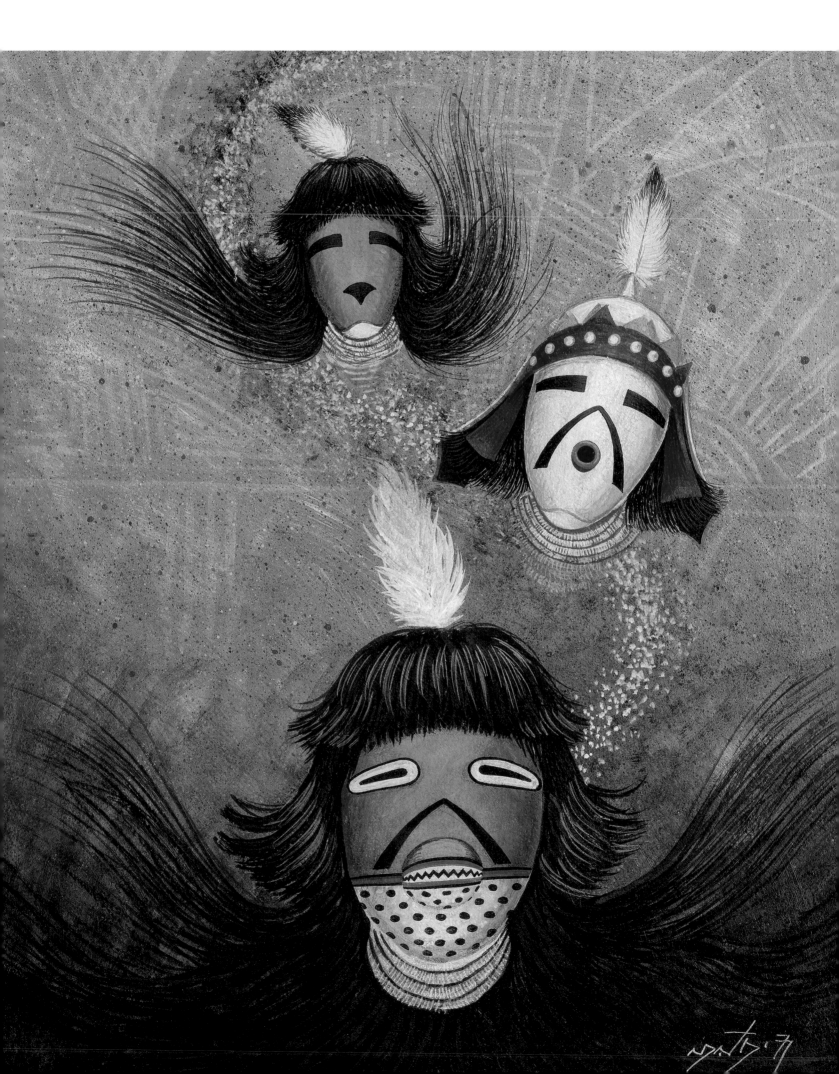

left: Fig. 18 Neil David, Hopi, *Kachina Spirits*, 1977.
Hartmann Collection, 1980. Gouache on cardboard,
height ca. 45 cm, width ca. 40 cm.
Ethnologisches Museum Berlin, Inv. No. IV B 13065.

Fig. 19 Neil David, Hopi: *Longhair with Maid*,
(*Angaktsina with Angaktsinmana*), 1978. Malotki
Collection, 1979. Pen-and-ink drawing on cardboard,
height ca. 32 cm, width ca. 27 cm.
Ethnologisches Museum Berlin, Inv. No. IV B 12997.

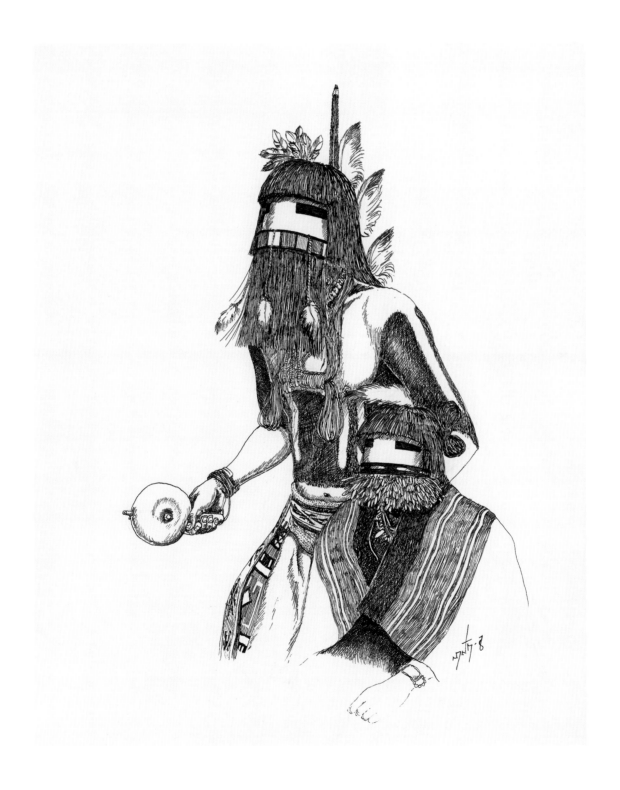

Fig. 20 Michael (Mike) Kabotie (Lomawywesa), Hopi, *From Zuni They Came*, 1978. Seybold Collection, 2010. Acrylic on canvas, height 91.5 cm, width 91.5 cm. Ethnologisches Museum Berlin, Inv. No. IV B 13235.

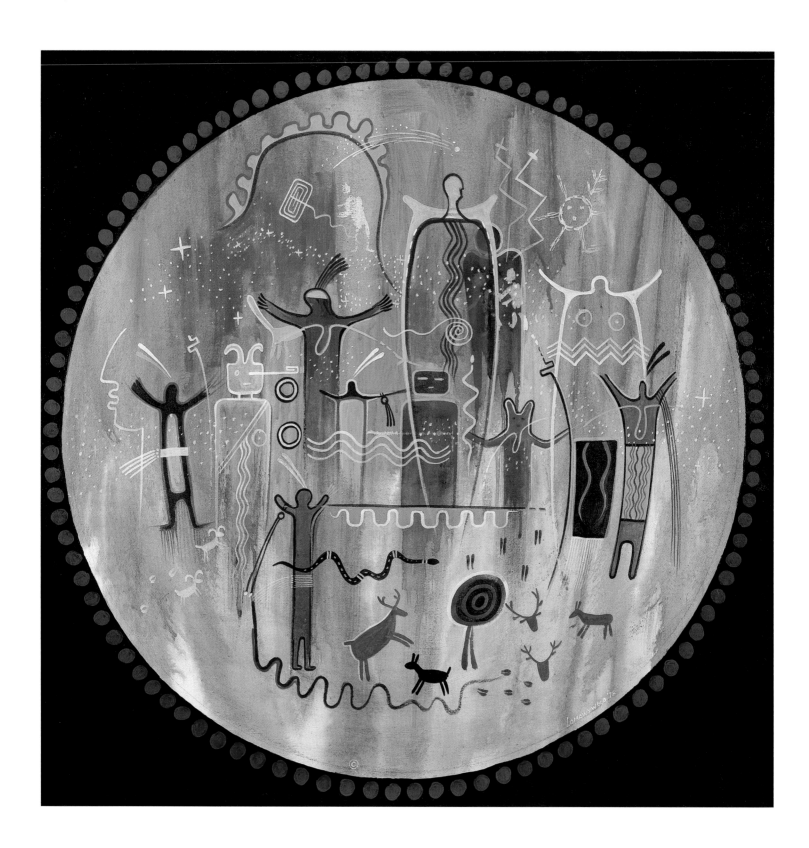

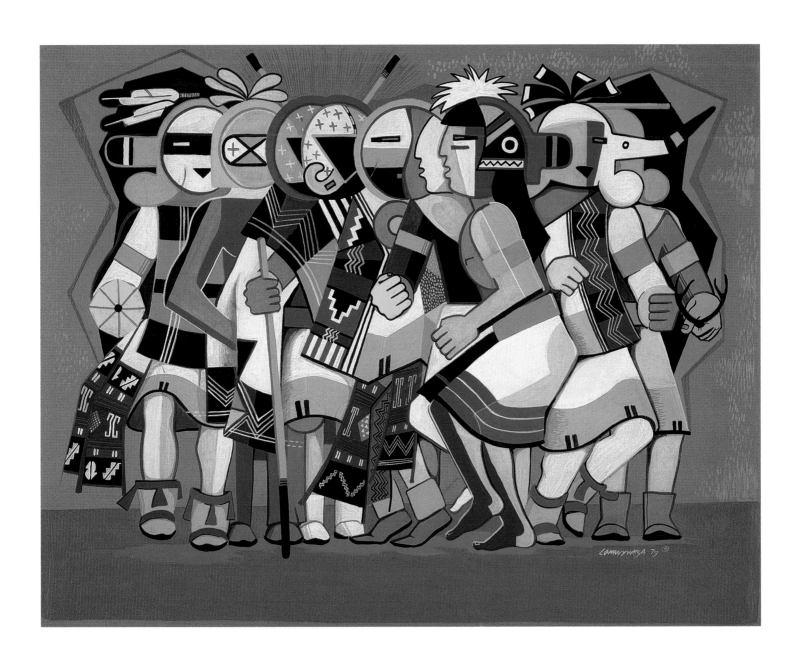

Fig. 22 Michael (Mike) Kabotie (Lomawywesa), Hopi,
Kachina Song Blessing, 1986. Nuzinger Collection, 1991.
Lithograph printed in seven colors with additional hand
coloring (edition number 46/75), height 39 cm, width 56 cm.
Ethnologisches Museum Berlin, Inv. No. IV B 13127.

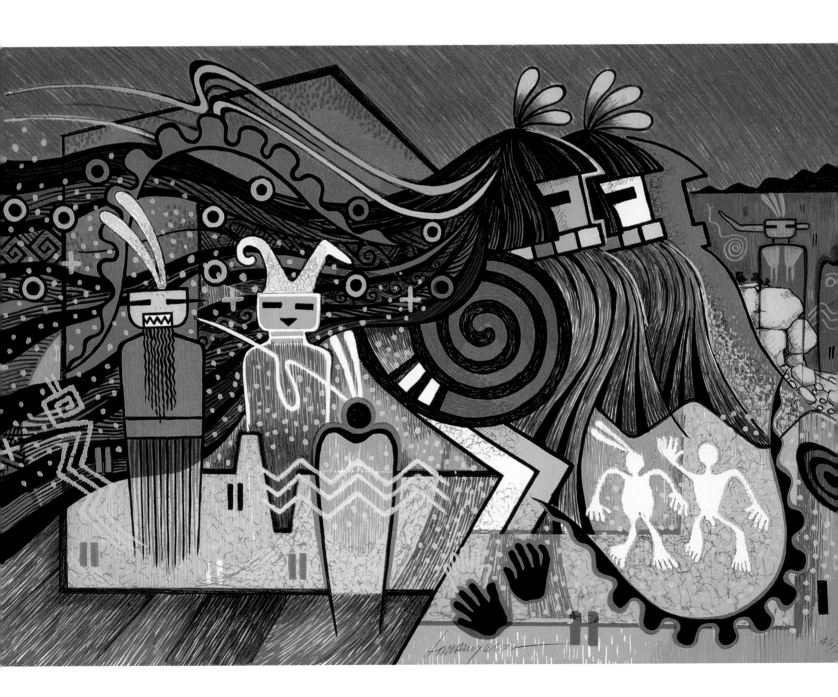

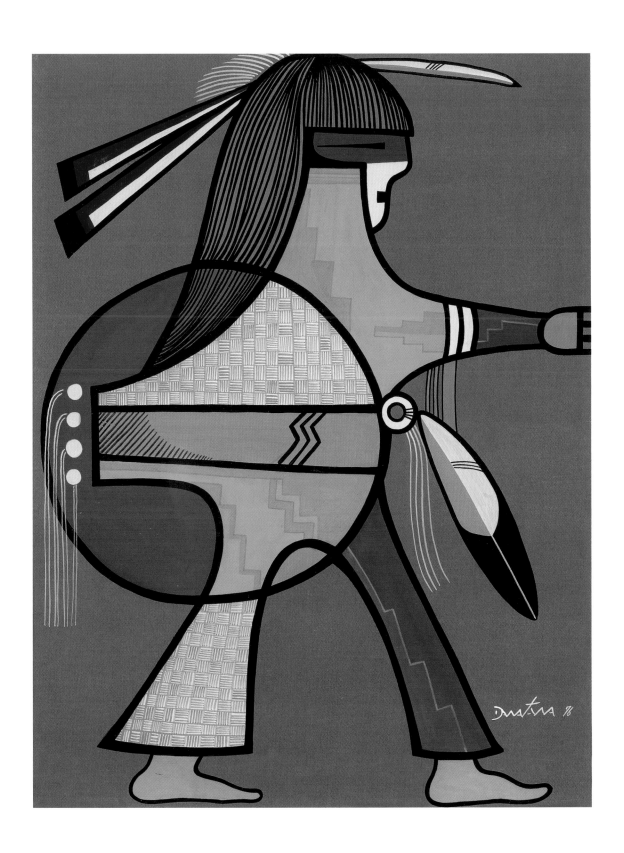

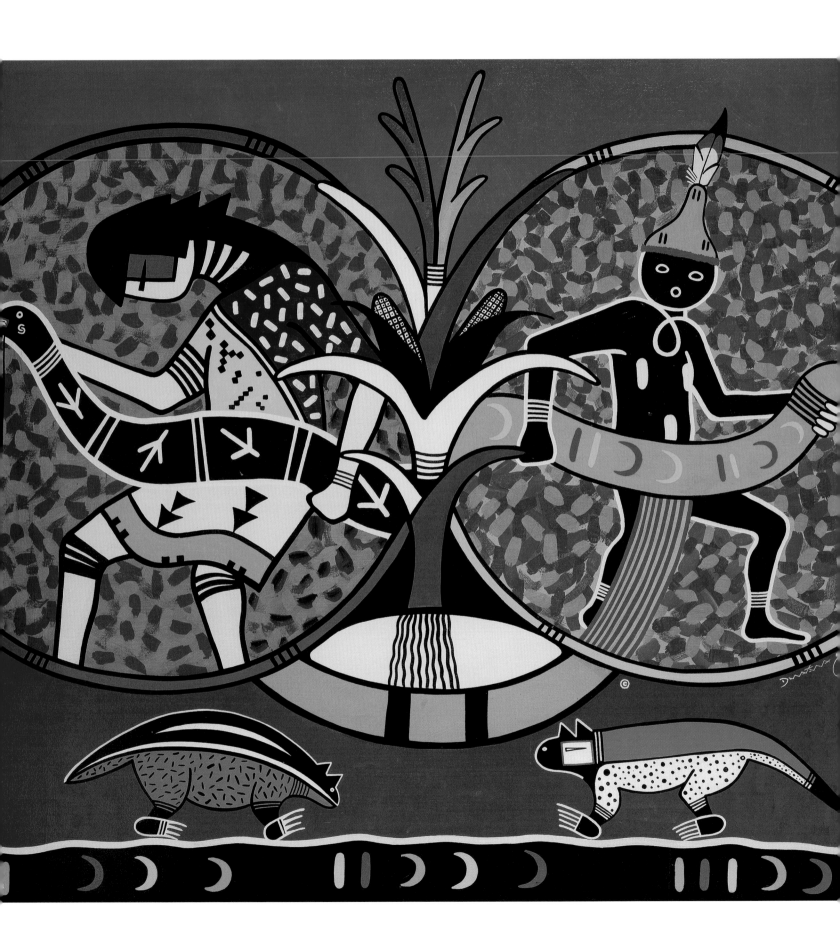

left: **Fig. 24** Milland Lomakema (Dawakema), Hopi,
Warrior God, 1977. Seybold Collection, 2010.
Acrylic on canvas, height 104 cm, width 112 cm.
Ethnologisches Museum Berlin, Inv. No. IV B 13237.

Fig. 25 Milland Lomakema (Dawakema), Hopi,
Symbols of Big Horn and Maiden, 1977.
Hartmann Collection, 1980. Gouache on cardboard,
height 51 cm, width 40.5 cm.
Ethnologisches Museum Berlin, Inv. No. IV B 13058.

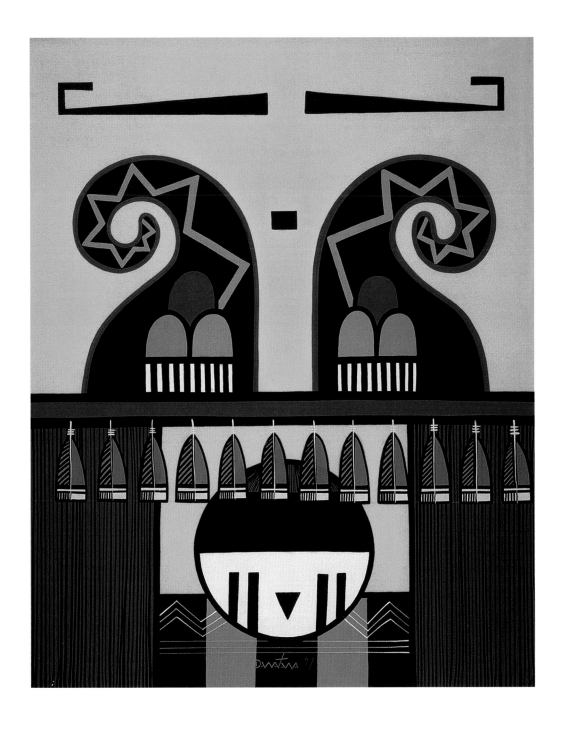

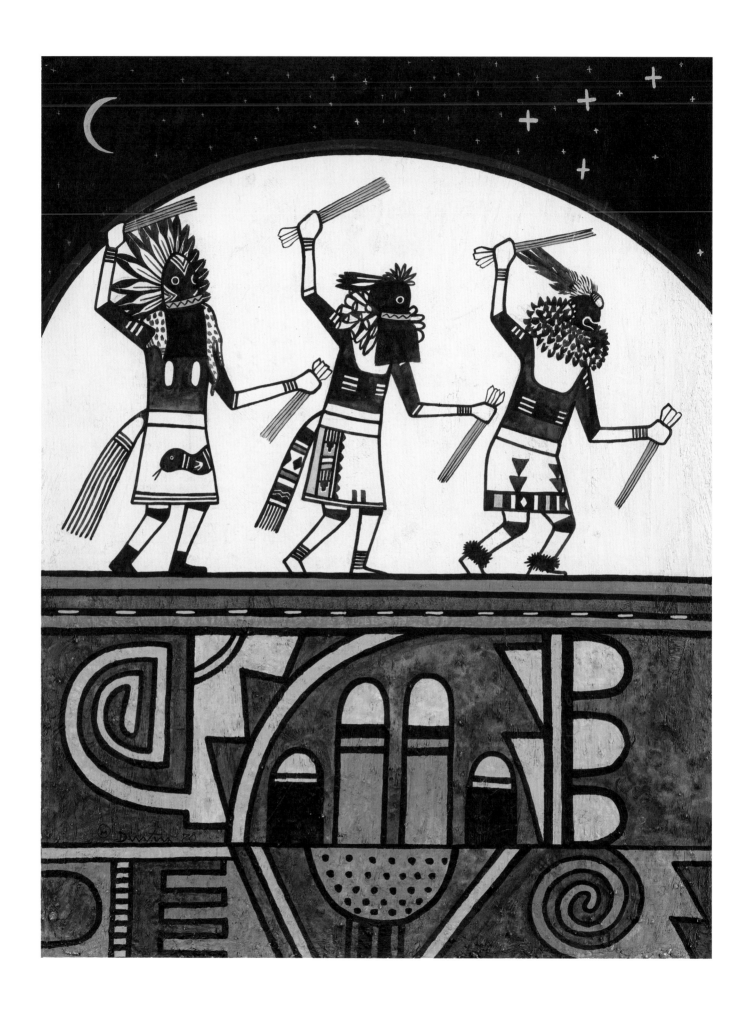

left: **Fig. 26** Milland Lomakema (Dawakema), Hopi, *The Whippers*, 1978. Malotki Collection, 1984. Acrylic on canvas cardboard, height 61 cm, width 45.5 cm. Ethnologisches Museum Berlin, Inv. No. IV B 13106.

Fig. 27 Milland Lomakema (Dawakema), Hopi, *Symbols of War Society*, 1979. Malotki Collection, 1984. Acrylic on canvas cardboard, height 51 cm, width 60.5 cm. Ethnologisches Museum Berlin, Inv. No. IV B 13107.

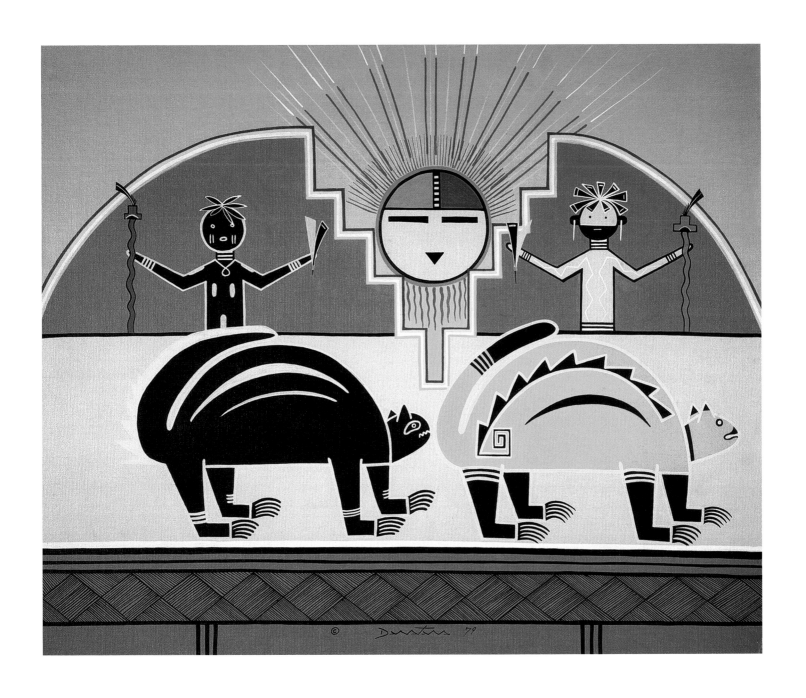

Independent Painters in the Southwest and California

Aside from the Hopi artists with their predominantly traditional orientation, two Navajo painters are represented in the Berlin collection. While each of them developed an individual style early on, the themes chosen for their works always expressed their close ties to their Southwest homeland.

Grey Cohoe (1944–1991) belonged to the first generation of artists trained at the Institute of American Indian Arts in Santa Fe. He became best known for his depiction of everyday scenes in the Navajo reservation, which often relate to autobiographical experiences (Wade and Strickland 1981: 64–65). In *Rite for Autumn Harvest* (Fig. 28), however, he portrays a scene in a Pueblo village, with a line of deer dancers in the foreground. The autumnal harvest ritual has an unusual outcome given that the Southwest is mostly arid: huge green apples rain down from the red, stormy sky. It is widely known, there is constant rivalry between the Navajo and the Puebloans; being Navajo, Grey Cohoe quite obviously took the liberty of seasoning his painting with a touch of irony.

Rudolph Carl Gorman (1933–2005), whose first names were always abbreviated as "R. C.," was one of the most unusual figures among the artists of the Southwest. He is associated with one single subject: monumental images of women, printed as lavish color lithographs in ever new variations (Monthan 1978). As Gorman constantly refined his lithographs, the shades of color on his later sheets are incredibly nuanced. The picture *Taos Traders* (1989, Fig. 29) is printed in no less than 46 colors. It shows two women completely covered by their white garments, sitting by the roadside and selling painted pottery. One of these pots is placed in the foreground as an individual piece of art that is intended to attract the attention of potential buyers.

In 1968 Gorman opened his own gallery in Taos, New Mexico, which is a well-known artists' colony. In the 1970s and 80s he was one of the most popular artists in the U.S. and welcomed not only film stars such as Liz Taylor in his atelier, but celebrity artist Andy Warhol as well. Those who could not afford to buy one of his expensive originals could at least grace their homes with a Gorman poster. His work was shown in numerous exhibitions throughout the U.S., and in 1982 gallery owner Ilse Keller organized a tour in Germany where Gorman's works of art were exhibited in Neustadt an der Weinstraße, Düsseldorf, and Frankfurt. This was probably the largest individual exhibition of any Native American artist ever presented in the country of Karl May (Keller 1982). In 1987, Gorman had his graphic works – which by then amounted to 404 – published in a large coffee-table book (Adams and Newlin 1987).

Fig. 28 Grey Cohoe, Navajo, *Rite for Autumn Harvest*, 1983. Seybold Collection, 2011. Acrylic on canvas, height 102.5 cm, width 127 cm. Ethnologisches Museum Berlin, Inv. No. IV B 13238.

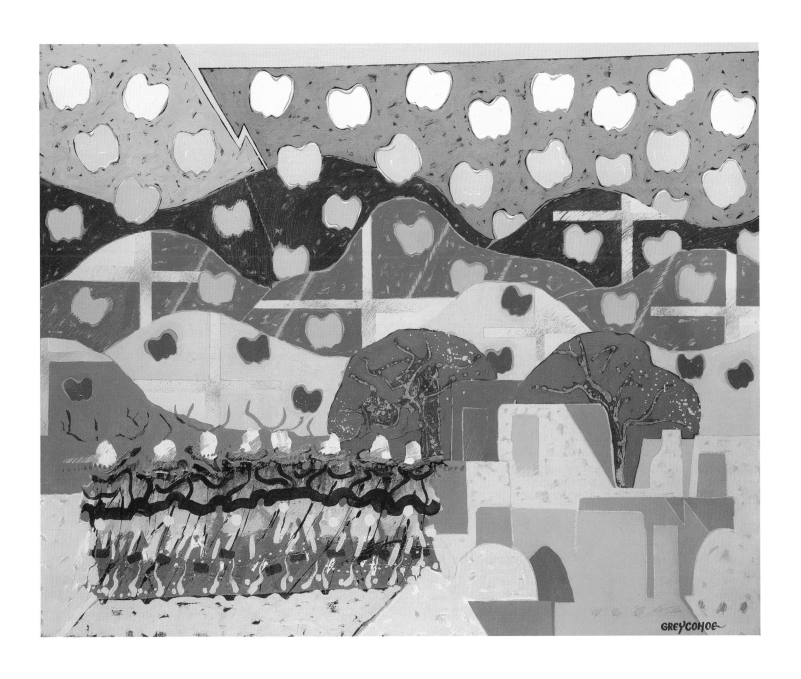

right: Fig. 30 Frank LaPena, Wintu, *Red Cap*, 1989.
Nuzinger Collection, 1994. Acrylic on canvas,
height 122 cm, width 91 cm.
Ethnologisches Museum Berlin, Inv. No. IV B 13131.

Fig. 29 R.C. Gorman, Navajo, *Taos Traders*, 1989.
Nuzinger Collection, 1991. Lithograph in 46 colors
(edition number 197/224), height 66 cm,
width 92 cm. Ethnologisches Museum Berlin,
Inv. No. IV B 13126.

California is, in the broadest sense, part of the former Spanish colonial possessions in the Southwest.
During the course of the 1848 Gold Rush, most of the local Native Americans were displaced, murdered,
and bereft of their land. As a result, traditions and customs disappeared, only gradually re-emerging in the
wake of the Native American protest movements of the 1960s. One of the pioneers of the revival of Native
culture in California is Maidu artist Frank Day (1902–1976), who in the 1960s began to paint historical and
mythical scenes from the Maidu world (Dobkins 1997).

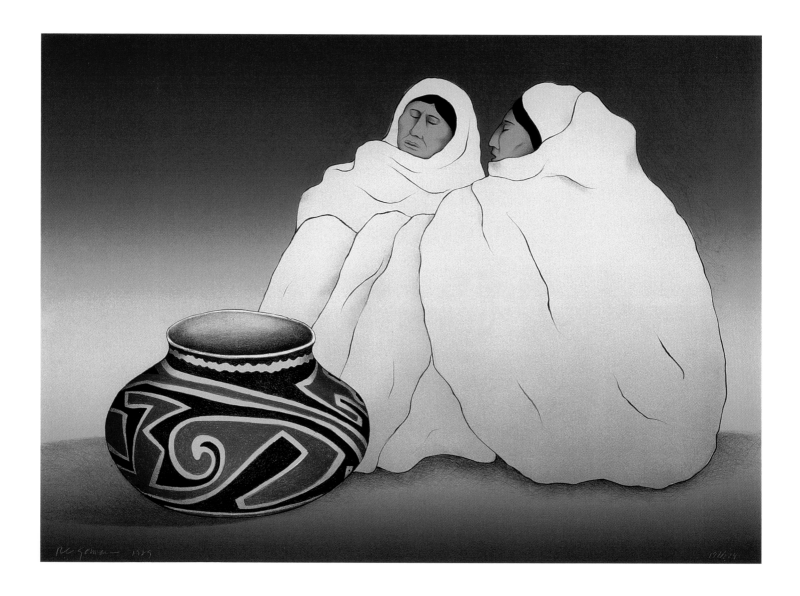

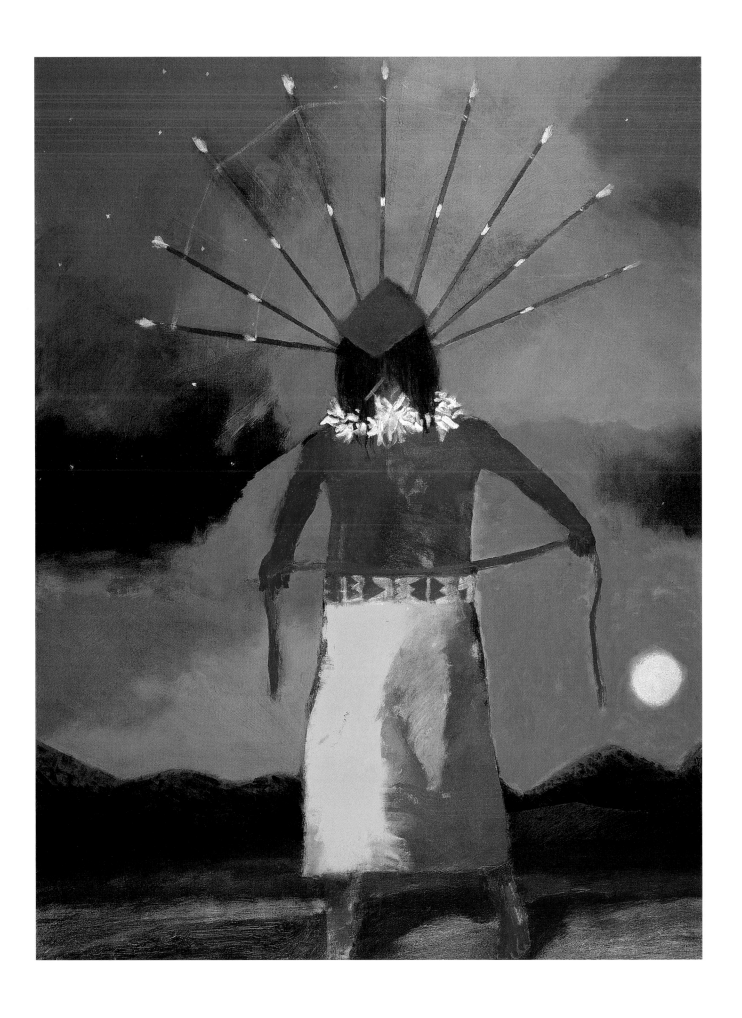

Wintu artist **Frank LaPena** (*1937) followed in Day's footsteps and was among the first to attempt to study and document the traditional knowledge of the Wintu in northern California. As a writer and artist, he feels particularly committed to the traditions of his people (LaPena 2004). At first sight, his paintings seem to merely express the "generic" mystical and spiritual nature of Native American religion; a closer look, however, reveals that they also relate specifically to the Native American traditions of Northern California (Highwater 1980: 132–134, Wade and Strickland 1981: 60–61).

The painting *Red Cap* (Fig. 30) shows a Big Head dancer against the background of a dark night sky. He wears a red leather cap and a headdress made of wooden sticks with white feathers, representing a female spirit. In accordance with tradition, his belt consists of woodpecker feathers. Despite the ethnological details, the entire design of the image is intended to create an emotional impact by means of the pronounced contrasts between colors. LaPena thus proves to be an artist who is a master in translating traditional elements into a modern artistic language.

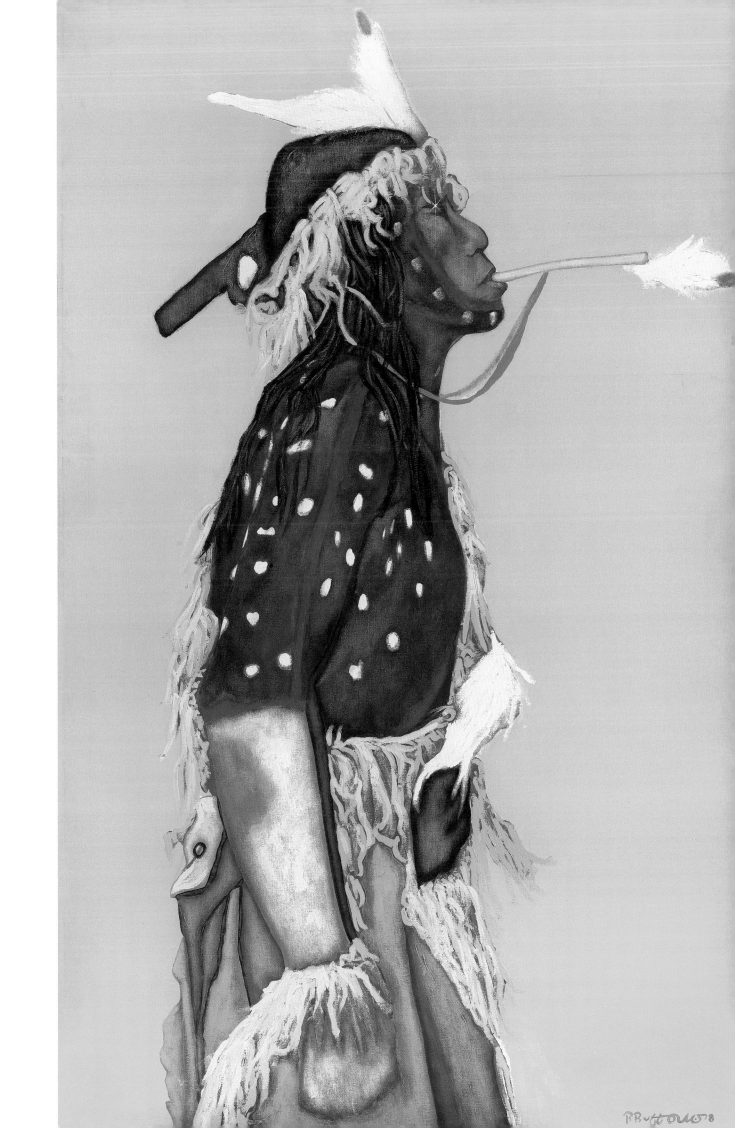

Fig. 32 Benjamin (Ben) Buffalo, Cheyenne, *Girl in Elk Tooth Dress*, 1978. Seybold Collection, 2010. Acrylic on canvas, height 125.5 cm, width 66 cm. Ethnologisches Museum Berlin, Inv. No. IV B 13227.

Plains and Oklahoma

In the Prairies and Plains there exists a long tradition of figural and abstract painting on leather, which in the late 19ᵗʰ century was replaced by paintings on textiles and paper. Today's state of Oklahoma in the Southeastern Plains emerged from the former Indian Territory into which tribes such as the Cherokee, Choctaw, Creek, and Seminole had been relocated beginning in 1830. These were later joined by additional indigenous nations from the Northeast and from the Eastern and Northern Plains regions. Thus, Oklahoma today consists of a conglomerate of various Native American traditions that merge and mutually influence each other. Needless to say, this encounter of different cultures has also influenced the artistic development in that region, so that painting styles cannot always be traced to the tribal provenance of artists.

The Berlin museum does not own any artworks from the origins of modern Plains painting, such as the *Kiowa Five*. The earliest works were made by some of the first graduates of the Institute of American Indian Arts in Santa Fe. This includes **Benjamin (Bennie** or **Ben) Buffalo** (1948–1994), a Cheyenne born in Clinton, Oklahoma. Unfortunately, little biographical facts are known of him, and even the exact date of his death was difficult to establish. John Anson Warner writes about him: "During his all too short life, he was a prolific artist who produced many canvases of note" (Warner 1996b: 96). In an exhibition presented by the Indian Arts and Crafts Board in Andarko, Oklahoma, in 1972, Ben Buffalo is represented by an abstract-ornamental oil painting (Libhart 1972: 52), the same is true for the 1973–1974 *Alumni Exhibition* of the Institute of American Indian Arts (New 1974: 8–9). Shortly thereafter, however, he appeared before the public with large acrylic paintings in a style referred to as "photographic realism." As an example of this, Highwater's book (1980: 59) features Buffalo's painting "Sun Dancer" (1978). As one of his earliest works of that creative period, this piece was purchased for the Berlin collection in 2010 (Fig. 31). It is charged with symbolic meaning, as the Sun Dance was prohibited in the Plains since about 1880 and did not undergo a revival until the 1970s. In addition, *Sun Dancer* seems to be the only painting by Ben Buffalo with religious content.

In the 1981 exhibition at the Philbrook Art Center in Tulsa, Oklahoma, Ben Buffalo was represented by three paintings in the category of Modernism (Wade and Strickland 1981: 70–72); two of these showed Native women on horseback: a "rodeo queen" and an Indian "princess," respectively. Gerhard Hoffmann's travelling exhibit featured three of Buffalo's paintings as well (Hoffmann 1985: 287–289). Ben Buffalo's realism does not only pertain to his way of painting, but also to the content of his pictures: they reflect contemporary Native American reality and show participants in powwows, rodeos, and other festive events on the reservation. These paintings include *Girl in Elk Tooth Dress* (Fig. 32), which presents us a teenage girl who has

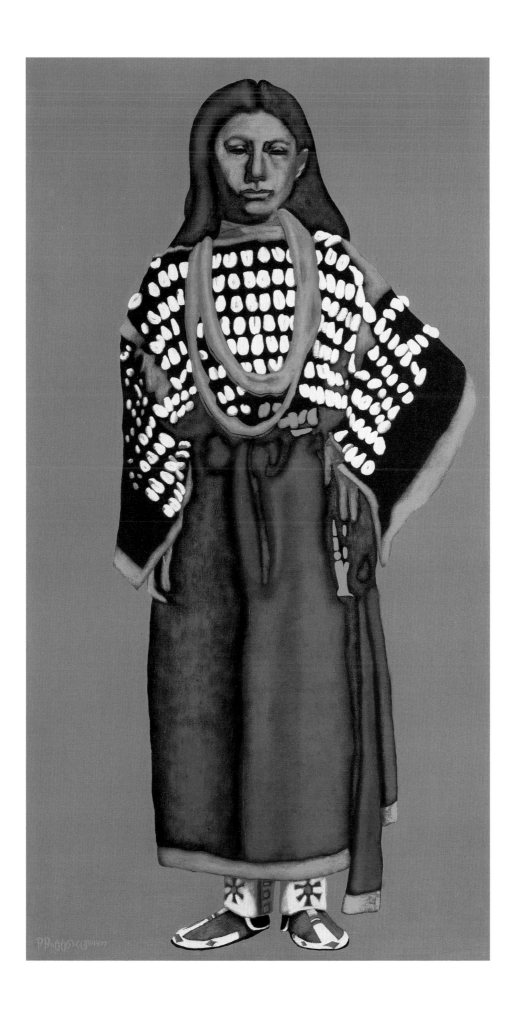

Fig. 33 Benjamin (Ben) Buffalo, Cheyenne,
Daughter of the Native American Revolution, 1982.
Seybold Collection, 2011. Acrylic on canvas,
height 61 cm, width 76 cm.
Ethnologisches Museum Berlin, Inv. No. IV B 13233.

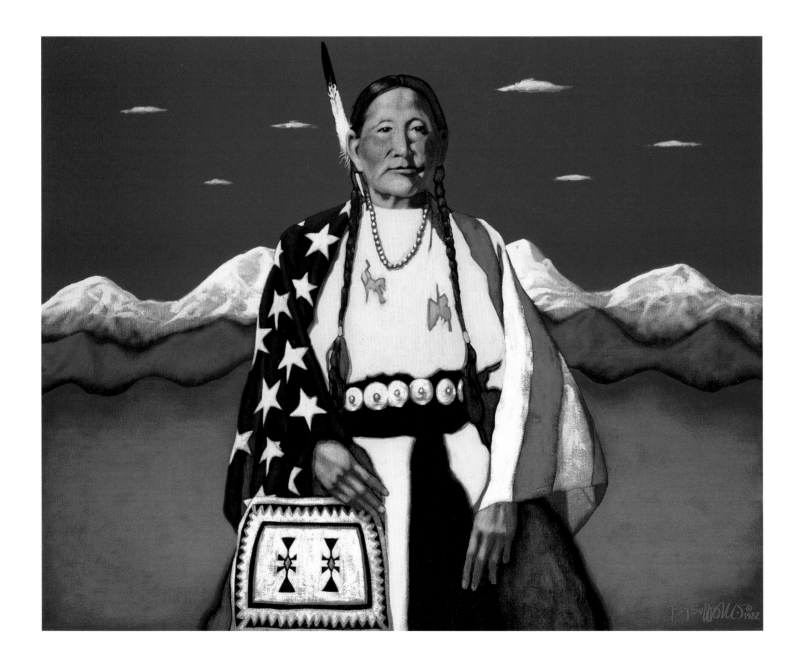

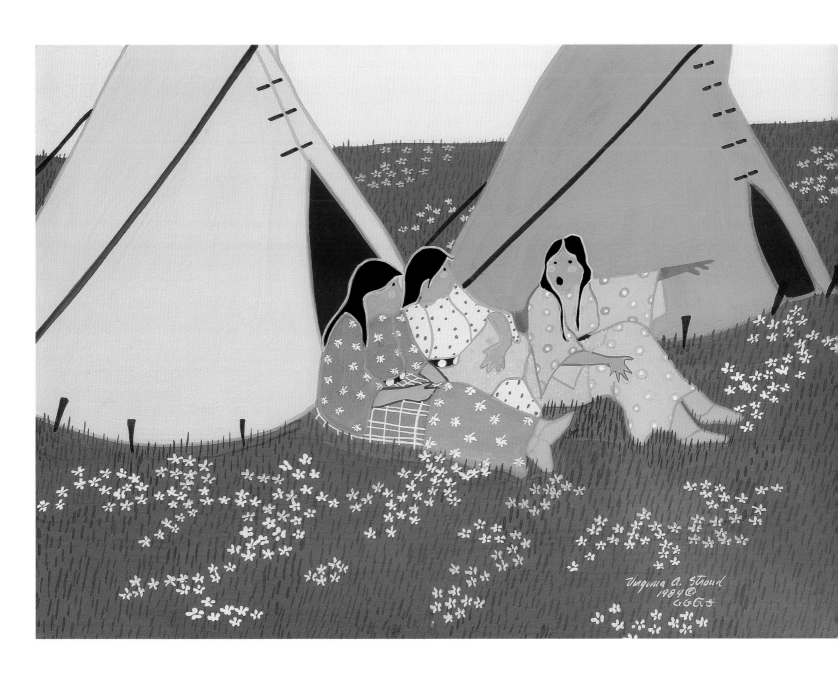

Fig. 34 Virginia Stroud, Cherokee-Creek, *Outside the Tipi*, 1984. Seybold Collection, 2011. Tempera on cardboard, height ca. 28 cm, width ca. 38 cm. Ethnologisches Museum Berlin, Inv. No. IV B 13234.

Fig. 35 Jerry Ingram, Choctaw-Cherokee (Oklahoma),
Personal Strength (*Personal Medicine*), 1982. Seybold
Collection, 2011. Acrylic on canvas, height 76 cm,
width 61 cm. Ethnologisches Museum Berlin,
Inv. No. IV B 13231.

donned a very special dress for a powwow, a dress that has likely been handed down from mother to daughter for generations.

The most recent painting by Ben Buffalo, purchased for the Berlin collection in 2011, was created in 1982. At first glance, it shows a middle-aged Native woman in front of mountain scenery. Actually, however, it portrays a Daughter of the Native American Revolution (Fig. 33). The title alludes to a patriotic American women's association called Daughters of the American Revolution, which has existed since 1890. The Native American woman wearing the American flag as a shawl is thus a Native American patriot, and Ben Buffalo's painting is a tribute to all those Native American women who were at the forefront of Native American resistance, demonstrations, and occupation campaigns.

Virginia Stroud (*1951) is an artist who became quite popular in the 1980s. Her naïve-looking pictures of Plains women performing traditional activities lend themselves perfectly to the type of greeting cards that tourists love to send from "Indian country." Stroud is usually said to be of Cherokee-Creek descent, however, since she was adopted by a Kiowa family, studied in Oklahoma, and was awarded art prizes in Tulsa, she can also be regarded as a Plains Indian. Her painting *In Front of the Tipi* (Fig. 34) shows three Plains Indian women having a chat, sitting in front of their tents on a lush green meadow. The setting is thus an intact, peaceful Native world still unspoiled by problems caused by the White Man.

Like Ben Buffalo, **Jerry Ingram** (*1941) was one of the first graduates of the Institute of American Indian Arts in Santa Fe. Despite his Choctaw-Cherokee descent the artist, who grew up in Oklahoma, has always felt attracted to subjects related to 19th century Plains culture. The book by Monthan and Monthan (1975: 96–105) features some of his early tempera paintings in which he addressed the topic of Peyote religion, using subtle shades of light blue. His fame, however, is due to his portraits of Plains Indians with ceremonial or war regalia and face paintings, which are referred to by Wade and Strickland as the "work of a historic romantic" (1981: 50). While his works have often been compared to those of George Catlin and Karl Bodmer, they also show the influence of German-born Art Deco painter Winold Reiss (1886–1953) who since 1919 had painted numerous portraits of Blackfoot Indians.

Ingram's work became first known in Germany as a result of the traveling exhibition *Signale indianischer Künstler* (Signals of Indian Artists) compiled by gallery owner Katrina Hartje in 1984 (Hartje 1984: 76–77). The two paintings exhibited there both came to the Berlin Collection in 1989. The exhibition *Indianische Kunst im 20. Jahrhundert* (20th Century Indian Art), which presented three of his paintings (Hoffmann 1985: 266–268), gained Ingram even more attention in Germany. His painting entitled *Personal Medicine* (actually, *Personal Strength*, as is noted on the back of the picture) did not only feature prominently on the cover of the catalogue, but also on advertising posters for the exhibition that was shown in no less than seven cities in Germany and Switzerland. This painting also came to the Berlin collection in 2010. With his works,

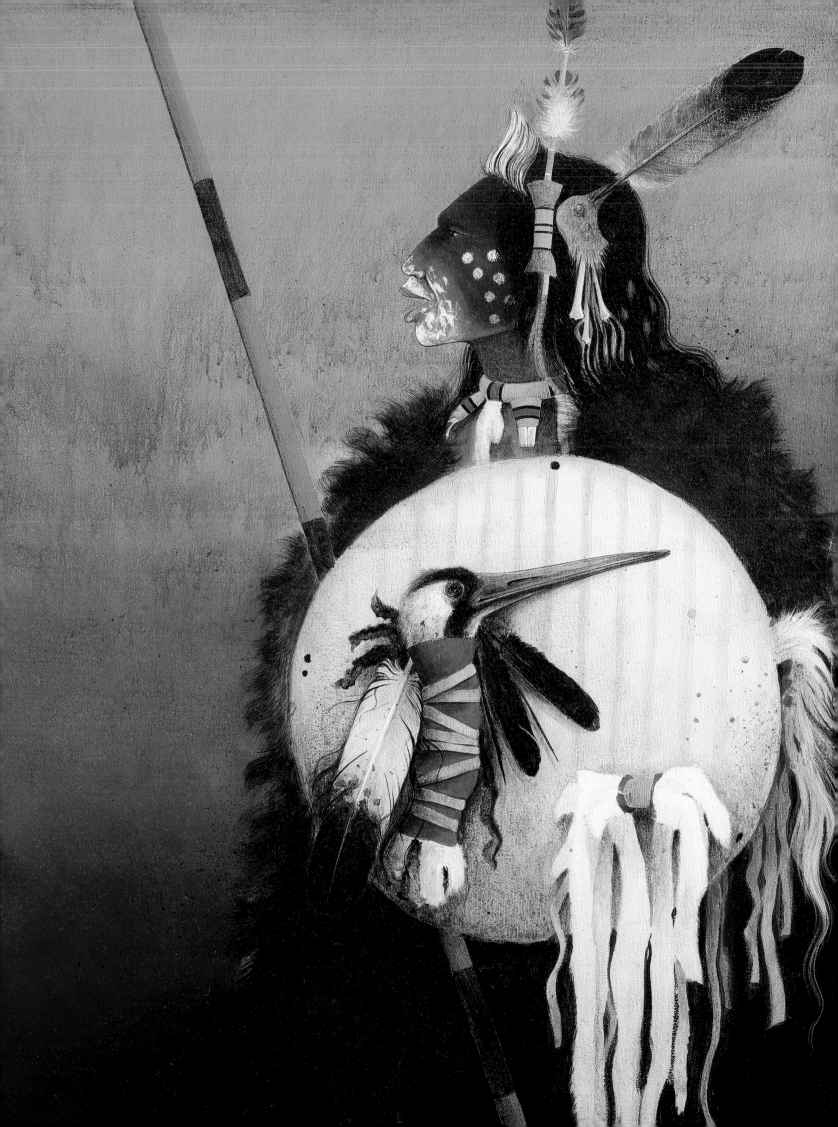

Fig. 36 Jerry Ingram, Choctaw-Cherokee (Oklahoma),
Hunter's Song, 1981. Hartje Collection, 1989. Acrylic on
canvas, height 61 cm, width 91.5 cm.
Ethnologisches Museum Berlin, Inv. No. IV B 13115.

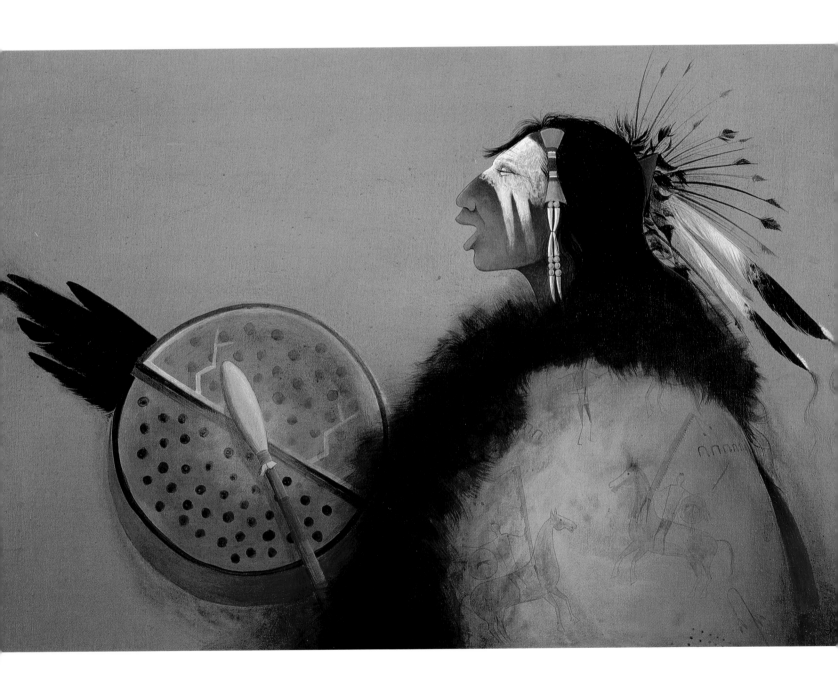

Fig. 37 Jerry Ingram, Choctaw-Cherokee (Oklahoma),
With the Bear as His Medicine (*Bear as Medicine Man*),
1982. Hartje Collection, 1989. Acrylic on canvas,
height 81 cm, width 102 cm.
Ethnologisches Museum Berlin, Inv. No. IV B 13114.

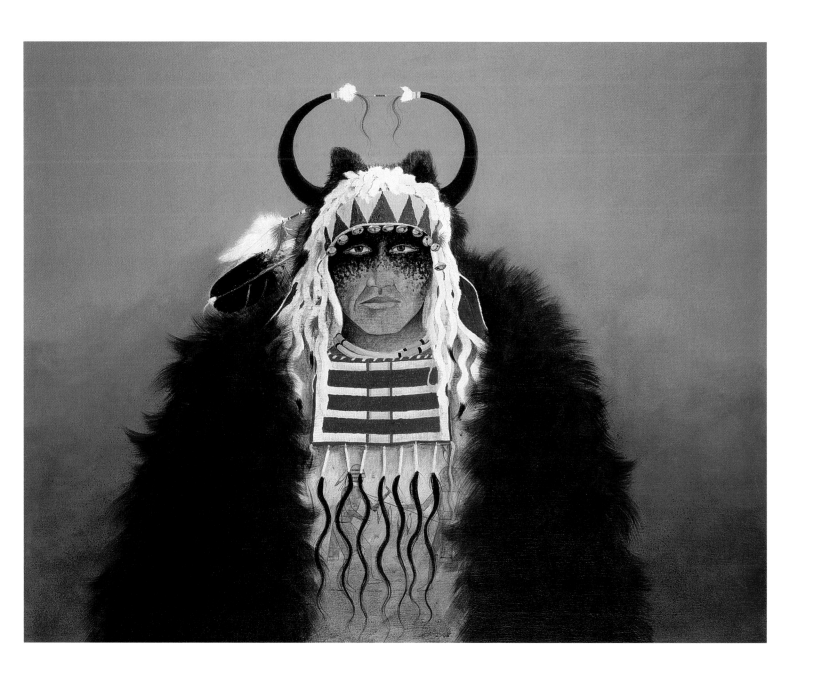

right: **Fig. 39** Kevin Red Star, Crow, *Painted Crow Wolf*,
1982. Hartje Collection, 1989. Acrylic on canvas,
height 89 cm, width 74 cm.
Ethnologisches Museum Berlin, Inv. No. IV B 13117.

Fig. 38 Kevin Red Star, Crow, *Walks Long (Walks Along)*,
1981. Hartje Collection, 1989. Acrylic on canvas, height
71.5 cm, width 61 cm.
Ethnologisches Museum Berlin, Inv. No. IV B 13116.

Ingram perfectly pandered to the romantic ideal of the 19th century Plains Indian as imagined by American and European "Indian enthusiasts."

The painting *Personal Strength* (Fig. 35) shows a Native American warrior who is easily identifiable as a Crow Indian by his shield, his hair adornments and combed-up hairdo. His strength emanates from the shield, whose decoration is based on a vision in which the warrior's personal guardian spirit appeared to him. Despite all ethnographic detail, the focus of Ingram's pictures is on the mystical and visionary. This is also true for his other two paintings in the Berlin collection: *Hunter's Song* (Fig. 36) shows a hunter who is

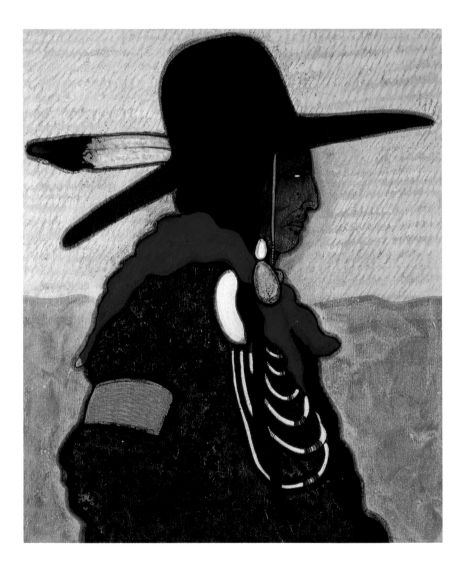

withdrawn into himself. Wearing a painted bison robe and holding a drum, he prepares for the upcoming hunt by singing a special song and asking the supernatural powers for luck in hunting and for protection. The painting entitled *With the Bear as His Medicine* (Fig. 37) portrays a Blackfoot medicine man who wears a horned cap trimmed with ermine fur, and has put a bearskin around his shoulders. The ears of the bear's head protrude from behind the ermine cap. The bearskin is the outward symbol of the bear's power, which can be summoned by this shaman in his curing rituals.

In contrast to the painters so far discussed, who are all from Oklahoma, Crow artist **Kevin Red Star** has his roots in the Northern Plains. He was born in 1943 into a traditionally oriented family on the Crow reservation in Lodge Grass, Montana. From 1962–1965 he studied at the Institute of American Indian Arts, where he was undoubtedly strongly influenced by his teacher Fritz Scholder. In his paintings, Red Star attempts to create an expressionistic effect while at the same time remaining faithful to the traditions of his people; that is, his portrayals of Crow Indians are not set in the present but in the late 19th century. Even

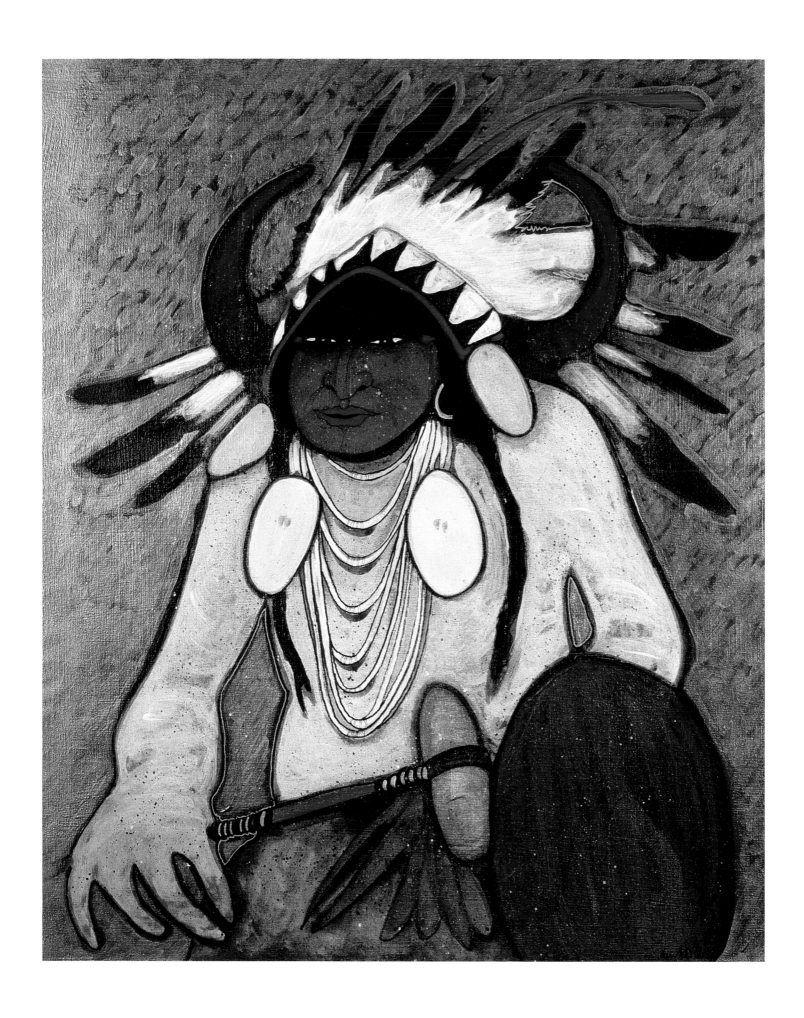

Fig. 40 Kevin Red Star, Crow, *Rainbow Woman*, 1983.
Seybold Collection, 2011.
Acrylic on canvas, height 112.5 cm, width 86.5 cm.
Ethnologisches Museum Berlin, Inv. No. IV B 13232.

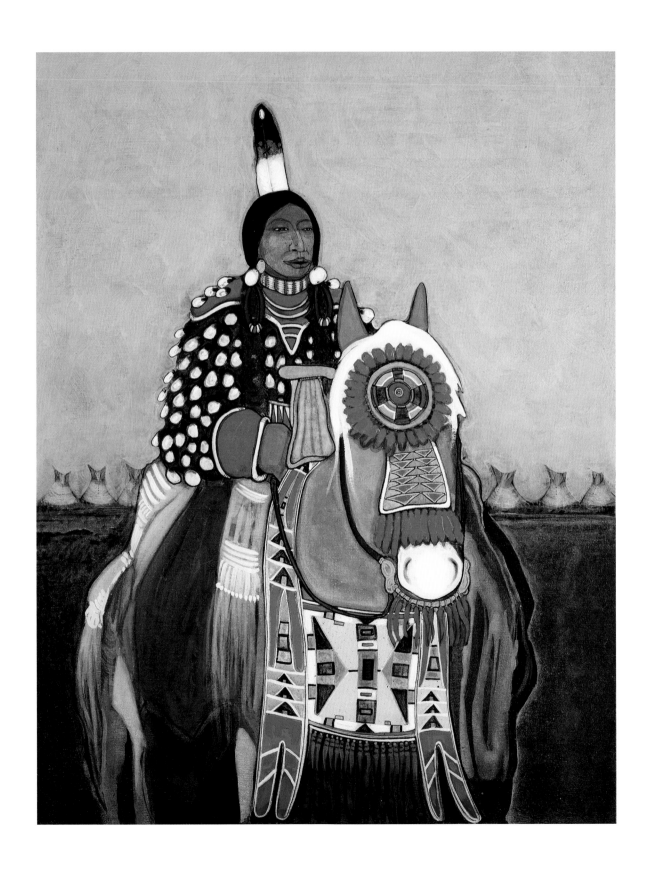

Fig. 41 Kevin Red Star, Crow, *Full Moon Riders*, 1986. Peiper-Riegraf Collection, 2008. Serigraph (edition number 39/275), height 76.5 cm, width 57 cm. Ethnologisches Museum Berlin, Inv. No. IV B 13171.

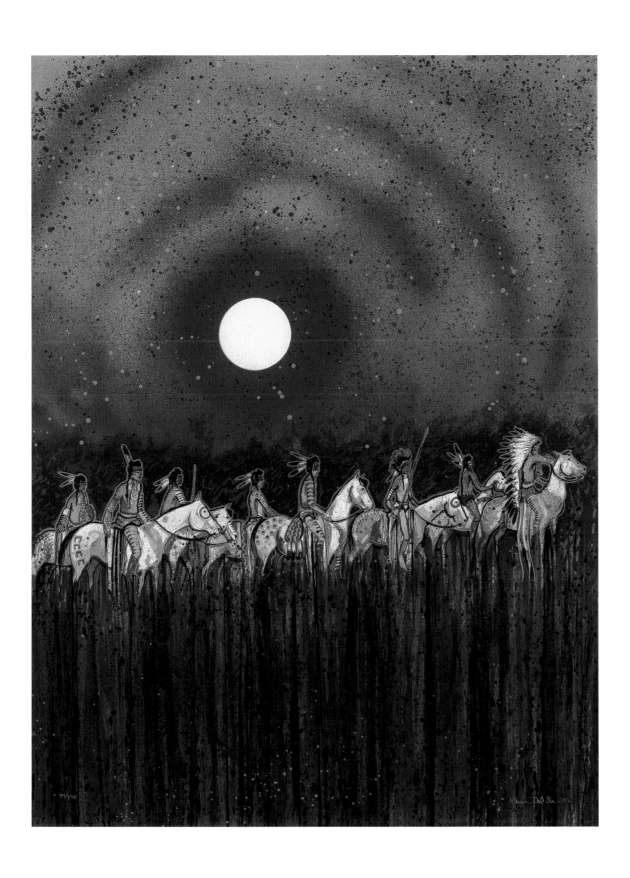

though his figures are "traditional" in terms of clothing, they show physical deformations that reveal that they actually come from a different world – the mythical world of the Crow. These deformations can also be interpreted as reflecting the introduction of White influence, which caused Crow culture to undergo progressively more changes.

The painting entitled *Walks Long* (Fig. 38) shows a Native American man dressed in the style typical of reservation times: black hat, red neckerchief, and blue shirt. In addition, he wears the traditional Crow adornments. *Painted Crow Wolf* (Fig. 39), on the other hand, is a portrait of a Crow warrior armed with a shield and stone club, and wearing a large feather bonnet with bison horns. He is not about to go to war in these regalia, but participating in a ritual dance. Both paintings were first shown in the 1984 exhibition *Signale indianischer Künstler* (*Signals of Indian Artists*; Hartje 1984: 86–87) and purchased for the Berlin collection in 1989.

Rainbow Woman (Fig. 40) shows a female participant in the big parade held on the occasion of the Crow Fair, which still takes place on the Crow reservation every summer. The picture is timeless in character, as the woman's dress and the equipment of the horse might as well date from the time around 1900, and pieces of equipment that have been owned by families for generations are still used during these parades. The picture was first exhibited in Germany in 1985 (Hoffmann 1985: 292) and came to the Berlin collection in 2011.

The print *Full Moon Riders* (Fig. 41), on the other hand, a romantic reminiscence of the bygone horse and war culture of the Crow, looks like a scene straight from a Hollywood movie: lit by the moon, a long row of painted warriors go to war on painted horses. This is unadulterated Native American nostalgia.

Regrettably, these are the only works by Native American artists from the Northern Plains in the Berlin Collection. In North and South Dakota there is a particularly active group of Sioux painters that includes Arthur Amiotte, Roger Broer, Robert Freeman, Donald Montileaux, Vic Runnels, and others who invoke the heritage of Oscar Howe and continue to cultivate the artistic traditions of that region (Nauman 1990, Lindner 2011).

The Northeast

The Woodland culture of northeastern North America produced a type of pictorial writing in which drawings were engraved into birch bark. These engraved drawings were primarily used by the members of the Midewiwin Society – a secret society of the Ojibwa dedicated to curing the sick – as a memory aid for the recitation of songs. The sacred traditions and legends of that society were kept on these inscribed birch-bark scrolls, and only initiated members were able to interpret the content of the drawings. The Ojibwa belong to the Algonquian language family whose speakers occupy the largest part of the Northeastern Woodlands. These peoples have rich oral traditions of mythical figures, supernatural tricksters, cannibal monsters, spirit beings, and culture heroes.

When **Norval Morrisseau** (Copper Thunderbird, 1932–2007), an Ojibwa from the Sand Point Reservation in Ontario, began to capture beings from these sacred legends in color on birch bark and paper in the 1950s, he met with fierce resistance on the part of the tribal elders. Morrisseau, who was obviously acting on a vision, was the first artist to break the existing taboos. Unwaveringly, he continued to paint legendary beings on birch bark and other materials that were available until he was discovered by Jack Pollock, an influential art dealer, in 1962. The latter bought a number of Morrisseau's works and exhibited them in his gallery in Toronto. This was the beginning of Morrisseau's career as a professional artist (Hill 2006). As has been stressed by art historian Ruth Philips, Morrisseau felt like an independent artist in the western sense due to the influence of his sponsors: "He encountered a public that was willing to see his paintings not merely as curios or illustrations, but as unique works of equal rank with western art, representing the values and beliefs of an independent culture" (Philips 1998: 167). By now, Morrisseau himself has become a legendary figure in Canada, not only due to his success as an artist, but also because of his womanizing and alcohol excesses. His life story has even been immortalized in a stage play by Marie Clements. Entitled *Copper Thunderbird*, the play had its world premiere at the National Arts Centre in Ottawa in May, 2007 (Clements 2007).

Morrisseau's images of Algonquin legends were trendsetting for the following generations of Woodland painters. In the next decades his acrylic paintings, created in bright colors with clear contour lines, inspired more than fifty artists to adopt the style which is now called Woodland School or Legend Painting. With regard to content, this style of painting is strongly associated with shamanism, supernatural beings, and the battle between good and evil powers as told in the ancient legends. The motifs are so much fraught with symbolism that only the artists themselves are able to interpret them in any detail. The figures are often painted without background, in the so-called X-ray Style that renders the internal organs

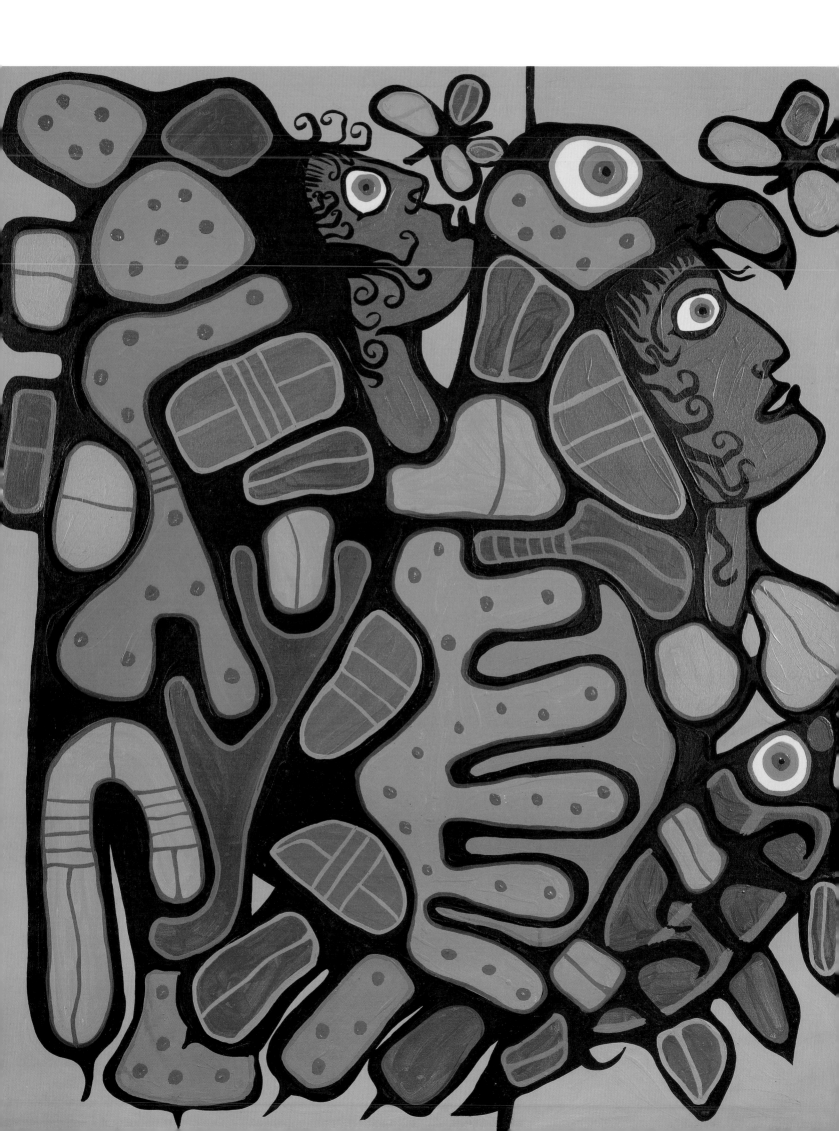

Fig. 42 Norval Morrisseau (Copper Thunderbird),
Ojibwa, *Hunting*, 1980. Antonitsch Collection,
1999. Acrylic on canvas, height 51 cm, width 61 cm.
Ethnologisches Museum Berlin, Inv. No. IV B 13155.

left: Fig. 43 Norval Morrisseau (Copper Thunderbird),
Ojibwa, *Thunderbird, Shaman, and Earth Mother*,
ca. 1985. Seybold Collection, 2011. Acrylic on canvas,
height 122 cm, width 101.5 cm.
Ethnologisches Museum Berlin, Inv. No. IV B 13230.

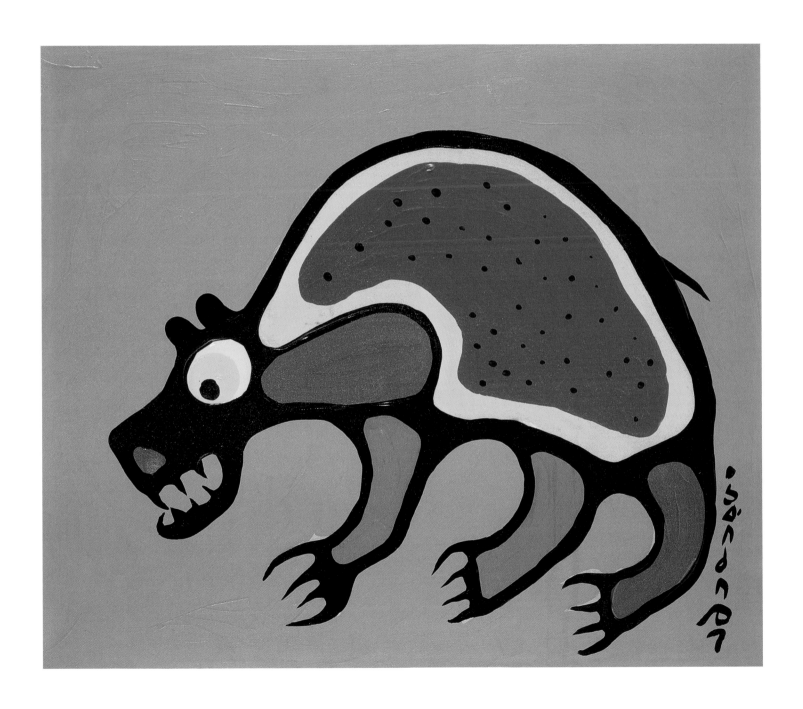

visible. This emphasizes the spiritual character of the figures, in which anatomical details are unimportant (McLuhan and Hill 1984).

The immediate successors of Morrisseau include his student Carl Ray (Cree) and Daphne Odjig (Ojibwa). Odjig is one of the few internationally renowned members of the Woodland School and she was the first artist of that group to run a gallery. In contrast to her fellow artists, she includes social topics related to modern reservation life in her works (Wood 2005). Other prominent representatives of the Woodland School are Goyce and Joshim Kakegamic (Cree), Roy Thomas (Ojibwa), Blake Debassige (Ojibwa), Samuel Ash (Ojibwa), and Saul Williams (Ojibwa).

During the 1970s these artists became known in Germany thanks to a number of exhibitions. In 1979, for example, the Interversa Company and the Museum of Ethnology Hamburg jointly organized an exhibition of works from the McMichael Canadian Collection. Presenting works by 20 artists, the exhibition featured several paintings by Norval Morrisseau (Interversa 1979). Ethnologist Peter R. Gerber began to purchase silk-screen prints for the Museum of Ethnology Zurich during that time, which he recently presented in an exhibition (Biasio and Gerber 2010: 43–60).

The Inuit Galerie in Mannheim had presented artists of the Woodland School back then as well. The first Morrisseau painting to come to the Berlin collection, entitled *Hunting* (Fig. 42), could be purchased from that gallery's holdings in 1999. Against a light blue background, the picture shows a bear outlined with clear black contour lines. The animal is on the hunt, and its wide-open jaws and strong claws are thus particularly conspicuous. The picture is signed with the name "Copper Thunderbird" in Cree syllabic writing. Another painting by Morrisseau came to the Berlin collection in 2011. It is a typical example of his later style of painting, which is not only much more complex, but also much more difficult to interpret (Fig. 43). The picture is undated and was originally untitled. However, the central figure of the painting is clearly a thunderbird, an important entity in Algonquin mythology that was often used by Morrisseau. The male figure to the right, which seems to have grown into one with the thunderbird, can only be a shaman, another recurrent motif in Morrisseau's work. He kept presenting himself as a shaman, and it is thus possible that the figure is a self-portrait of the artist. The figure to the left shows unambiguously feminine traits. Its long, flowing hair is interspersed with various plant-like forms. The figure may thus be a symbol of the Earth Mother who makes all things grow. The two butterflies on top represent the animals of the air; the fish at the bottom stands for the aquatic animals. The painting as a whole can thus be interpreted as an image of the cosmos as perceived by Ojibwa artist-shaman Morrisseau. Only the artist himself, however, might tell us whether the ascribed title of the painting *Thunderbird, Shaman, and Earth Mother* is correct.

The Northwest Coast

The Northwest Coast region comprises the narrow coastal strip along the Pacific Ocean that reaches from the U.S.-Canadian border in the south all the way up to southern Alaska. While painting and woodcarving have a long tradition in that area, the real heyday for both arts began when iron tools and commercial colors were introduced there. On the Northwest Coast, too, it was ethnologists and institutions that encouraged indigenous people to make drawings on paper. Franz Boas, for example, commissioned Haida artist Charles Edenshaw to record a number of tattoo designs for him, and around 1950 Mungo Martin, a famous woodcarver, created numerous color paintings for the Museum of Anthropology in Vancouver.

Today, Haida artist Bill Reid and ethnologist Bill Holm are usually mentioned as two of those who initiated the so-called Northwest-Coast Renaissance (Jonaitis 2006: 257). Other individuals were involved as well, however, such as Kwakiutl artist Ellen Neel who began to print traditional motifs onto silk shawls in the 1950s, using the silk-screen technique that is also refered to as serigraphy. In the 1960s, artist Henry Speck adopted that technique and produced silk-screen prints of mythical beings on paper. Other artists such as Tony Hunt, Robert Davidson, and Art Thompson followed suit, and today there are more than 100 artists working in that method (Hall, Blackmann and Rickard 1981).

The early serigraphs were printed with only one color on colored paper. When the designs became more and more differentiated, however, they needed to be printed on white paper with several colors. While the editions were quite large in the beginning, they later became strictly limited, which is common practice with regard to artist prints. Each print was hand-signed and numbered. In the beginning, the motifs of the silk-screen prints were strictly based on traditional models; they had a purely two-dimensional design, and thus neither perspective nor background. In the 1980s more figural elements were added to the repertoire, and some artists began to create three-dimensional sceneries.

The serigraphs of the Northwest Coast are, above all, the expression of a cultural continuity whose creativity is distinguished by the continuous addition of new forms and motifs. In that process, the artists draw on a shared pool of traditional basic patterns that are combined into ever changing designs. Such forms are the collective property of a family or village community, and subject to an inherited type of copyright. The artists are thus moving within a canon of forms that can be varied individually, yet in its entirety always reveals its traditional origins (Bolz 2010b). Haida artist Clarence Mills expresses this as follows: "This, of course, distinguishes us strongly from non-Native artists. While non-Native artists focus on the

Fig. 44 Robert Davidson, Haida, *Beaver*, 1972.
Gift of the artist, 1976. Serigraph (without edition
number), height 29.5 cm, width 27 cm.
Ethnologisches Museum Berlin, Inv. No. IV A 9518.

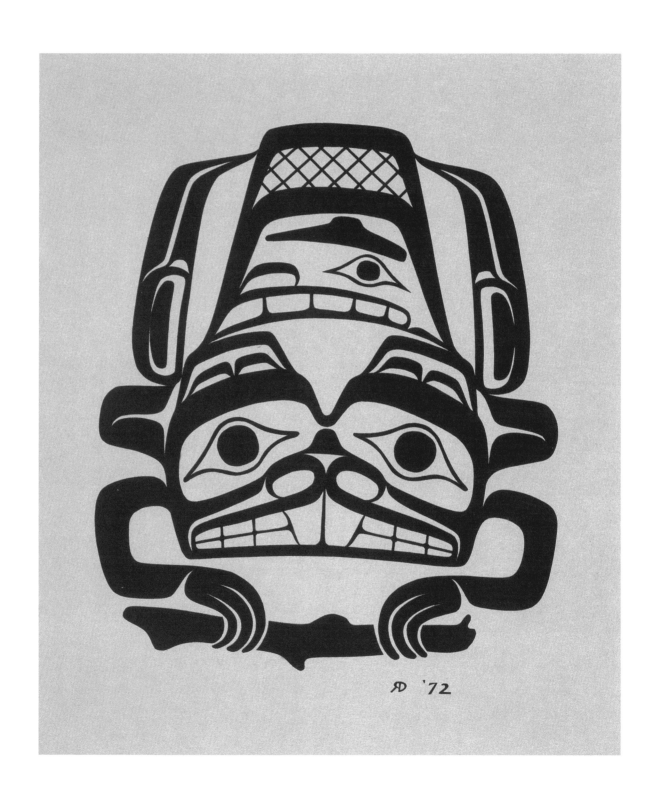

Fig. 45 Robert Davidson, Haida, *Raven*, 1973. Gift of the
artist, 1976. Serigraph (edition number 73/150),
height 32.5 cm, width 28.5 cm.
Ethnologisches Museum Berlin, Inv. No. IV A 9520.

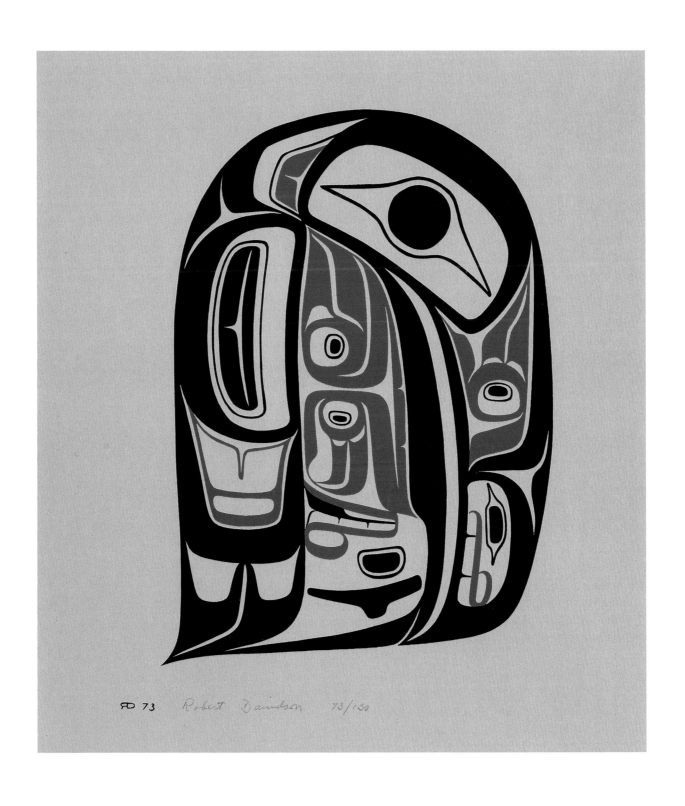

artistic individualism of their work, Native artists commit themselves to their culture. In comparison to cultural heritage, individual creativity is of secondary importance" (Streum 1993: 60).

When the Kitanmax School of Northwest Coast Indian Art was founded in 'Ksan in northern British Columbia in 1968, it soon emerged as a Native American cultural center that spawned new artistic ideas and trends. In 'Ksan, a "northern" style of art developed that was markedly different from that of the Haida and Kwakiutl. That style, however, never really established itself in the art market for Northwest Coast prints; thus, that market is still dominated by the pieces of artists who work in the "classic" Haida and Kwakiutl style.

The foundation of the Northwest Coast Indian Artists Guild in 1977 was another important step in the development of modern Northwest Coast art. The guild aimed to establish new standards in the development of graphic art, and to elevate it to the level of "fine art." The founding members included Joe David, Robert Davidson, Ron Hamilton, Roy Hanuse, Richard Hunt, Gerry Marks, Larry Rosso, Russell Smith, Norman Tait, Roy Vickers and Francis Williams (MacDonald 1977).

In Germany, these silk-screen prints became particularly known due to the large *Donnervogel und Raubwal* exhibition (*Thunderbird and Killer Whale*) shown at the Museum of Ethnology in Hamburg on the occasion of the museum's 100th anniversary in 1979 (Haberland 1979). The catalogue includes ten prints by various artists. Calvin Hunt (Kwakiutl) from Alert Bay designed a silk-screen print especially for the exhibition: *Southern Kwa-gulth Thunder Bird and Killer Whale*, which gave the exhibition its name. This is why that particular silk-screen motif also appeared on the cover of the catalogue and on the posters advertising the exhibition. Since at least that time, modern Northwest Coast art has found its way into other European ethnological museums as well. Following Wolfgang Haberland's example, Viola König exhibited sixteen prints collected by her at the Niedersächsisches Landesmuseum Hannover in 1992 (König 1992).

The Berlin collection begins with silk-screen prints presented to the museum as a gift by a Native American delegation from the Northwest Coast on the occasion of their visit to Berlin in 1976. The earliest of these were created by **Robert Davidson** (Haida, *1946, Figs. 44–45). It is no exaggeration to say that today he is the most important living Northwest Coast artist. As early as in 1993, a large solo exhibition at the Vancouver Art Gallery was dedicated to him (Thom 1993).

From amongst the Kwakiutl artists, **Tony Hunt** (*1942, Figs. 51–52) deserves particular mention. In the 1970s he created not only serigraphs based on traditional models, but also prints with Christian-religious content (Hall, Blackman and Rickard 1981: 105). His grandfather Mungo Martin and his father Henry Hunt in-

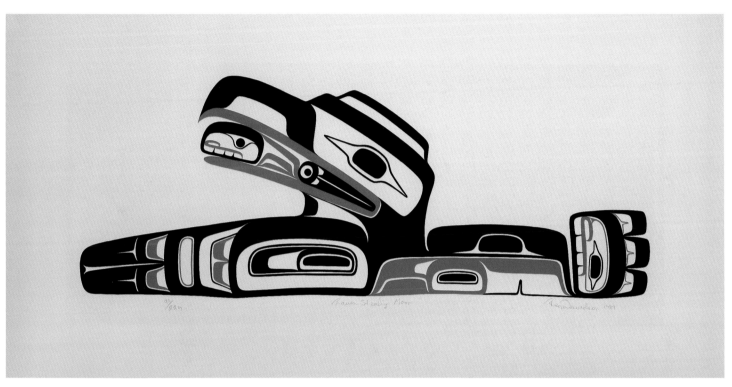

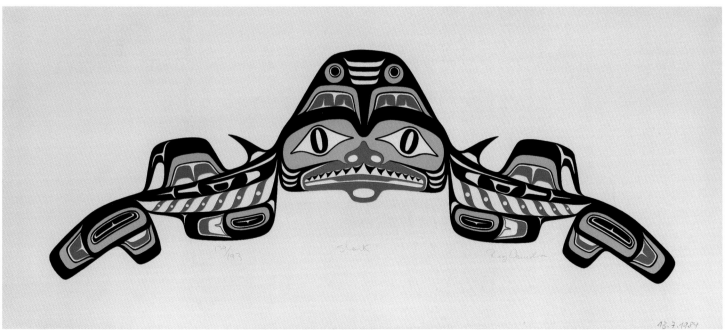

Fig. 48 Clarence S. Mills, Haida, *Haida Moon*, 1993. Larink Collection, 2000. Serigraph (without edition number), height 38 cm, width 33 cm. Ethnologisches Museum Berlin, Inv. No. IV A 9544.

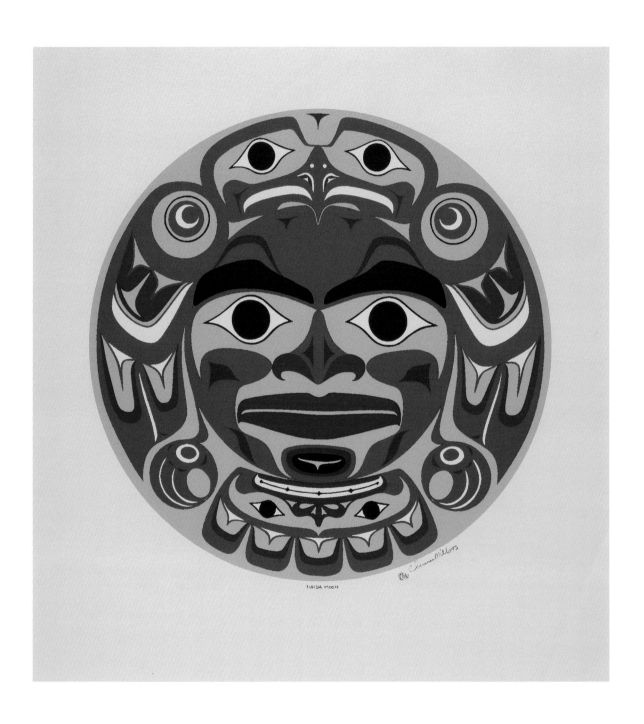

Fig. 49 Clarence S. Mills, Haida, *Haida Raven and Moon Totem*, 1996. Larink Collection, 2006. Serigraph (edition number 50/199), height 71 cm, width 45.7 cm. Ethnologisches Museum Berlin, Inv. No. IV A 9627.

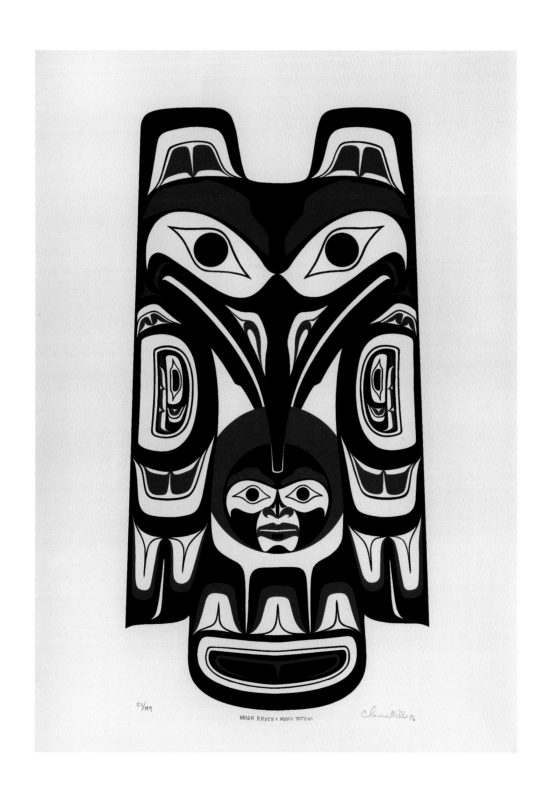

structed him in the art of woodcarving, and in 1969 he opened the Arts of the Raven Gallery in Victoria; this was the first gallery owned by a Native American in that region. By providing high-quality Northwest Coast art, Tony Hunt made a major contribution to the revival of artistic skills on the Northwest Coast, and set new standards for the relationship between Native American art and white society. Today, the Hunt family ranks among the best-known artist dynasties of the Northwest Coast (MacNair and Hunt 1994).

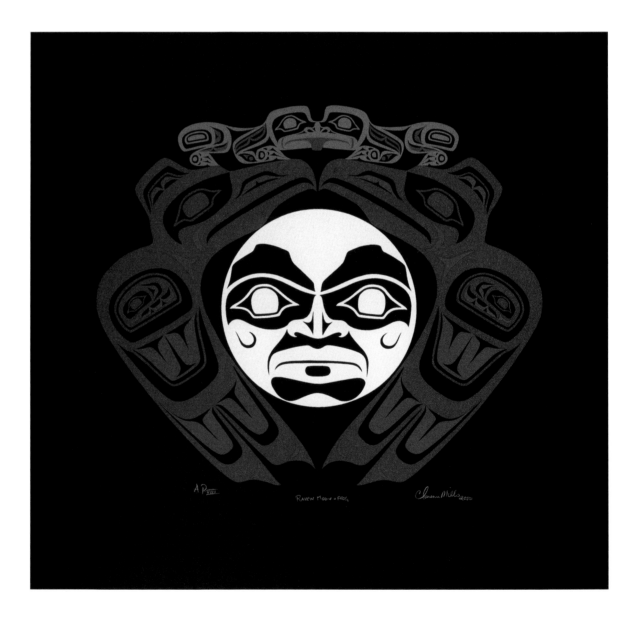

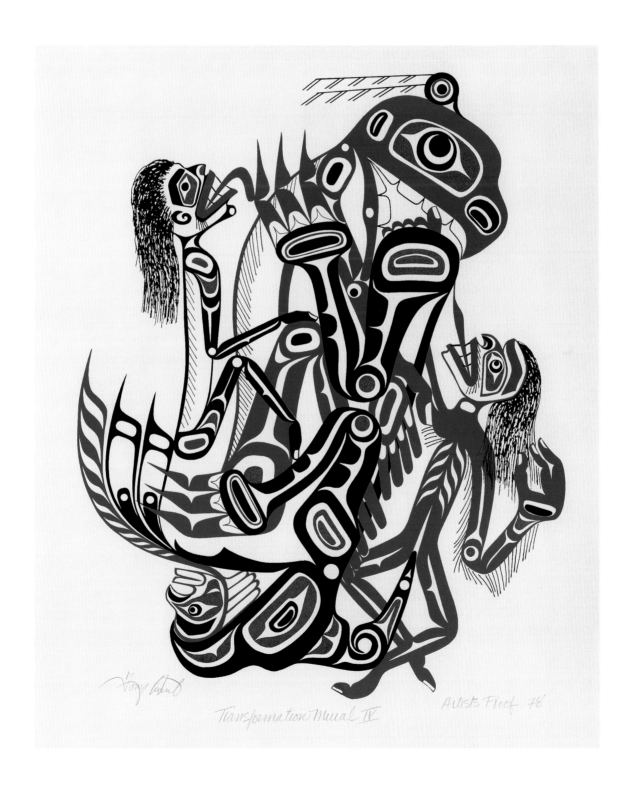

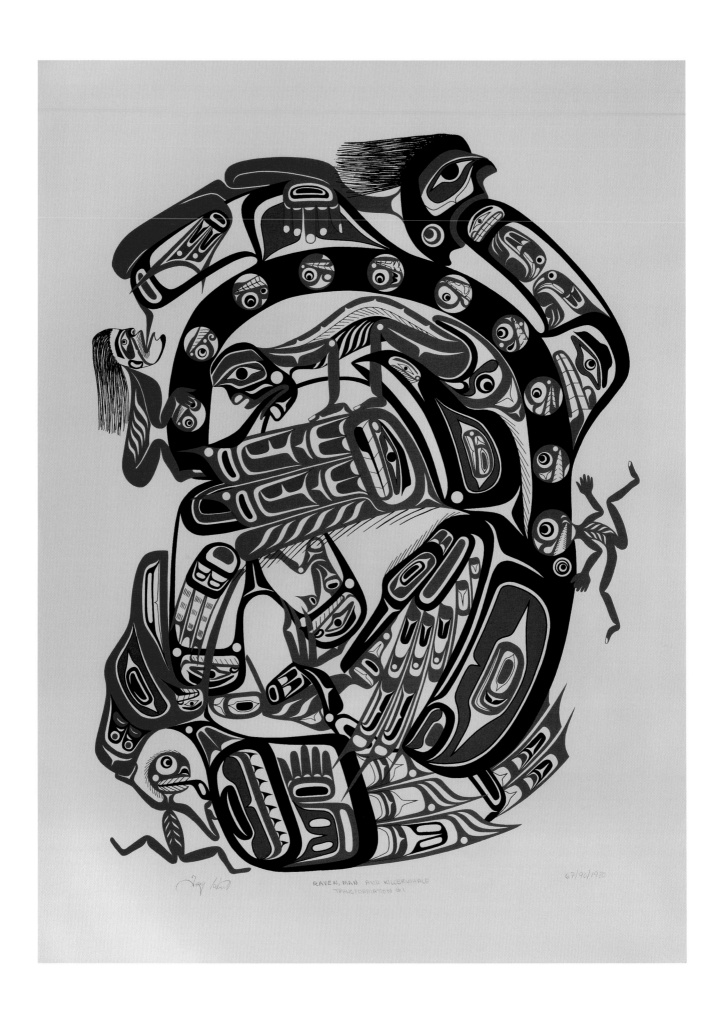

RAVEN, MAN AND KILLERWHALE
TRANSFORMATION #1 67/90/1980

On the occasion of the exhibition *Maskentänze der Kwakiutl* (*Mask Dances of the Kwakiutl*) in 1990, the Berlin museum purchased four silk-screen prints, all of which were created by Kwakiutl artist **Frances Dick** (Kasten 1990). Thanks to generous gifts by collector Walter Larink, a large collection of Northwest Coast prints – comprising about 90 sheets – came to the Ethnologisches Museum Berlin between 1998 and 2011. Being a staff member of the Canadian Embassy (first in Bonn, then in Berlin), Larink has travelled to the Northwest Coast repeatedly since 1979 together with his wife, and bought numerous works of art which have been shown in smaller and larger exhibitions (Larink and Streum 1995, Rousselot, Müller and Larink 2004).

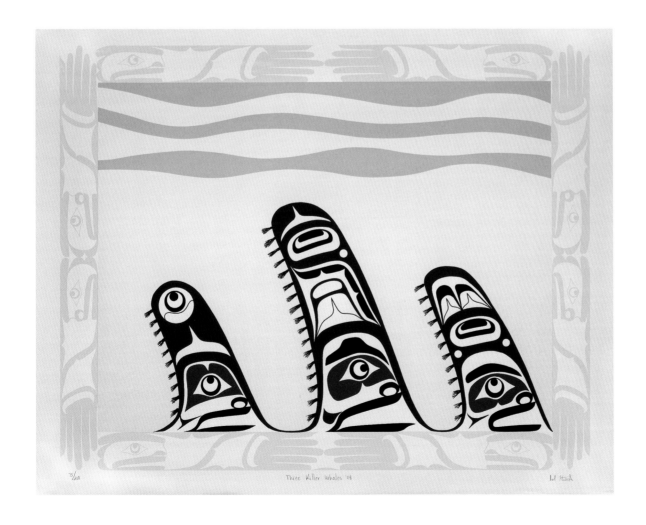

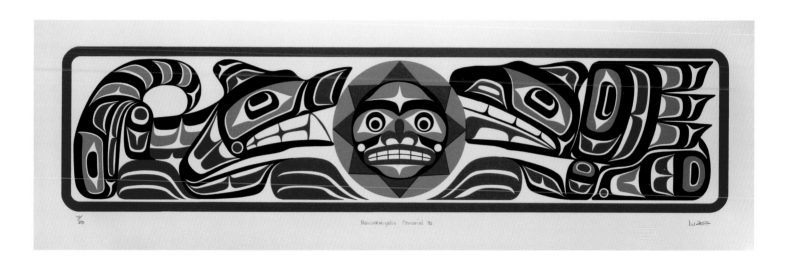

Namu Kanyalis Memorial '92

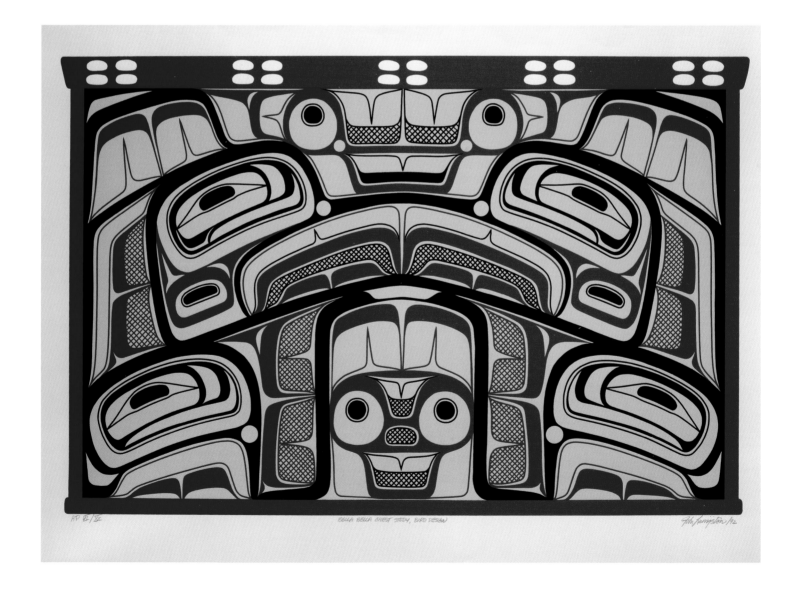

Bella Bella Chest Study, Bird Design

top left: **Fig. 54** Calvin Hunt, Kwakiutl, *Namukwiyalis Memorial*, 2003. Larink Collection, 2003. Serigraph (edition number 47/200), height 24 cm, width 76.5 cm. Ethnologisches Museum Berlin, Inv. No. IV A 9590.

below left: **Fig. 55** John Livingston, Kwakiutl (adopted), *Bella Bella Chest Study, Bird Design*, 1992. Larink Collection, 2002. Serigraph (artist's Proof), height 53.4 cm, width 73.6 cm. Ethnologisches Museum Berlin, Inv. No. IV A 9579.

Fig. 56 Frances Dick, Kwakiutl, *Kawadelekala's House*, 1995. Larink Collection, 2005. Serigraph (edition number 9/150), height 36.4 cm, width 50.5 cm. Ethnologisches Museum Berlin, Inv. No. IV A 9611.

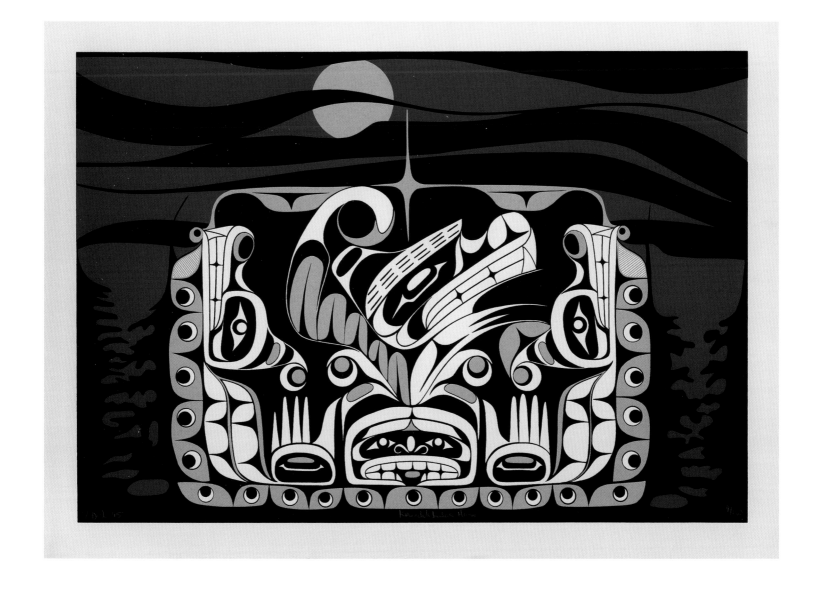

Fig. 57 Frances Dick, Kwakiutl, *Honoring Malidi*, 1995.
Larink Collection, 2007. Serigraph
(edition number 3/100), height 76.4 cm, width 38 cm.
Ethnologisches Museum Berlin, Inv. No. IV A 9633.

Due to the large size of the Larink Collection, it was necessary to choose only a selection for the present exhibition. The choice of works was chiefly guided by criteria related to historical and stylistic developments; thus, not every artist represented in the collection is automatically represented in the exhibition as well.

The most significant artists in the Larink Collection include Haida artists **Reg Davidson** (*1954, Figs. 46–47) and **Clarence S. Mills** (*1958, Figs. 48–50), Kwakiutl artists **Tony Hunt** (*1942, Figs. 51–52), **Calvin Hunt** (*1956, Figs. 53–54), **John Livingston** (Fig. 55), and **Frances Dick** (*1959, Figs. 56–57), Nootka artist **Art Thompson** (1948–2003, Fig. 58), and Tlingit artists **Eugene Alfred** (*1970, Fig. 59) and **Mark Preston** (*1960, Fig. 60).

Up until the 1980s, representatives of the tribal groups mentioned above were leaders in the production of silk-screen art. This changed only when **Susan A. Point** (*1952) appeared on the scene, a Coast Salish artist who grew up on the Musqueam reservation near Vancouver (Gerber and Katz-Lahaigue 1989, Wyatt 2000). She used ancient Salish motifs in her art, especially that of the spindle whorl, a wooden disk with a hollow center and carved relief decoration. Point had so much success with these works that she began to experiment with other art forms as well, such as relief prints and glass engraving (Figs. 61–67). Today, other Coast Salish artists such as Leslie Robert Sam (who signs his works with his "de-colonized" name "lessLIE") are just as successful. As a result, Coast Salish art, which for a long time was eclipsed by that of the Kawkiutl and Haida, is now of equal rank with them (Blanchard and Davenport 2005, Walsh 2007, 2008).

Few Northwest Coast artists have yet tried their hand at painting, and only one of these has been really successful: **Lawrence Paul** (*1957), a Coast Salish who lives in Vancouver and calls himself by his Native American name *Yuxweluptun*, "Man of the Mask." His large scale surrealistic acrylic paintings address current themes such as environmental damage, land-grab, and prostitution; they are intended to provoke. He himself calls his style of painting "Salvation Art," and uses it to claim his right to live on the undamaged land of his forefathers as a Native American (Townsend-Gault 1995: 13).

An exhibition at the Museum of Ethnology Zurich made it possible to purchase three paintings by Lawrence Paul for the Berlin museum in 1989 (Gerber and Katz-Lahaigue 1989). Additional paintings by him came to the museum in Zurich and into the hands of private collectors; a large part of Paul's early works is thus not kept in Canada, but in German-speaking countries.

In 1995, the Art Gallery of the University of British Columbia in Vancouver dedicated a large solo exhibition to his works, which included the three paintings from the Berlin collection as loans (Townsend-Gault 1995). In the *Colour Zone* exhibition, which was shown in various Canadian museums from 2001 to 2003, Paul

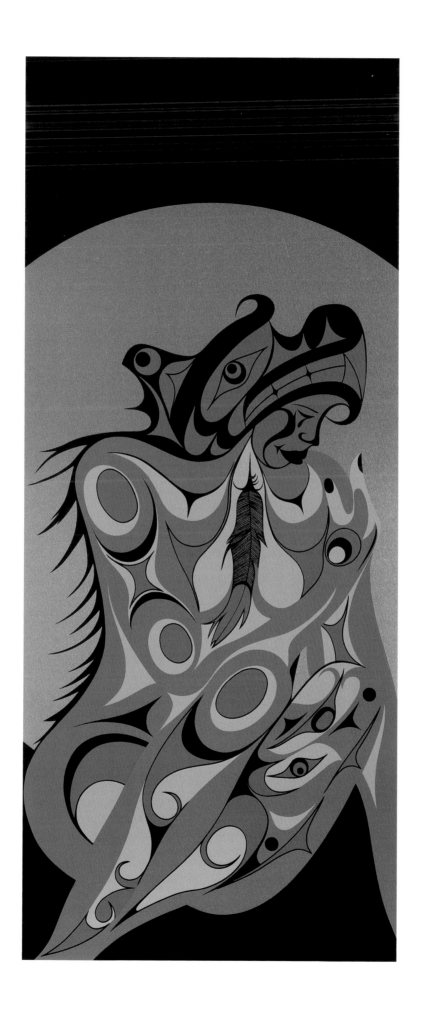

right: **Fig. 59** Eugene Alfred, Tlingit, *Raven Stealing the Light*, 1999. Larink Collection, 2003. Serigraph (edition number 54/170), height 43 cm, width 33.3 cm. Ethnologisches Museum Berlin, Inv. No. IV A 9588.

Fig. 58 Art Thompson, Nootka, *Gambler* (*Lehac Player*), 1985. Larink Collection, 2003. Serigraph (edition number 38/100), height 61 cm, width 56 cm. Ethnologisches Museum Berlin, Inv. No. IV A 9547.

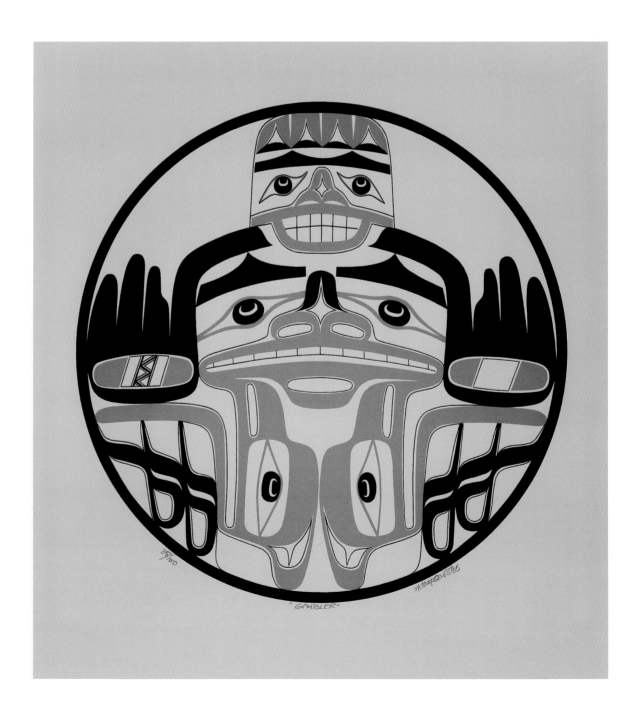

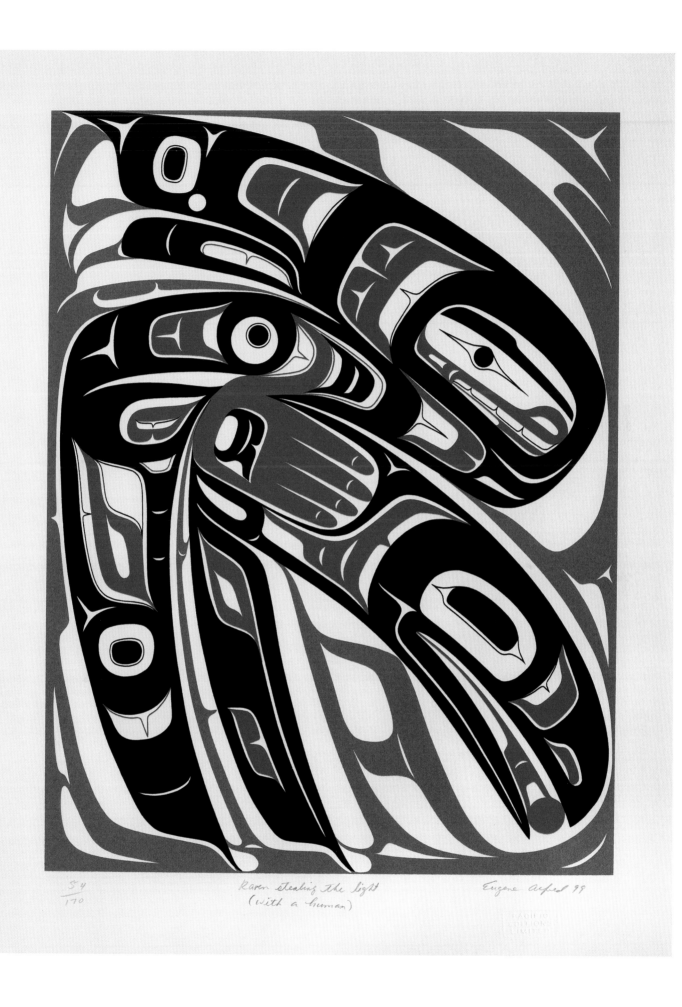

54/170 Raven stealing the light Eugene Alfred 99
(with a human)

Fig. 60 Mark Preston (Tenna Tsa The), Tlingit,
The Salmon Returns, 1999. Larink Collection, 2005.
Serigraph (edition number 22/180),
height 41 cm, width 61.8 cm.
Ethnologisches Museum Berlin, Inv. No. IV A 9619.

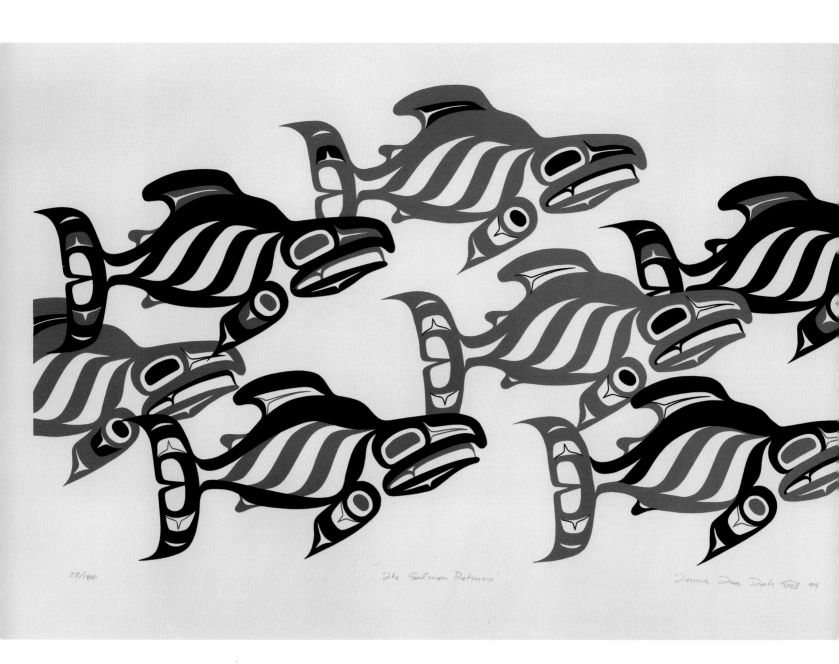

Fig. 61 Susan A. Point, Coast Salish, *Harmony*, 1991. Larink Collection 2007. Serigraph (edition number 43/91), height 33 cm, width 31.3 cm. Ethnologisches Museum Berlin, Inv. No. IV A 9642.

Fig. 62 Susan A. Point, Coast Salish, *Completing the
Circle*, 1992. Larink Collection 2004. Serigraph
(edition number 40/50), height 41.5 cm, width 41.5 cm.
Ethnologisches Museum Berlin, Inv. No. IV A 9607.

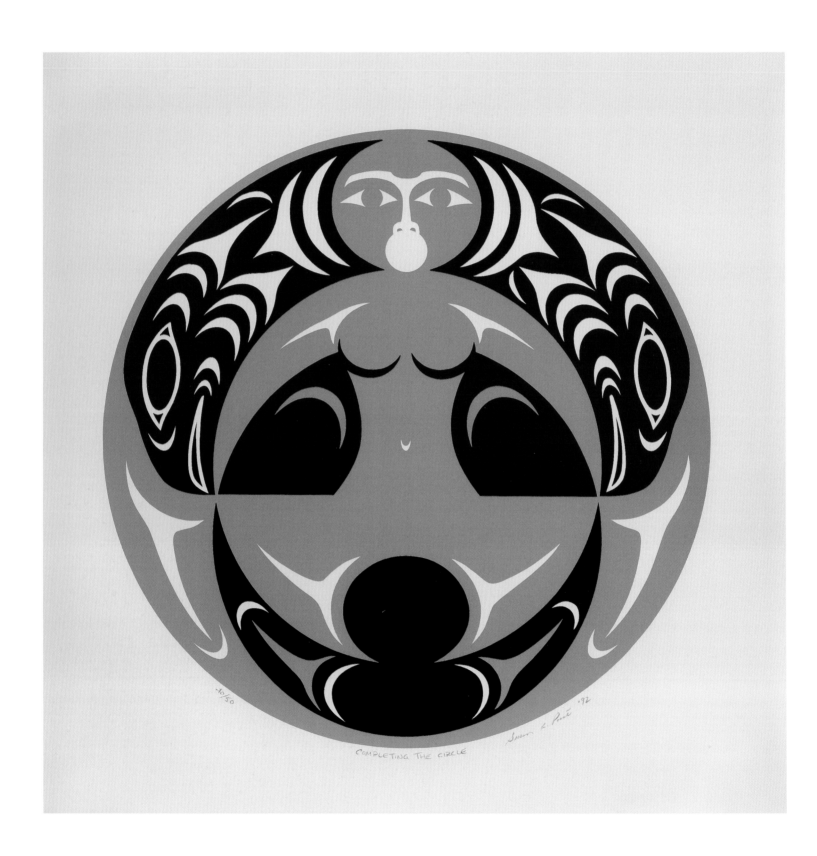

Fig. 63 Susan A. Point, Coast Salish, *Sea*, 1993.
Larink Collection, 2002. Intaglio print (relief print,
edition number 6/30), height 76 cm, width 76 cm.
Ethnologisches Museum Berlin, Inv. No. IV A 9583.

Fig. 64 Susan A. Point, Coast Salish, *Land*, 1993.
Larink Collection, 2002. Intaglio print (relief print,
edition number 6/30), height 76 cm, width 76 cm.
Ethnologisches Museum Berlin, Inv. No. IV A 9584.

Fig. 65 Susan A. Point, Coast Salish, *Sky*, 1993.
Larink Collection, 2002. Intaglio print (relief print,
edition number 6/30), height 76 cm, width 76 cm.
Ethnologisches Museum Berlin, Inv. No. IV A 9585.

Fig. 66 Susan A. Point, Coast Salish, *Water –*
The Essence of Life, 1996. Larink Collection, 1999.
Serigraph (edition number 13/ 166),
height 59 cm, width 56.3 cm.
Ethnologisches Museum Berlin, Inv. No. IV A 9539.

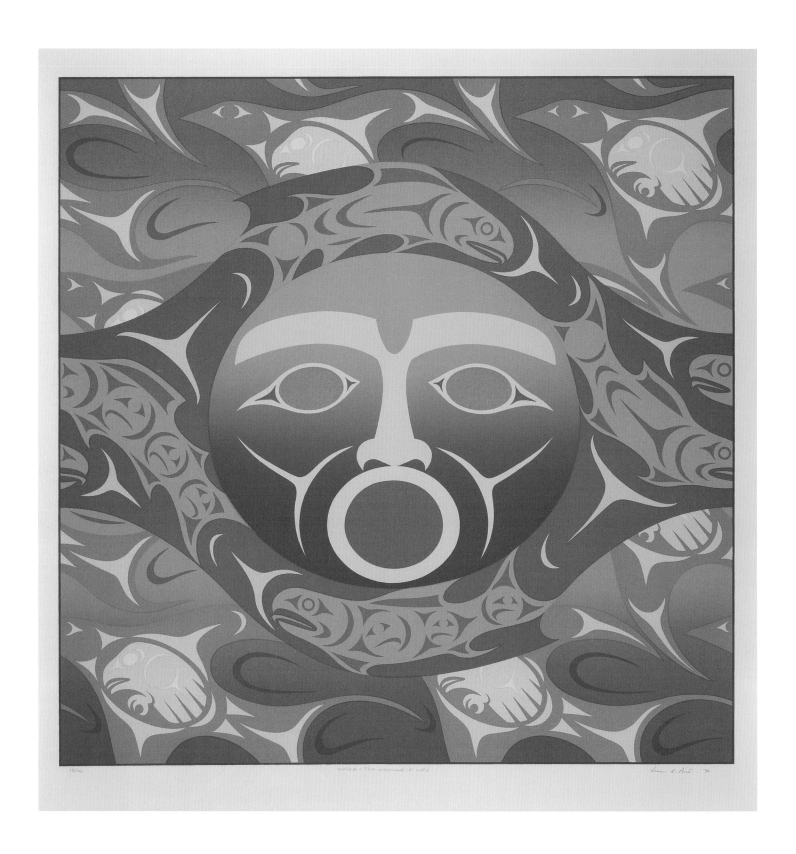

Fig. 67 Susan A. Point, Coast Salish, *Giving Voice*, 1993. Larink Collection, 2007. Glass engraving (edition number 17/25), diameter 45 cm. Ethnologisches Museum Berlin, Inv. No. IV A 9646.

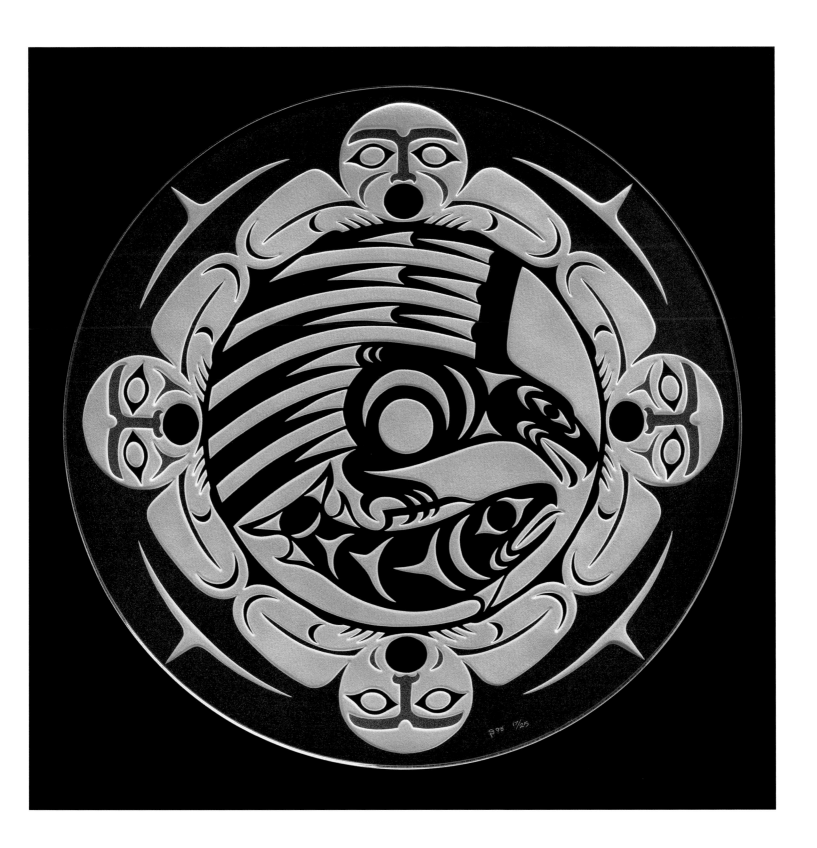

followed in the surrealist footsteps of Max Ernst by proclaiming his "Manifesto of Ovoidism," in which he traces Northwest Coast art back to its basic element, the ovoid (Watson 2003). One of the most recent exhibitions of his œuvre was dedicated to his drawings, with which he untiringly fills one sketchbook after the other (Watson 2010).

The three paintings by Lawrence Paul that were purchased by the Berlin museum in 1989 can be viewed as being representative of the themes of his painting: *Native Winter Snow Fall* (Fig. 68) shows a surreal winter scenery in which the mountains in the background are covered with multi colored ovoid forms, and green ovoids with faces hang in the snow-covered cedar trees. The very language to these forms reveals that the scenery can only be located on the Canadian Northwest Coast, which for millennia has been part of the traditional settlement area of the local Native American population.

Downtown Vancouver (Fig. 69), on the other hand, addresses one of those problems that were unknown in the country prior to Canada's colonization by Europeans: prostitution in the metropolis of Vancouver, a melting pot of people of varied ancestry and skin colors. A black woman, an Asian woman, and a Native American woman are courting a white client's favor. The man has humbly fallen to his knees and turns to the Indian woman, his tongue lolling lecherously from his mouth. The poster in the background campaigns for solidarity with the Haida Indians in their fight against the land destruction on Lyell Island.

The 1987 abstract painting, which shows ovoids that float in space, has the lengthy title *I Have a Vision that Some Day All Indigenous People Will Have Freedom and Self Government* (Fig. 70). On the one hand, it represents Paul's continuous quest for ideal ovoid forms and their interrelationships; on the other, its title reclaims what the Native Americans of British Columbia were bereft of due to colonization by the white conquerors: freedom and self-determination. Today, Lawrence Paul is not only one of the most important Canadian artists, he also uses his art to side with his people, who are involved in a permanent struggle against breaches of contracts by the Canadians, deforestation, and other forms of environmental destruction.

Native American/First Nations art is very present in the public space in Canada, even more so than in the U.S. Northwest Coast art is perceived as an indispensable part of Canadian art by all segments of the population. This does not only apply to the totem poles that are omnipresent in Vancouver, Victoria, and other cities, or the monumental bronze sculptures by Bill Reid in front of Vancouver's aquarium and in the airport. The art of Canada's indigenous population has also found its way into an increasing number of public museums in the country, where it is accepted as part of the national artistic heritage.

Fig. 68 Lawrence B. Paul (Yuxweluptun), Coast Salish,
Native Winter Snow Fall, 1987. Purchased from the
artist, 1989. Acrylic on canvas,
height 125 cm, width 184 cm.
Ethnologisches Museum Berlin, Inv. No. IV A 9509.

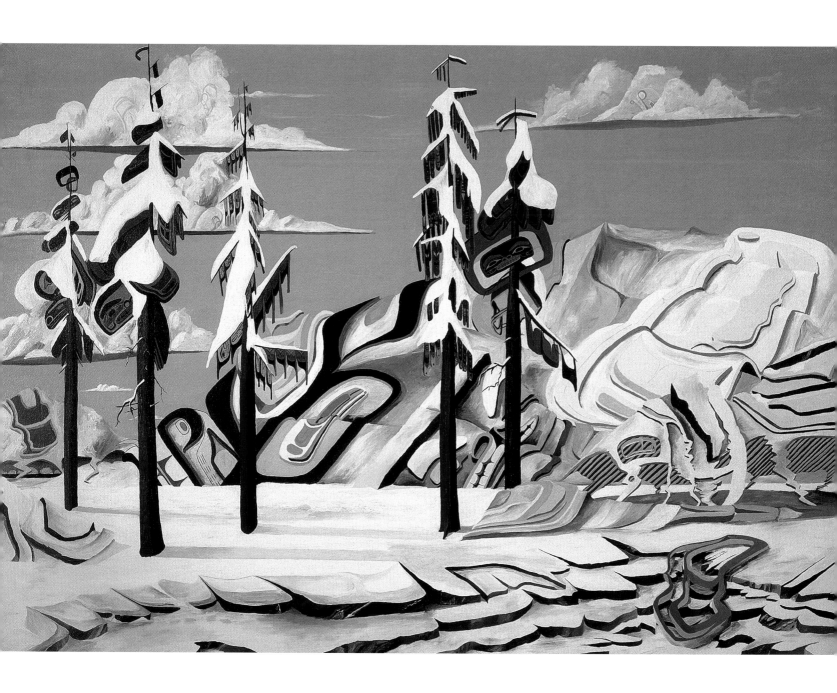

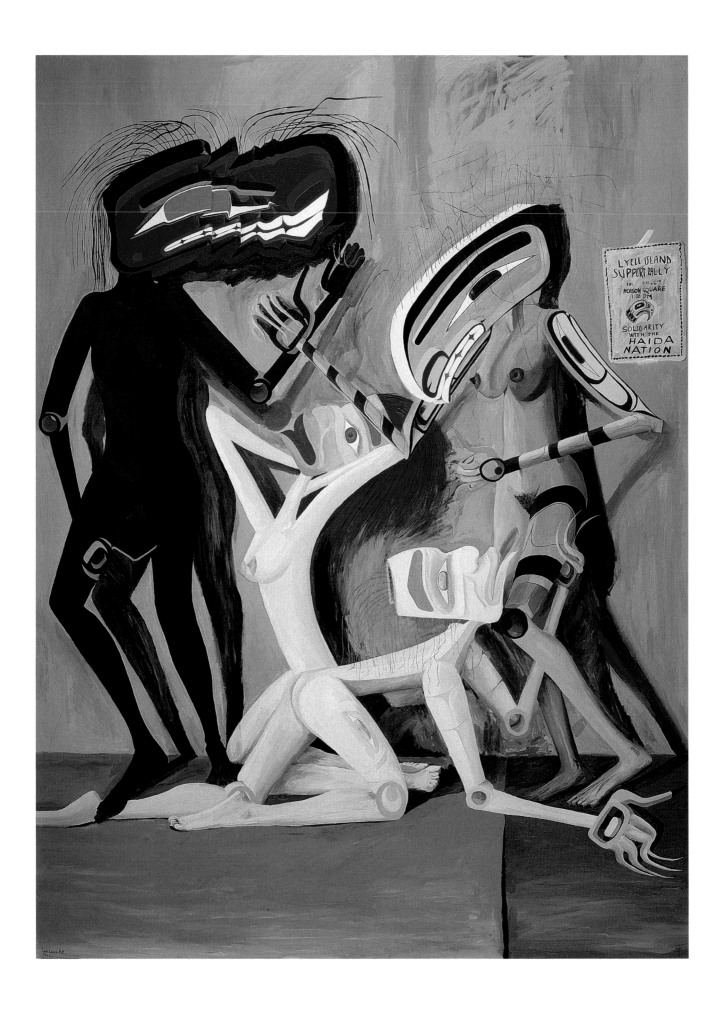

left: Fig. 69 Lawrence B. Paul (Yuxweluptun), Coast Salish, *Downtown Vancouver*, 1988. Purchased from the artist, 1989. Acrylic on canvas, height 174 cm, width 127 cm. Ethnologisches Museum Berlin, Inv. No. IV A 9510.

Fig. 70 Lawrence B. Paul (Yuxweluptun), Coast Salish, *I Have a Vision that Some Day All Indigenous People Will Have Freedom and Self Government*, 1987. Purchased from the artist, 1989. Acrylic on canvas, height 174 cm, width 211 cm. Ethnologisches Museum Berlin, Inv. No. IV A 9511.

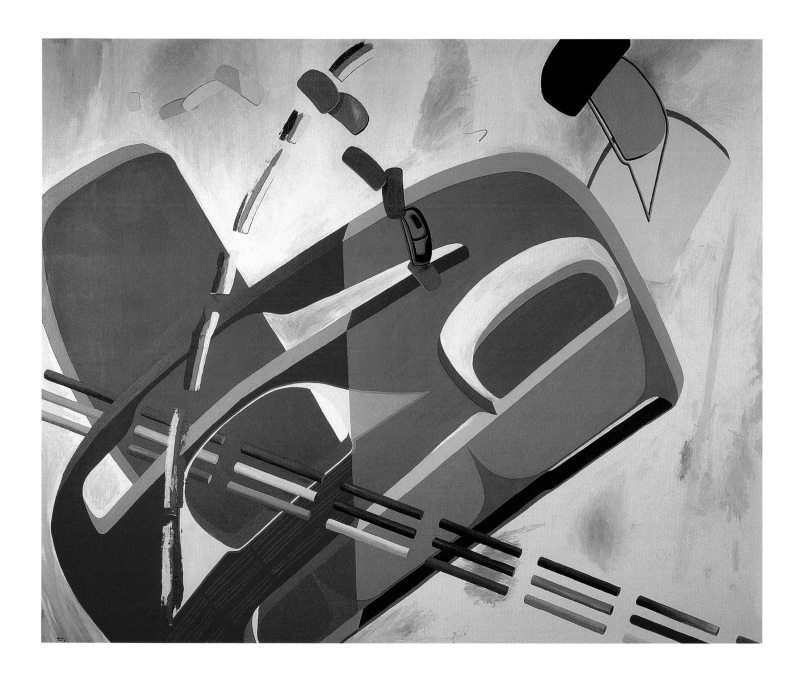

Non-Regional Art

As long as art features stylistic elements that can be unambiguously attributed to a specific region, it is easily recognizable as "Indian." Difficulties arise if some artist is recognized as a member of a specific tribe, yet has no interest in keeping to regional or tribal standards. Even more difficulties arise if his art does not display any "Indian" elements at all. Is it still Indian art? This issue has been hotly discussed by generations of gallery owners, art dealers, collectors, art historians, and ethnologists; there is no categorical answer. The question of what is Indian art and what is not can only be answered in individual cases.

The biggest issue of controversy in the history of Native American art was doubtlessly **Fritz Scholder** (1937–2005) who descended from Californian Luiseño Indians, yet also had German ancestors. In Germany he took center stage in the 1973 exhibition *Indianische Malerei in Nordamerika* (*Indian Painting in North America*), which was presented in Stuttgart and was the first to address the issue of Pan-Indian painting (Schulze-Thulin 1973).

Not only did Scholder's paintings and prints turn the formerly valid norms upside down, they could also not be linked to any specific region. A Native American in a bar holding a beer can is a common sight in North America, particularly in the cities. The same is true of the motif of a Native American wearing a traditional bison-horn cap and treating himself to a cool cone of ice cream after performing a dance that made him sweat. The pictures of feather-adorned Native Americans, exposed by Scholder as stereotypes, are not associated with any particular region either (Breeskin and Turk 1972, Taylor et al. 1982, Zacharias 1995, Sims 2008).

The same applies to artists Harry Fonseca, George Longfish, and Jaune Quick-To-See Smith. Their art is universally Native American or Pan-Indian, as it is often called. Other writers refer to them as individualists or nonconformists. However, no attempt will be made here to affix any new label to this type of art; rather, it is perceived as what it is: part of the manifold and very creative contemporary art scene of Indian America.

The Ethnologisches Museum does not own any paintings by **Fritz Scholder**, because they were prohibitively expensive as early as the 1990s. The lithograph *Indian Portrait with Tomahawk* (Fig. 72), purchased in 1993, was at that time the most expensive work of art ever acquired for the Berlin collection. The lithograph is modeled on a photograph of the famous Sioux chief Sitting Bull, and stands in place of the omnipresent stereotypical image of the feather-adorned Indian warrior who is always ready to raise his weapons against the White Man.

Scholder's *Patriotic Indian*, created in 1975 (Fig. 71), on the other hand, shows a Native American who is wearing a feather bonnet and sits motionlessly on a chair in a photo studio, waiting for the photographer to capture his shadow, and thus symbolizes the appropriation of the Native Americans by means of the civilizing accomplishments of the White Man.

Fig. 71 Fritz Scholder, Luiseño, *Patriotic Indian*, 1975. Nuzinger Collection, 1992. Lithography (edition number 22/50), height 57 cm, width 39 cm. Ethnologisches Museum Berlin, Inv. No. IV B 13128.

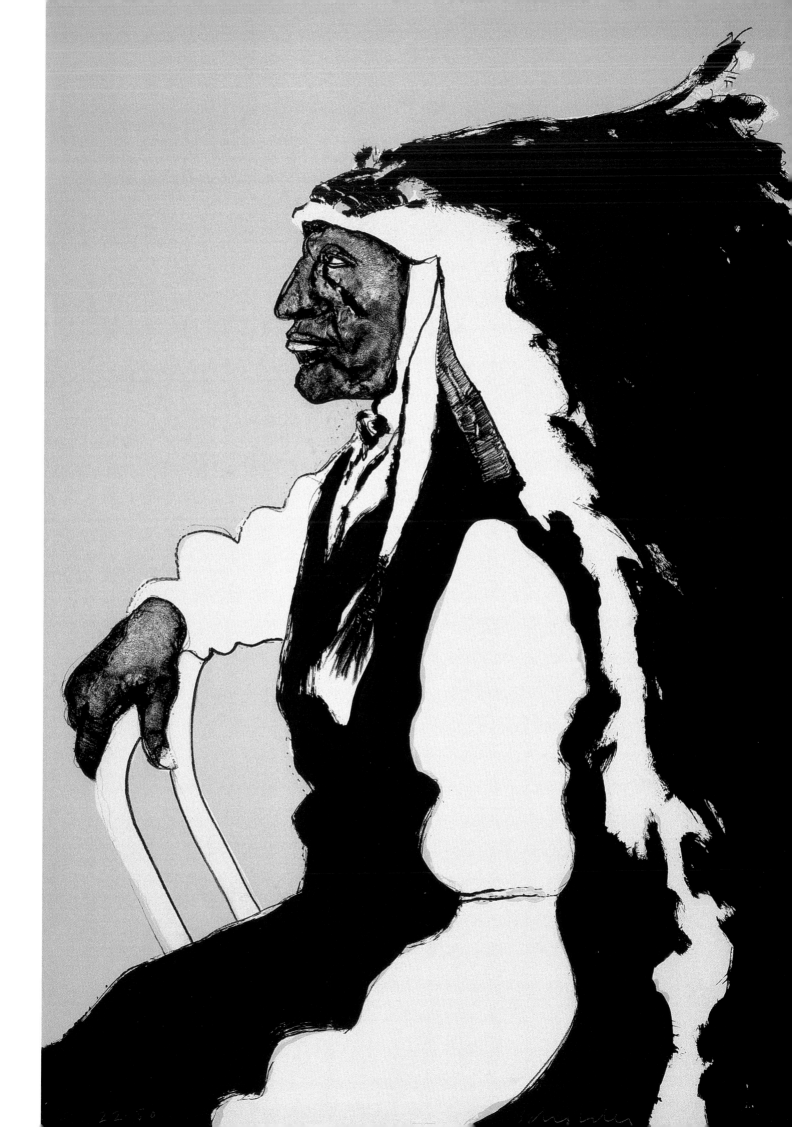

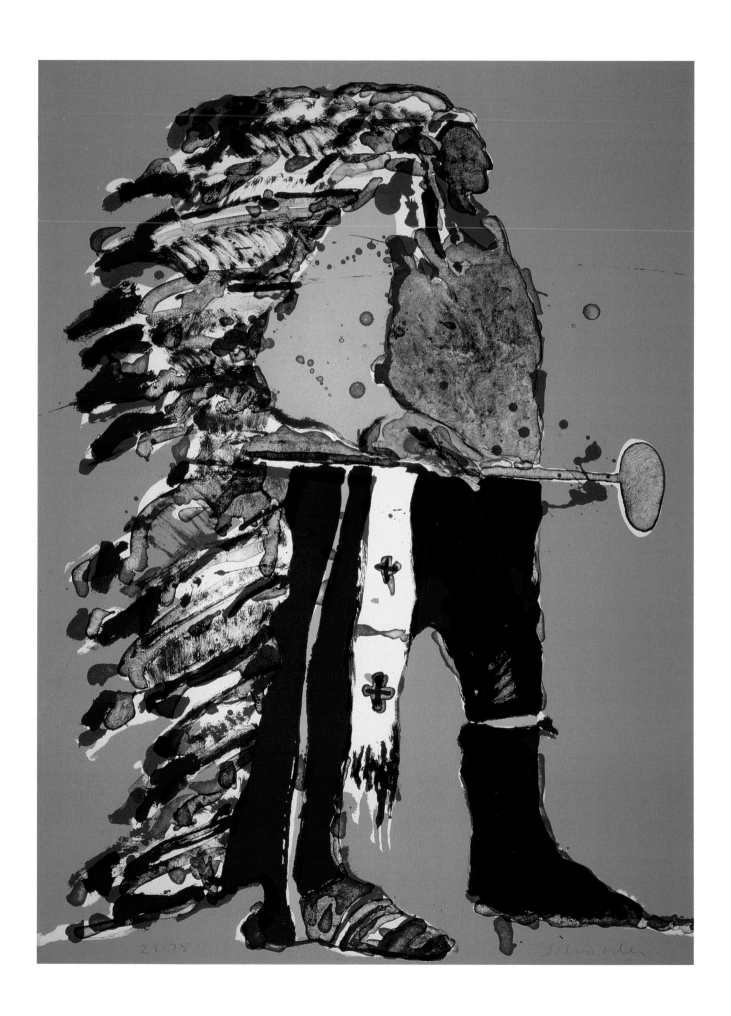

Fig. 72 Fritz Scholder, Luiseño, *Indian Portrait with Tomahawk*, 1975. Nuzinger Collection, 1993. Lithography in four colors (edition number 28/75), height 77 cm, width 57 cm. Ethnologisches Museum Berlin, Inv. No. IV B 13129.

Harry Fonseca (1946–2007) entered the stage of Indian art with a figure he had created – Coyote, who is continuously transforming and appears in ever new disguises. Fonseca's ancestors included Californian Maidu, and his uncle introduced him to the traditions and stories of that people. One of the most dazzling characters of that mythical world is Coyote, who created first the land, then the plants and finally the humans (the animals existed from the outset). Fonseca illustrated a collection of these myths in 1981 (LaPena, Bates and Medley 1989). The Coyote trickster figure is found not only in California; when Fonseca settled in Santa Fe – the artist capital of the Southwest where he opened a gallery of his own in 1990 – he discovered that the coyote was omnipresent as a creator and jester there as well. "Coyote means many things to many people – for me Coyote is a survivor and is indeed the spice of life" (Harry Fonseca, quoted in Bivins 1983: 30).

In the 1983 painting *Coyote – Cigarstore Indian* (Fig. 73) he has universally immortalized this trickster character. Coyote appears in more than one disguise: on the one hand, he is shown as a break dancer wearing a leather jacket and sneakers; on the other, he appears in the guise of a cigar-store Indian. During the 19th century such wooden Indians, holding a bunch of cigars in their hand, used to stand as advertisements in front of American tobacco stores. Today, they are viewed as the epitome of the stereotyping of Native Americans, and this is particularly emphasized by Fonseca's use of the long feather bonnet. This painting is complemented by *Rose* (Fig. 74), which shows Coyote as a broad-hipped female bar singer whose shadow lets out the coyote's nighttime howl. With these pictures, Fonseca has created a uniquely original couple in the world of Native American art.

The works of **George Longfish** (*1942) lead us to the very margins of Native American art. Some experts in this art market hold the opinion that such non-conformist paintings can no longer be viewed as "Indian," because they hardly differ from Western art. Longfish is Seneca-Tuscarora, that is, a descendant of two ethnic groups that once belonged to the powerful League of the Iroquois. He studied at the Art Institute of Chicago, far away from the original Native American painting schools in the Southwest. The contents of Longfish's paintings rarely reveal Native American elements; on the other hand, however, the titles of his paintings are rife with linguistic symbolism which is often difficult to decipher. Wade and Strickland (1981: 78) call this "the creative dilemma of the Native American artist who seeks to combine European technique with Indian image or theme." Longfish himself comments as follows: "My Native American descent is clearly visible in my works, yet they also contain international elements. My images combine symbolic elements of traditional Native American art with modern symbols. My paintings are intended to create a link between the dominant white culture and my Native American culture … I challenge the statement that a traditional style is the only acceptable form of expression in Native American art … The fact that I do not portray any Native American figures in my paintings does by no means imply that I do not have any

relationship to my culture! The point is to avoid classification into some category of 'Indian art' that is fraught with stereotypes" (Hartje 1984: 114).

Many of Longfish's paintings are not on stretcher frames, but on tent canvas that hangs loosely from the wall, supposedly in order to "suggest the flexibility and lack of constraint of the muslin panels used to make old-time tipis" (Hoffmann 1985: 278). This also applies to the painting in the Berlin collection. Created in 1984, it is entitled *Everything is the Same Size Shuffles Off To Buffalo With the Three Sisters* (Fig. 75). In the turquoise colored outline of a figure in the foreground, Longfish has portrayed himself as an apprentice who is still in the process of learning the art of healing. The Three Sisters – a term used by the Iroquois to refer to corn, beans, and squash – are suggested as round shapes at the top right of the picture. The background shows some sketched mythical scenery. Longfish does not explain the details of his pictures, he leaves it up to the beholders to discover and interpret their own visions in the images (Bivins 1983: 28).

His 1988/89 painting *Ralph Lauren's Polo War Shirt* (Fig. 76), on the other hand, is easier to interpret in terms of content. It is part of an entire series of war shirts created by Longfish. War shirts are an element of Plains culture; in this painting, the artist combines such a shirt with a symbol of American commerce culture. The two beaded sleeve strips and the fringes hanging from them are typical features of war shirts. The triangular piece of cloth at the neckline is studded with two buttons that establish the link to Ralph Lauren's polo shirts.

Jaune Quick-To-See Smith (*1940) is undoubtedly the best-known contemporary Native artist in North America. Her ethnic background aptly illustrates the complexity of "Indian" identity today: her father was of Flathead, Metis, and Shoshone descent; her mother was half Cree. As she grew up on the Flathead reservation in western Montana, she was an enrolled member of the Confederated Salish and Kootenai Tribes. In literature she is usually referred to as Cree/Shoshone, "Flathead" and sometimes even French/Cree/Shoshone/Kootenai. She started out as an art teacher and then studied art at the University of New Mexico in Albuquerque. Beginning in 1978 she participated in various exhibitions and as early as 1980 was included in Jamake Highwater's publication of 50 contemporary Native American artists (Highwater 1980: 179–180). Today, she is active at various levels in American art business: she has founded two artists' cooperatives, works as a curator for exhibitions, gives lectures on Native American art, and has been a honorary professor at Washington University in St. Louis since 1989 (Abbott 1994: 209–212). Her works were first shown in Germany in 1983 at the Galerie Akmak in Berlin (Hartje 1984: 116–117); after that she was represented in the 1985 exhibition *Indianische Kunst im 20. Jahrhundert* (*20th Century Native American Art*; Hoffmann 1985: 280–282). These were followed by numerous other exhibitions in Germany, for example, at the Galerie Calumet

in Heidelberg and the Galerie Peiper-Riegraf in Frankfurt (Peiper-Riegraf 1989: 12–13). She was even chosen as a representative of modern Native American art for the art series *1000 Meisterwerke* (*1,000 Master Pieces*) broadcasted on German television. This means that Quick-To-See Smith is also one of the best-known and most exhibited Native American artists in Germany (Bolz 2003: 190).

She attracted particular attention in the U.S. in recent years due to her map paintings, paintings or collages of the U.S. map designed in ever new variations and given provocative titles such as *Indian Country Today* or *Where Do We Come From?* The American art historian Dean Rader claims that the language of her art is guided by ethical principles and thus an expression of Native American sovereignty. For this reason, he calls her works "models of engaged resistance": "To call Smith a political painter is to say nothing. All art is political. However, what distinguishes Smith's work from that of contemporary mainstream American museum art is its foregrounding of otherwise ignored political issues" (Rader 2011: 50–53).

The *Big Green* collage, created in 1992 and purchased for the Berlin collection in 2003, is such a work of "engaged resistance." The ambiguous title alludes to both the green hues of nature and the color of dollar bills. On the top left of the painting there is the inscription: "U.S. money is GREEN, it takes precedence over nature." The various animals, rock-painting motifs, names of Native American tribes, and quotes from the works of writers all underline the artist's intention to attract attention not only to America's man-made environmental problems, but also to the fact that the country once belonged exclusively to the indigenous population.

Rick Bartow (*1946) is from the small town of Newport in Oregon, a region right at the shore of the Pacific Ocean where he continues to live and work. Being a Yurok Indian, he grew up with the stories and traditions of his people. In 1969 he graduated with a degree in art education. Instead of entering that profession, however, he was drafted and sent to Vietnam. His wartime experiences left their mark on his art: in the beginning, painting served as a kind of therapy to soothe his anxiety attacks (Banks 1986: 5). His early works dealt with the theme of transformation: humans transform into animals, and vice versa. Ravens and other birds, which play an important role in the Native American cultures of the West Coast, figure prominently in many of these paintings. According to art historian Carol Podedworny, Bartow's art is situated at the margins between Native American art and mainstream art. She writes: "The activity and voice of Bartow's generation has enabled the discussion of their work to take place in a framework defined by the so-called fine art world" (Podedworny 2001: 21).

In the early 1990s, Bartow concerned himself with the reinterpretation of traditional stories and ceremonies, including those that were found outside Yurok culture. Dobkins (2002: 32) reproduces a painting by Bartow entitled *The Offering*, which shows a Sun Dancer who undergoes piercing. Among the Plains Indians this was the supreme form of religious sacrifice offered during the Sun Dance ceremony.

The painting in the Berlin collection, created in 1992 and entitled *Give Away* (Fig. 78), shows a similar scene: a close-up of a Sun Dancer who has already undergone piercing. The wound with a wooden skewer in it is clearly visible on his chest. Further piercings can be seen in the dancer's shoulder and upper arm. They symbolize the sacrifice of little pieces of skin that can be additionally offered at the Sun Dance. In the background, we see the medicine man or one of his helpers performing the ritual of sacrifice. The title *Give Away* refers to giving these pieces of skin away to honor a pledge made by the dancer prior to the ceremony. This painful and bloody sacrifice is thus the fulfillment of his pledge, a way of giving thanks to the powers of the universe. His face is contorted with pain, but no sound comes from his open mouth, as this would not be appropriate for the ceremony.

Give Away comes from a solo exhibition of Rick Bartow's work presented by the Galerie Peiper-Riegraf in Frankfurt in 1994. In the same year he had exhibitions in Canada, the U.S., and Japan, 1999 in New Zealand, and 2005 in Mexico (Bustamante 2005). He is thus one of the most internationally successful contemporary Native American artists.

David Bradley (*1954) is a Chippewa (Ojibwa) from Minnesota, and a representative of the second generation of students from the Institute of American Indian Arts in Santa Fe. Subsequently, he continued his education at the University of Arizona in Tucson. This long-time relationship with the Southwest is expressed in almost all of his works. He decided early on in favor of a "naïve" or "primitive" style modeled after that of French artist Henri Rousseau, to whose work he alludes again and again. He is also a committed fighter for Native American rights, particularly when it comes to exposing swindlers and fraudsters in the Native American art scene. As he writes himself, he had to step on many influential toes. "As a result, I became the most blacklisted Indian artist in the country" (Hatchadoorian 2009: 26).

This commitment is expressed in many of his paintings, though sometimes in a hidden way that is only visible to insiders. He loves to quote American and European art, or to caricature that art in ever new variations. One of his favorite characters is the Mona Lisa, whom he enjoys transforming into an Indian princess, always with a cigarette in her hand. The careworn farmer couple from Grant Wood's *American Gothic* of 1930 is another of his favorites; they appear in numerous variations, frequently as a Native American couple with a tipi replacing the Gothic-looking gable in the background. Another of Bradley's specialties is pictures where people of varied backgrounds sit at a large table. For example, he used Leonardo da Vinci's *Last Supper* as the model for a painting where 24 Native Americans, most of them

well-known figures from history, sit together at a large table. In the center, the Sioux chief Sitting Bull is enthroned like the figure of the Savior (Wooley 1991: 16–17). Many of Bradley's paintings are teeming with people and allusions to the Native American art scene in and around Santa Fe, and he has often portrayed well-known Southwest artists, for example R.C. Gorman (Navajo) engaged in a conversation with painter Georgia O'Keeffe (Hatchadoorian 2009: 4). In one of his paintings, he even managed to surround collector and gallery owner Dorothee Peiper-Riegraf with 17 female and male Native American artists (Peiper-Riegraf 1989), many of whom would refuse to even talk to each other in real life.

The Berlin painting *Indian Market Manifesto* (1997; Fig. 79) from the Peiper-Riegraf collection perfectly exemplifies Bradley's ironical way of looking at the Santa Fe art scene. The actual market event takes place in the upper middle of the painting and is merely indicated. In the foreground, we see the shops and galleries that are the hubs of the real big business. The gallery in the middle of the row of houses advertises "quick-to-sell amateur arts and crafts." Rumor has it that artist Jaune Quick-To-See Smith was not amused when she learned about this. In addition, "wannabe Indian art" is for sale there, and a board below lists all those artists regarded by Bradley as wannabes. The term wannabe (derived from "want-to-be") refers to would-be Indians who make money producing Native American art even though they are not Native. By thus pillorying some of his fellow artists, Bradley has gotten into a lot of trouble.

The building to the right houses a "flaw office" (instead of "law office") where dubious attorneys offer their services, and in the shop window next to that "all fake Indian jewelry and kachinas" are up for sale at 90 percent off. Even the house numbers have symbolic meaning: 1492, the discovery of America and the beginning of misery for all Native Americans; 1680, the uprising of the Pueblo Indians that resulted in a temporary expulsion of the Spaniards; 1876, the Battle at Little Bighorn with victory over the U.S. Army and General Custer, who is still viewed as enemy no. 1 by all patriotic Native Americans. To the left in the window we see painter Georgia O'Keeffe (wearing a white headscarf), whom Bradley reveres, and above her, a successful businessman (probably an art dealer) who is tossing dollar bills all around. All the way into its background, which shows "Santa Fe" adopted from the Hollywood font, the painting is rife with historical and cultural allusions; and in the foreground we see French artist Henri Rousseau's sleeping gypsy woman – Bradley's way of paying homage to his big role model in the genre of naïve painting.

The painting *Pueblo Feast Day 2005* (Fig. 80) shows a scurrilous dinner party in one of the Rio Grande pueblos, where an open house takes place once a year. On that occasion, friends are welcomed and treated to traditional dishes. The host, dressed in traditional garb, is sitting at the left of the table, and to his left is the cigarette-smoking Mona Lisa who wears the hunchbacked flute player Kokopelli as a neck ornament. In the middle – the place of honor – the Lone Ranger has taken seat. He is the hero of a TV series of

the same name that is familiar to virtually everyone in the U.S.; as he wants to remain incognito, he always wears a black mask. At his side is painter Georgia O'Keeffe (in her younger years), recognizable by her broche shaped to form the letters "OK." At the right head end of the table, we can identify *Whistler's Mother*, a portrait created by American artist James McNeill Whistler in 1871, which is an icon of American painting. With his back to the beholder, Saint Francis, who was able to talk to plants and beasts, is sitting to the left. Not only a bible, but also a newspaper with the headline "Church Sex Scandal" poke out of his bag on the floor. The Mexican in the middle is Emiliano Zapata, the legendary leader of the 1910 Mexican Revolution, and next to him sits a Navajo woman with her small son. The tourists to the left in the background are the above-mentioned farmer couple from *American Gothic*, and to the right we encounter a well-known figure by Belgian surrealist René Magritte. The window permits us to watch a ceremonial dance performed on the plaza of the village. In the background, we see a gambling casino; to the right is a Catholic church, and in front of the latter the artist couple Frida Kahlo and Diego Rivera. The artist has immortalized himself, together with his wife and son, in the left corner of the window. Like most of Bradley's pictures, *Pueblo Feast Day 2005* is an exaggerated portrayal of what constitutes Native American existence today: the seamless combination of tradition and modernity.

Bradley's third work in the Berlin collection is a sculpture entitled *Land O'Lakes, Land O'Bucks, Land O'Fakes* (Fig. 81). Every American will immediately recognize this sculpture as being an oversize package of "Land O'Lakes" brand butter, two variants of which are for sale in the supermarkets: the package of salted butter has a yellow background color, while that of unsalted butter is blue. The central motif on each is a kneeling Native American woman who submissively offers a packaged butter to the white buyer – a gesture that causes flushes of anger not only among Native American feminists. At the same time, the package is a symbol of the commercialization and marketing of Native American culture by white society. All attempts by political Native American organizations to have this stereotypical image of a fictitious Indian princess banned as sexist and racist have as of yet been futile. For that reason, David Bradley uses other means to fight this discrimination: he exposes the lovely "Land of Lakes" as a land of dollar bills (bucks) and delusions (fakes). The blue-colored counterpart of Bradley's sculpture (Hatchadoorian 2009: 13) is on exhibit at the Denver Art Museum's new permanent exhibition on North American indigenous art.

Onondaga Iroquois artist **Peter B. Jones** (*1947) is one of those few students of the Institute of American Indian Arts in Santa Fe who came from the Northeast. He was represented in the 1974 Alumni Exhibition of that institute with several clay sculptures, and continues to work in that medium. As early as then he remarked: "I don't like the term Indian Art. I am an Indian who happened to choose art as a way of life … I work in clay because I like the immediacy of the material … I believe my people are natural beings and that

they do not need to be romanticized as stoic, red, colourful, cultural oddities in 20th century America by art or artists, although they are" (New 1974: 24).

His early clay figures usually relate to everyday scenes on the reservation, such as Native Americans in overalls or a singer with a drum who wears street clothing. Later, his figures became fraught with more symbolism. His 2002 sculpture *Indian with Baggage* shows an elderly Native American sitting at a bus stop with three suitcases and wearing an American flag as a cloak. The pieces of luggage have inscriptions that only catch the eye on second view: Wounded Knee, BIA, Tradition, Removal Act – burdens that have been borne by the Native Americans for more than one hundred years. His sculptural commentary on the gambling casinos on Indian land shows the figure of a Native American whose body consists of a slot machine. If we look at the back of the figure we are grinned at by a skull (Kasprycki and Stambrau 2003: 84–85).

His clay figure entitled *Effigy for the Last Real Indian* (1993; Fig. 82) was first shown in 1998 at the exhibition *Iroquois Art* presented by the Amerika Haus in Frankfurt/Main (Kasprycki 1998). Subsequently, it was purchased for the new permanent *Indianer Nordamerikas* exhibition (*Indians of North America*) at the Ethnologisches Museum Berlin. It shows a human figure wrapped in cloths, looking like a mummified corpse. The spots in its face represent the sicknesses introduced by the Whites, such as smallpox and cholera, which wiped out entire Native village communities and depopulated large stretches of land. The sculpture reminds the artist of the lament of one of his friends who said that he was the last one to speak the ancient tribal language fluently, and thus the last "real" Indian (Kasprycki 1998: 82–83). This sculpture thus stands for the genocide of the Natives of the Americas – not only their physical destruction, but also the destruction of their ancient languages and cultures.

Sculptor **Bob Haozous** (Chiricahua Apache, *1943) followed in the footsteps of his father, artist Allan Houser, who today is regarded as the most important Native American sculptor. His choice of the Apache spelling of his name (instead of the Americanized Houser) reveals the artist's connection to his ethnic background. This is also expressed in his sculptures made of wood, stone, steel, or aluminum, which often relate to Apache culture. One of his most impressive works is a column entitled *Apache Holocaust Memorial*. About five meters high, it was the focus of an exhibition shown in 1993 in Santa Fe (Sanchez 2005: 15–17, 26). Seven barred jail windows with wooden skulls behind them are set into the column; the base features the names of those who did not survive prosecution, deportation, jail, or boarding schools. On top of the column sits an Apache warrior who wears traditional garb from the time around 1880; with iron shackles on his feet, he is awaiting execution.

Such political messages are also found in most of the artist's other works, for example, *Landscape* (1989; Fig. 83). This steel sculpture shows a stylized Gaan figure (the gaan are supernatural protectors and teach-

ers of the Apache) soaring above the clouds; below is a column of five cars. Haozous thus demonstrates that modern life, symbolized by the cars, and the mythical spirit world of the Apache are not necessarily in conflict with each other. Rather, they can form a harmonious union, as exemplified in this sculpture. According to his own words, he is concerned with keeping and preserving traditional values in a modern world (Peiper-Riegraf 1989: 24).

By invitation of the Peiper-Riegraf Gallery and the City of Frankfurt, Bob Haozous stayed in the metropolis on the Main as an artist in residence in October 1992. There he created a series entitled "Apfelbaum – Sacred Images," composed of eleven sculptures. The series shows the apple trees in various states of being, from standing upright to lying on the ground after having been felled. A welded-on axe indicates that they have been cut down by the hand of humans. The trunk of the sculpture purchased for the Berlin collection in 2010 (Fig. 84) is cut in two at its center, and its globular crown with painted red apples lies on the ground. The artist comments this as follows: "With these trees, I wish to make a statement about the destruction of the environment which everyone can understand – regardless whether child and adult, or whether he or she is living in Germany, the U.S., or at the North Pole" (Hendricks 1998: 12). Haozous further stresses that he does not intend to appear as an Native American environment guru; he wants to personally campaign against environmental destruction (Hendricks 1998: 10). "There's more to being an Indian than just blood or a number," he says. "We've got to get through the surface to the philosophy. An indigenous way of looking at the earth is what defines us, not the other stuff, not the politics or the skin color" (Sanchez 2005: 21–22).

The Berlin Collection

In comparison with the total holdings of the North America collection in the Ethnologisches Museum, which comprises about 30,000 objects, the inventory of contemporary Native American art is quite small. Its real value, however, is not due to absolute numbers, but to the collection's presence and meaningfulness. To be sure, the North America collection in Berlin includes a considerable number of new objects, such as Hopi basketry and kachina figures, Iroquois false-face masks, Lakota peyote utensils, ceremonial masks and a canoe from the Kwakiutl. These are all objects that derive from the traditional culture of their respective ethnic groups. They show that these traditions continue to exist today, despite ongoing oppression by white society. They do not show, however, the new aspects that have emerged from the combination of Native American tradition and white America's "civilization." This can only be accomplished by modern Native American art, which bridges these two worlds.

Horst Hartmann (1923–2010), the former curator of the North America collection at the museum – which was at that time called the Museum für Völkerkunde – was the first to purchase modern Native American art. During his term as head of the department of Amerikanische Naturvölker (1956–1985) he undertook many study trips to the U.S. (Bolz 2010c). When he bought several paintings by Native American artists on the occasion of one of his stays in the Southwest in 1975 (and again in 1980), he had not yet envisioned a new field of collecting within North American ethnology. Rather, he wanted to complement the existing collections with paintings of religious ceremonies, because at that time there was a ban on taking photographs of these. He therefore purchased ten paintings and the bronze sculpture by Allan Houser by 1983. On his travels he established contact with Ekkehard Malotki, a German American who back then was working as an ethnolinguist at Northern Arizona University in Flagstaff. Malotki is specialized in Hopi language and culture, on which he has as yet published 21 books and numerous articles. Hartmann commissioned Malotki to collect modern objects from Hopi culture for the Berlin museum, with a focus on figures and depictions of kachinas. It was in this way that nine more paintings by Pueblo artists came to Berlin between 1979 and 1984.

This collection was the basis for those purchases that were made after 1989. When I took office as head of the North America collections in 1989, I set myself the goal of broadening the collection of modern Native American art in such a way that artists from all over North America would be represented. That same year, the Directorate-General provided special funds for purchases of ethnic art from South Asia and North America. No extra funds were provided for travels to the U.S., however, and I had no choice but to look in galleries in Germany and other nearby countries. It was thus a lucky coincidence that Katrina Hartje, a Frankfurt-based gallery owner, was just then closing her gallery of modern Native American art; this enabled me to buy six paintings from her at a good price: two each by Jerry Ingram, Kevin Red Star, and Harry Fonseca.

At the same time Peter Gerber, a colleague at the Museum of Ethnology of the University of Zurich, presented an exhibition with art from the North American Northwest Coast in which Lawrence Paul – then a still largely unknown young artist – was represented with numerous paintings. As these were for sale, I selected three of them for the Berlin museum. The artist, who came to visit Berlin from Zurich, made out the invoice himself. There was no additional fee to be paid to a middleman. This is how I was able to purchase altogether nine paintings in 1989 for the quite moderate amount of DM 50,000 – from today's point of view this would definitely be regarded as a bargain.

Because the funds came from the Directorate-General, the Assembly of Directors of the National Museums Berlin had to give an expert opinion of the purchase, which they did at a special meeting in Berlin-Dahlem. Since the majority of the directors were art historians, they made all kinds of comparisons between Native American and European art, particularly with regard to the Surrealist-looking paintings by Lawrence Paul. Eventually, everyone basically agreed that this type of art was in good hands at an ethnological museum. The directors also held the opinion that Native American art did not stand a chance of ever being presented at the New National Gallery; after all, this would suggest that it is at the same level as works of European artists – an inconceivable idea (Bolz 2010a: 115–116).

Thus assured, I could continue to purchase modern Native American art in the years that followed, yet quite irregularly. The Ethnologisches Museum continued to have a budget for purchases in the 1990s, but these funds were never sufficient to fulfill the wishes of all curators. Thus, at the end of the year there was only occasionally enough money left for the acquisition of a work of Native American art. Whenever this was the case, Ms. Christa Nuzinger's Galerie Calumet in Heidelberg proved very helpful and cooperative, enabling me to buy several paintings and prints by Michael Kabotie, R. C. Gorman, Frank LaPena, Fritz Scholder, and George Longfish between 1991 and 1994. After that time, however, the funds dried up because the new Director-General established other priorities. In 1998 the sculpture by Peter Jones from the exhibition *Iroquois Art* in Frankfurt could be bought thanks to funds allocated to the new North America exhibition; the purchase was kindly arranged by my Frankfurt-based colleague Doris Stambrau. One year later, the painting *Hunting* by Norval Morrisseau was purchased from the Antonitsch family, owner of the Inuit Galerie in Mannheim.

The permanent exhibition *Indianer Nordamerikas – vom Mythos zur Moderne* (*North American Indians – from Myth to Modernity*), which opened in Berlin-Dahlem in November 1999, was the first of its kind in Europe to explicitly address modern Native American art as a whole, and to present it as a distinct part of the exhibition. Some journalists, who had formerly perceived North American Indians as merely people from some forgotten past, had a problem when they were all of a sudden confronted with this type of art.

The journalist Harald Jähner, who wrote for the *Berliner Zeitung*, recorded his aversion to this art as follows: "The last room shows modern Indian art, a horrible cabinet of kitsch presenting Indian motifs in the style of warehouse-expressionism" (Berliner Zeitung, 03.12.1999). I called that journalist and asked him whether he was ready to defend his position in a public discussion at the museum. He answered in the negative, on the grounds that he did not know the first thing about modern Native American art (Bolz 2010a: 116).

This shows that despite the Germans' "enthusiasm for Indians" it is very difficult to dispel firmly established stereotypes, and get people to recognize that not only 19th century Native Americans are "genuine Indians," but also those living in the 20th and 21st centuries. And if these modern Indians furthermore paint with acrylics on canvas instead of sewing beads onto moccasins, the average journalist is over-challenged by the task of covering Native American art in an unbiased manner.

The next acquisition was owed to a somehow deplorable incident: objects in the South America collection had suffered damage, and in 2003 the director of the museum gave permission to use money from the settlement of these damages for the purchase of Jaune Quick-To-See Smith's collage *Big Green* from the Galerie Calumet in Heidelberg.

In the years that followed, no further purchases of modern Native American art were possible. When former Frankfurt gallery owner Dorothee Peiper-Riegraf offered the museum two paintings by David Bradley in 2008, Viola König, the director of the Ethnologisches Museum, presented these works at the directors' conference of the National Museums and strongly advocated consent to the purchase. Surprisingly, all directors complied with her request. In the following year the two sculptures by Bob Haozous from the Peiper-Riegraf collection, first only presented by the museum as loans in the exhibition *Anders zur Welt kommen* (*A Different Approach to the World*), were purchased as well. In addition to this, Ms. Peiper-Riegraf became a generous patron by presenting the Berlin museum with two works by Rick Bartow and Kevin Red Star, respectively, in 2008, and an additional large collection of pottery and other objects from the U.S. Southwest in 2010.

When shortly afterward there was an opportunity to buy parts of a private collection in Würzburg, the director of the Ethnologisches Museum strongly advocated the purchase at the directors' conference. By then, the discussion about the planned Humboldt-Forum – the reconstruction of the Berlin City Palace – had drawn attention to the significance of ethnic art, and fostered willingness to make the new museum a truly innovative place. In addition, a large part of these paintings originally came from the collection of Gerhard Hoffmann, who had organized the much-noticed exhibition *Indianische Kunst im 20. Jahrhundert* in 1985. The collection was owned by Christine and Johannes Seybold and included paintings by Michael

Kabotie, Milland Lomakema, Grey Cohoe, Ben Buffalo, Jerry Ingram, Kevin Red Star, Norval Morrisseau, and George Longfish. In order to make the acquisition possible, Director König provided the Ethnologisches Museum with a budget for purchases over the next years, and the directors agreed to the allocation of additional special funds by the Directorate-General.

Notwithstanding all of these, we must not forget the gifts made to the museum since the 1970s. First of all, the delegation of seventeen people from the Northwest Coast deserves mention. Visiting the museum in July 1976, they brought eight silk-screen prints as a present. The best-known artists in that group included Bud Mintz from Vancouver and Reg Davidson from Masset.

In December 1998 Walter Larink, a former staff member of the Canadian Embassy and a lover of Northwest Coast art, presented the museum first with a serigraph from his collection as a Christmas gift. To this, he added a larger number of serigraphs in December 1999 – the year when the permanent North America exhibition opened. In the years that followed, there were more Christmas gifts from the Renate and Walter Larink Collection, and to date the museum has received altogether 90 serigraphs and other objects from that private collection, including an engraved glass bowl by Susan Point. The museum is all the more grateful for these gifts as they include many works of art from the 1980s that have by now become rarities on the collectors' market and can no longer be purchased. The Larink Collection at the Ethnologisches Museum is probably the largest and most precious collection of silk-screen prints from the Northwest Coast found at any German museum.

Containing altogether about 160 paintings, sculptures, and prints dating from the 1970s until the present, the Ethnologisches Museum Berlin thus owns one of the largest collections of modern Native American art in Europe. As becomes apparent from this catalogue, the various regions are quite unevenly represented; moreover, Native Americans today are creative in a multitude of other media. This means that the collection is by no means complete, and we call upon the future custodians of the North America collection to help make Native American art at the Ethnologisches Museum grow and prosper.

Bibliography

Abbott, Lawrence
1994: *I Stand in the Center of the Good. Interviews with Contemporary Native American Artists.* Lincoln: University of Nebraska Press.

Adams, Clinton
1975: *Fritz Scholder, Lithographs.* Boston: New York Graphic Society.

Adams, Ben Q., and Richard Newlin
1987: *R. C. Gorman. The Graphic Works.* Albuquerque: Taos Editions.

Amerika Haus Berlin
1983: *American Indian Art: Allan Houser, Dan Namingha.* Berlin: Amerika Haus.

Baker, Joe, and Gerald McMaster (ed.)
2007: *Remix. New Modernities in a Post-Indian World.* Washington and New York: National Museum of the American Indian.

Banks, Kenneth
1986: *Portfolio. Eleven American Indian Artists.* San Francisco: American Indian Contemporary Arts.

Berlo, Janet C. (ed.)
1996: *Plains Indians Drawings, 1865–1935. Pages from a Visual History.* New York: Harry N. Abrams.

Berlo, Janet C.
2006: *Arthur Amiotte, Collages 1988–2006.* Santa Fe: Wheelwright Museum of the American Indian.

Berlo, Janet C., and Ruth B. Phillips
1998: *Native North American Art.* Oxford: Oxford University Press.

Bernstein, Bruce, and W. Jackson Rushing
1995: *Modern by Tradition. American Indian Painting in the Studio Style.* Santa Fe: Museum of New Mexico Press.

Biasio, Elisabeth, and Peter R. Gerber
2010: *Willkommene Kunst? Druckgrafiken aus Kanada und Äthiopien.* Zurich: Völkerkundemuseum der Universität Zürich.

Bivins, Richard A.
1983: *Contemporary Native American Art.* Stillwater: Gardiner Art Gallery, Oklahoma State University.

Blanchard, Rebecca, and Nancy Davenport
2005: *Contemporary Coast Salish Art.* Seattle: Stonington Gallery.

Blomberg, Nancy J. (ed.)
2008: *[Re]inventing the Wheel. Advancing the Dialogue on Contemporary American Indian Art.* Denver: Denver Art Museum.
2010: *Action and Agency. Advancing the Dialogue on Native Performance Art.* Denver: Denver Art Museum.

Bolz, Peter
2003: *Moderne indianische Kunst Nordamerikas: „Big Green" von Jaune Quick-To-See Smith.* Baessler-Archiv 51, 189–192.
2010a: "Ethnic Art or Fine Art? Twenty Years of Collecting Native American Art for the Ethnological Museum." In: Lidia Guzy, Rainer Hatoum, Susan Kamel (eds.), *From Imperial Museum to Communication Centre? On the New Role of Museums as Mediators between Science and Non-Western Societies.* Würzburg: Königshausen und Neumann, 113–119.
2010b: "Kunst der Nordwestküste Nordamerikas und ihre Bezüge zur zeitgenössischen Kunst." In: *Spurenleser. Festgabe für Peter R. Gerber zu seiner Pensionierung.* Zurich: Völkerkundemuseum der Universität Zürich.
2010c: "Nachruf: Horst Hartmann, 9. 4. 1923 – 3. 1. 2010." Baessler-Archiv 58, 163–170.

Bolz, Peter, and Bernd Peyer
1987: *Indianische Kunst Nordamerikas.* Köln: DuMont.

Bolz, Peter, and Hans-Ulrich Sanner
1999: *Indianer Nordamerikas. Die Sammlungen des Ethnologischen Museums Berlin.* Berlin: Staatliche Museen zu Berlin, G + H Verlag. English edition: *Native American Art. The Collections of the Ethnological Museum Berlin.* Seattle: University of Washington Press.

Breeskin, Adelyn D., and Rudy H. Turk
1972: *Scholder/Indians.* Flagstaff: Northland Press.

Broder, Patricia Janis
1978: *Hopi Painting. The World of the Hopis.* New York: E. P. Dutton.

Brody, J. J.
1971: *Indian Painters and White Patrons.* Albuquerque: University of New Mexico Press.
2009: *Kiowa and Pueblo Art. Watercolor Paintings by Native American Artists.* Mineloa: Dover Publ.

Bustamante, René
2005: *Rick Bartow.* Oaxaca, México: Galeria Manuel Garcia.

Chase, Katherin
1982: *Navajo Painting.* Plateau vol. 54 no. 1. Flagstaff: Museum of Northern Arizona.

Clements, Marie
2007: *Copper Thunderbird.* Vancouver: Talonbooks.

Dobkins, Rebecca J.
1997: *Memory and Imagination. The Legacy of Maidu Indian Artist Frank Day.* Oakland: Oakland Museum of California.
2002: *Rick Bartow: My Eye.* Willamette: Hallie Ford Museum of Art, Willamette University.

Dunn, Dorothy
1968: *American Indian Painting of the Southwest and Plains Areas.* Albuquerque: University of New Mexico Press.

Fewkes, Jesse Walter
1900: *Hopi Kachinas Drawn by Native Artists.* Washington: Bureau of American Ethnology, Annual Report 21, 3–126.

Gerber, Peter, and Vanina Katz-Lahaigue
1989: *Susan A. Point, Joe David, Lawrence Paul. Indianische Künstler der Westküste Kanadas/Native Artists from the Northwest Coast.* Zurich: Völkerkundemuseum.

Gritton, Joy L.
2000: *The Institute of American Indian Arts. Modernism and U.S. Indian Policy.* Albuquerque: University of New Mexico Press.

Haberland, Wolfgang
1979: *Donnervogel und Raubwal. Die indianische Kunst der Nordwestküste Nordamerikas.* Hamburg: Hamburgisches Museum für Völkerkunde.

Hall, Edwin S., Margaret B. Blackman, and Vincent Rickard
1981: *Northwest Coast Indian Graphics. An Introduction to Silk Screen Prints.* Seattle: University of Washington Press.

Hatchadoorian, Lisa (ed.)
2009: *David Bradley: Restless Native, the Journey.* Casper: Nicolaysen Art Museum and Discovery Center.

Hartje, Katrina
1984: *Signale indianischer Künstler.* Berlin: Galerie Akmak.

Hartmann, Horst
1973: *Die Plains- und Prärieindianer Nordamerikas.* Berlin: Museum für Völkerkunde.
1978: *Kachina-Figuren der Hopi-Indianer.* Berlin: Museum für Völkerkunde.

Hendricks, Alfred
1998: *Bob Haozous im Westfälischen Landesmuseum für Naturkunde.* Münster: Landschaftsverband Westfalen-Lippe.

Hibben, Frank C.
1975: *Kiva Art of the Anasazi.* Las Vegas: K.C. Publications.

Highwater, Jamake
1976: *Song from the Earth. American Indian Painting.* Boston: New York Graphic Society.
1980: *The Sweet Grass Lives On. Fifty Contemporary North American Indian Artists.* New York: Lippincott and Crowell.

Hill, Greg A.
2006: *Norval Morrisseau – Shaman Artist.* Ottawa: National Gallery of Canada.

Hill, Richard W., Lance Belanger, and Frank LaPena
1994: *This Path We Travel. Celebrations of Contemporary Native American Creativity.* New York: National Museum of the American Indian.

Hoffmann, Gerhard (ed.)
1985: *Indianische Kunst im 20. Jahrhundert.* Munich: Prestel.
1988: *Im Schatten der Sonne. Zeitgenössische Kunst der Indianer und Eskimos in Kanada.* Stuttgart: Edition Cantz.

Holm, Bill
1965: *Northwest Coast Indian Art. An Analysis of Form.* Seattle: University of Washington Press.

Hug, Alfons
1997: *Die anderen Modernen. Zeitgenössische Kunst aus Afrika, Asien und Lateinamerika.* Berlin: Haus der Kulturen der Welt, Edition Braus.

Interversa, Gesellschaft für Beteiligungen
1979: *Kinder des Nanabush. Die Waldland-Indianer in Kanada und ihre Kunst von heute.* Aus der McMichael Canadian Collection Kleinburg/Ontario. Hamburg: Interversa.

Jonaitis, Aldona
2006: *Art of the Northwest Coast.* Seattle: University of Washington Press.

Kasprycki, Sylvia S. (ed.)
1998: *Iroquois Art. Visual Expressions of Contemporary Native American Artists.* ERNAS Monographs 1. Altenstadt: Christian F. Feest.

Kasprycki, Sylvia S., and Doris I. Stambrau
2003: *Lebenswelten – Kunsträume. Zeitgenössische irokesische Kunst.* Frankfurt/Main: Museum der Weltkulturen.

Kasten, Erich
1990: *Maskentänze der Kwakiutl. Tradition und Wandel in einem indianischen Dorf.* Berlin: Museum für Völkerkunde.

Keller, Ilse E.
1982: *R. C. Gorman – der Stolz des Navajo-Stammes.* Amedian 6/82, 7–9.

Kidwell, Clara Sue, and Alan Velie
2005: *Native American Studies.* Lincoln: University of Nebraska Press.

König, Viola
1992: *Indianische Graphik aus Alaska in der Völkerkunde-Abteilung des Niedersächsischen Landesmuseums Hannover.* Hannover: Niedersächsisches Landesmuseum.

König, Viola (ed.)
2003: *Ethnologisches Museum Berlin.* Prestel Museumsführer. Munich: Prestel.

Kunze, Albert (ed.)
1988: *Hopi und Kachina. Indianische Kultur im Wandel.* Munich: Trickster Verlag.

LaPena, Frank, Craig Bates, and Steven Medley
1981: *Legends of the Yosemite Miwok.* Illustrated by Harry Fonseca. Yosemite National Park: Yosemite Association (second edition 1993).

LaPena, Frank
2004: *Dream Songs and Ceremony. Reflections on Traditional California Indian Dance.* Berkeley: Heyday Books.

Larink, Walter, and Ralf Streum
1995: *Raubwal und Sonnenfinder. Zeitgenössische Kunst der kanadischen Nordwestküste.* Marburg: Universitätsbibliothek.

Leuthold, Steven M.
2011: *Cross-Cultural Issues in Art. Frames for Understanding.* New York: Routledge.

Libhart, Myles
1972: *Contemporary Southern Plains Indian Painting.* Anadarko: Oklahoma Indian Arts and Crafts Cooperative.

Lindner, Markus
2011: *"We All Have to Pay Bills." Zeitgenössische Sioux-Künstler und der Markt.* Paideuma 57, 135–159.

Lowe, Truman T.
2004: *Native Modernism. The Art of George Morrison and Allan Houser.* Washington und New York: National Museum of the American Indian.

MacDonald, George et al.
1977: *Northwest Coast Indian Artists Guild.* 1977 Graphics Collection. Ottawa: Canadian Indian Marketing Services.

MacNair, Peter, and Tony Hunt
1994: *Life of the Copper. A Commonwealth of Tribal Nations.* Victoria: Alcheringa Gallery.

McLuhan, Elizabeth, and Tom Hill
1984: *Norval Morrisseau and the Emergence of the Image Makers.* Toronto: Art Gallery of Ontario.

Monthan, Doris
1978: *R. C. Gorman. The Lithographs.* Flagstaff: Northland Press.

Monthan, Guy, and Doris Monthan
1975: *Art and Indian Individualists. The Art of Seventeen Contemporary Southwestern Artists and Craftsmen.* Flagstaff: Northland Press.

Native American Rights Fund
2007: *Visions for the Future. A Celebration of Young Native American Artists.* Golden: Fulcrum Publishing.

Nauman, H. Jane
1990: *Vision of Hope. A Traveling Sioux Art Show in Commemoration of the 100th Anniversary of the Wounded Knee Massacre.* Chamberlain: Akta Lakota Museum, St. Joseph Indian School.

New, Lloyd Kiva
1974: *The Institute of American Indian Arts Alumni Exhibition.* Fort Worth: Amon Carter Museum of Western Art.

Parezo, Nancy J.
1983: *Navajo Sandpainting. From Religious Act to Commercial Art.* Tucson: University of Arizona Press.

Pearlstone, Zena
2001: *Katsina. Commodified and Appropriated Images of Hopi Supernaturals.* Los Angeles: Fowler Museum of Cultural History.

Peiper-Riegraf, Dorothee
1989: *Zeitgenössische indianische Kunst II.* Frankfurt/Main: Galerie Peiper-Riegraf.

Petersen, Karen Daniels
1971: *Plains Indian Art from Fort Marion.* Norman: University of Oklahoma Press.

Phillips, Ruth B.
1988: *"'Botschaften aus der Vergangenheit'. Mündliche Überlieferungen und zeitgenössische Kunst der Woodland-Indianer."* In: Gerhard Hoffmann (ed.), *Im Schatten der Sonne. Zeitgenössische Kunst der Indianer und Eskimos in Kanada.* Stuttgart: Edition Cantz, 161–172.

Podedworny, Carol
2001: "Rick Bartow: Transforming Images." In: W. Jackson Rushing, *After the Storm*. The Eiteljorg Fellowship for Native American Fine Art, 2001. Indianapolis: Eiteljorg Museum of American Indians and Western Art, 16–31.

Rader, Dean
2011: *Engaged Resistance. American Indian Art, Literature, and Film. From Alcatraz to the NMAI*. Austin: University of Texas Press.

Rochard, Patricia (ed.)
1993: *Indianer Nordamerikas – Kunst und Mythos. Internationale Tage Ingelheim*. Mainz: Hermann Schmidt.

Rousselot, Jean-Loup, Dietmar Müller, and Walter Larink
2004: *Totempfahl und Potlatch. Die Indianer der kanadischen Nordpazifik-Küste*. Oettingen: Residenzschloss, Zweigmuseum des Staatlichen Museums für Völkerkunde München.

Rushing, W. Jackson
2004: *Allan Houser, an American Master (Chiricahua Apache, 1914–1994)*. New York: Harry N. Abrams.

Sanchez, Joseph M.
2005: *Bob Haozous – Indigenous Dialogue*. Santa Fe: Institute of American Indian Arts Museum.

Schulze-Thulin, Axel
1973: *Indianische Malerei in Nordamerika*. Stuttgart: Linden-Museum.
1981: "Neuere Entwicklungen in der panindianischen Malerei der USA." *Tribus* 30, 241–253.

Seymour, Tryntje Van Ness
1988: *When the Rainbow Touches Down. The Artists and Stories Behind the Apache, Navajo, Rio Grande Pueblo and Hopi Paintings in the William and Leslie Van Ness Denman Collection*. Phoenix: The Heard Museum.

Silberman, Arthur
1978: *One Hundred Years of Native American Painting*. Oklahoma City: The Oklahoma Museum of Art.

Sims, Lowery Stokes
2008: *Fritz Scholder: Indian/Not Indian*. Munich: Prestel.

Stewart, Kathryn
1988: *Portfolio II. Eleven American Indian Artists*. San Francisco: American Indian Contemporary Arts.

Streum, Ralf
1993: *Der Rabe brachte die Sonne. Moderne Kunst der Indianer Nordwestamerikas*. Munich: Trickster Verlag.

Tanner, Clara Lee
1973: *Southwest Indian Painting. A Changing Art*. Tucson: University of Arizona Press.

Taylor, Joshua C., et al.
1982: *Fritz Scholder*. New York: Rizzoli.

Thom, Ian M.
1993: *Robert Davidson: Eagle of the Dawn*. Vancouver: Vancouver Art Gallery.

Townsend-Gault, Charlotte
1995: *Lawrence Paul Yuxweluptun. Born to Live and Die on Your Colonialist Reservations*. Vancouver: Morris and Helen Belkin Art Gallery, University of British Columbia.

Wade, Edwin L.
1981: "The Ethnic Art Market and the Dilemma of Innovative Indian Artists." In: Edwin L. Wade and Rennard Strickland, *Magic Images. Contemporary Native American Art*. Tulsa: Philbrook Art Center, 9–17.

Wade, Edwin L. (ed.)
1986: *The Arts of the North American Indian: Native Traditions in Transition*. New York: Hudson Hills Press.

Wade, Edwin L., and Rennard Strickland
1981: *Magic Images. Contemporary Native American Art*. Tulsa: Philbrook Art Center.

Walsh, Andrea N., et al.
2007: *Transporters. Contemporary Salish Art*. Victoria: Art Gallery of Greater Victoria.

Walsh, Andrea N.
2008: *lessLIE: Cunei Form-Line*. Victoria: Alcheringa Gallery.

Warner, John Anson
1994: "Paradigms of Twentieth Century Native American Painting: A Conceptual Framework." *The Journal of Intercultural Studies* 21, 36–80.
1995: "Northwest Coast Indian Art in Osaka, Japan: A Contextual Analysis." *The Journal of Intercultural Studies* 22, 42–122.
1996a: "Contemporary Canadian Native Art: Newly Emerging Art Styles." *Journal of Inquiry and Research* 63, 639–666.
1996b: "Native American Painting in Oklahoma: Continuity and Change." *The Journal of Intercultural Studies* 23, 14–129.
1997: "Contemporary Native American Arts: Traditionalism and Modernism." *The Journal of Intercultural Studies* 24, 20–101.

Watson, Petra
2003: *Colour Zone. Lawrence Paul Yuxweluptun*. Winnipeg: Plug In Editions.
2010: *Lawrence Paul Yuxweluptun. Neo-Native Drawings and Other Works*. Vancouver: Contemporary Art Gallery.

Wellmann, Klaus F.
1976: *Muzzinabikon. Indianische Felsbilder Nordamerikas aus fünf Jahrtausenden.* Graz: Akademische Druck- und Verlagsanstalt.
1979: *A Survey of North American Rock Art.* Graz: Akademische Druck- und Verlagsanstalt.

Wood, Morgan
2005: *Daphne Odjig. Four Decades of Prints.* Kamloops: Kamloops Art Gallery.

Wooley, David (ed.)
1991: *Restless Native: David Bradley.* Moorhead: Plains Art Museum.

Wyatt, Gary (ed.)
2000: *Susan Point, Coast Salish Artist.* Vancouver: Douglas and McIntyre.

Wyckoff, Lydia L. (ed.)
1996: *Visions and Voices. Native American Painting from the Philbrook Museum of Art.* Tulsa: Philbrook Museum of Art.

Zacharias, Thomas
1995: *Fritz Scholder: Rot – Red.* Munich: Nazraeli Press.

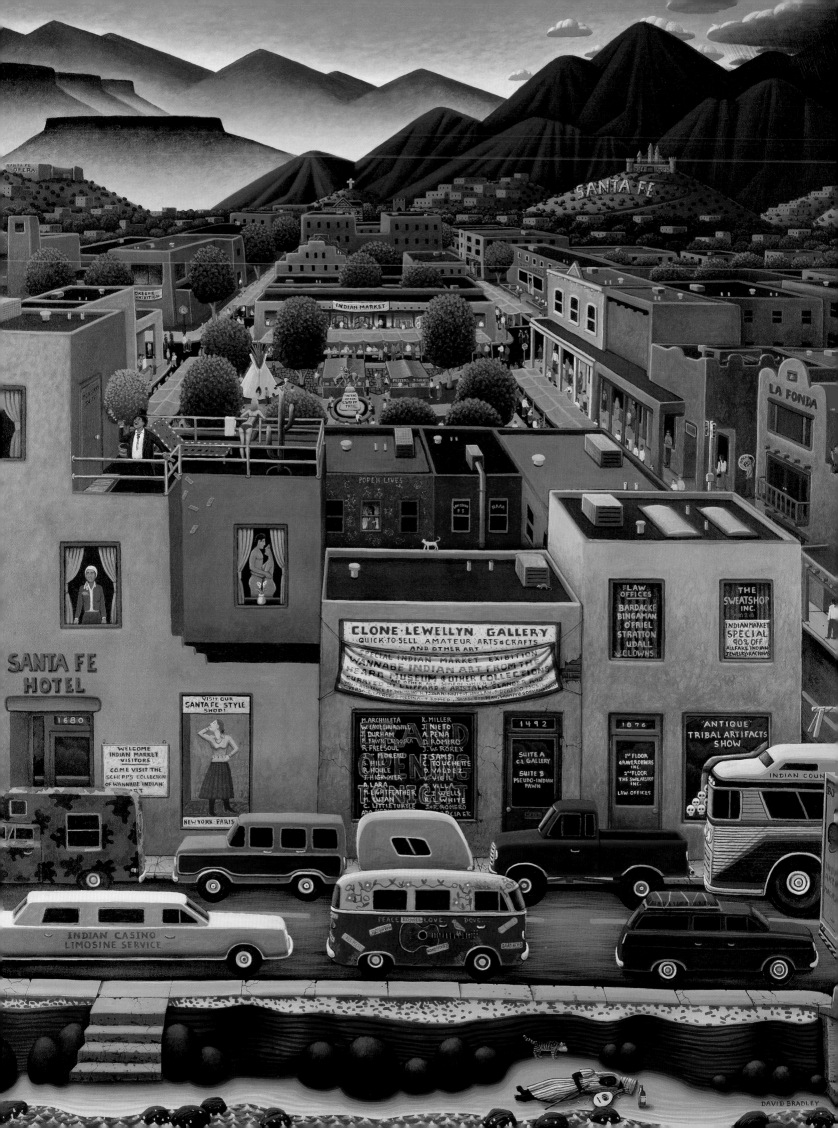

Viola König

NATIVE AMERICAN MODERNISM
North American Perspectives –
Voices, Positions and Statements by Art Historians,
Critics, Curators – and Artists

Introduction

In the following compilation, which is a collage of various original statements, opinions, perspectives and voices, American and Canadian artists and scholars give their opinions in their own words. I do not share all views that are expressed. This contribution is, for all intents and purposes, a 'test-run' of the concept to be realized in the Humboldt-Forum.[1] As curators of the collections, we believe that it is part of our mission to organize future exhibitions in cooperation with external curators – for example, Native American artists –, to consult them with regard to the selection of objects and their manner of presentation, or to put them in charge of exhibitions and publications. In the case of the present inventory catalogue, it is unnecessary to make choices. The description of the artworks confines itself to the basic data. We leave it to the specialists from various scholarly disciplines to interpret and assess them. The future will show which of the works will attract the attention of art historians and, more importantly, which artists and works will be of lasting importance within their own, Native American, society – still sometimes called "source community" – and have an impact on their successors.

As there is by now a vast bulk of literature on North American indigenous art, I had to make decisions with regard to the selection of quotes. I thus limit myself to the presentation of more recent quotes that have appeared in print after 2000, with a particular – yet not exclusive – emphasis on the voices of Native American intellectuals.[2]

Ethnicity, Cultural Self-Determination, Legal Framework

Most 20th century Native American artists are neither of purely Native American descent, nor do their ancestors all belong to the same ethnic group. The artists themselves decide about their cultural affiliation at various points in the course of their lives. This will sometimes result in measures that cause some bewilderment in Germany in view of the racist ideology of National Socialism and its terrible impacts that are still vividly remembered. As a consequence of centuries of oppression of Native American self-determination, however, the implementation of current legislation – supposedly meant to protect Native Americans – has some bizarre offshoots. This includes providing proof one's Indian ancestry by means of DNA tests, a procedure that can entail special rights and benefits for people who enroll themselves as tribal members.[3] On the local level, such as in Alaska, the Native American lobby has gained in power and now exerts considerable influence not only on governmental decisions, but also on the interpretation of legal regulations such as the "Native American Graves Protection and Repatriation Act" (NAGPRA). Particularly in Canada there has been a significant increase in Native American/First Nations political influence. Cree artist Alfred Young Man (who holds a PhD degree) reports:

"When the government wants to do something and Native people as a whole don't agree, they will raise their voice and their voice will be listened to [...] For instance, they were trying to several years back to pass a new Constitution. And because it didn't sit well with Native people, one Native person brought the whole thing down, Elijah Harper" (*A Time of Visions*, Interviews by Larry Abbott, http://www.britesites.com/native_artist_interviews/aman.htm. Accessed on Feb. 4, 2012.).

However, such measures can have disastrous effects on Native American artists if they are either unable to provide proof of their Native descent or give priority to gaining recognition as artists whose cultural self-definition is positioned in a globalized world, rather than emphasizing their Native descent. Ethnic affiliation has been a complex matter ever since the beginning of the era of Native American Modernism, and continues to be complex today; there have been some extreme examples, ranging from the production of Indian art by non-Natives to the creation of works by Native American artists whom critics deemed not sufficiently "Indian."

A recent example is the case of Jimmy Durham, an internationally renowned artist born in 1940. He could not provide proof of his status as a Cherokee Indian, and was thus officially denied membership in one of the federally recognized tribes with reference to the "Indian Arts and Crafts Act" passed in 1990. As an artist and writer, Durham has been a wanderer between the worlds since that time, moving back and forth between continents and countries, including Germany where he is well-known. We may hypothesize what would have happened if he had been able to keep his Native American status. Maybe he would never have become that famous as a recognized Native artist, and would never have had the opportunity to live up to his full potential as a visual artist and writer. Durham himself comments:

"Once you address the 'artworld' you look to do it with the most 'universal' way possible. [...] your background is there and there are exclusionary rules. Still, one shouldn't take comfort in it, enjoying being a victim. One should have as much of a dialogue with as much of the society as is possible" (quoted after MacMaster, Gerald, "Towards an Aboriginal Art History" in: W. Jackson Rushing III (ed.), *Native American Art.* London/New York 1999: 86).

Gerald MacMaster himself employs irony and humor in confronting the problems of ethnic categorization: *"Hello my name is Gerald Raymond (Christian names) McMaster (surname). My Indian name is Gerald McMaster [...] For convenience of the Indian Affairs Identification Program, I am Blackfoot, though I was raised on my mother's Reserve (the Red Pheasant First Nation); she and my biological father were also Plains Cree. My biological status, therefore, is 'full blood' Cree, but that could be questionable; however, my body does remain full of blood. I've been an urban Indian since the age of nine. I've attended art school in the United States, trained in the Western tradition; yet I am referred to as an 'Indian' artist. I have danced and sung in the traditional powwow style of Northern Plains, yet my musical tastes are global [...]"* (Gerald MacMaster, *"niya nehiyaw: Crossfires of Identity"* (Agnes Etherington Art Centre/Queen's University, Kingston, Ontario 1993, unp. in *A Time of Visions.* Interviews by Larry Abbott, http://britesites.com/native_artist_interviews/gmcmaster.htm. Accessed on Feb. 4, 2012.).

Kiowa writer and Pulitzer-Prize winner N. Scott Momaday once told of the following incident: *"In 1993, Allan Houser and I, along with others, were awarded the Elis Island Congressional Medal of Honor. A few weeks before the event I had received a letter informing me of my nomination. I imagine that Allan received the very same letter. If I should accept, the letter read, I would be flown to New York, ferried to Ellis Island, and honored at a black-tie gala. The letter went on to say that if I should care to avail myself of the computers there, I could determine precisely when my ancestors had reached the shores of America. I doubted it, and it crossed my mind that I might have been nominated by mistake, but I accepted the award. I was greatly pleased to find Allan at the ceremony. We were a camp within a camp. The first thing he said to me was, 'Your father would have been proud of you,' then, 'Have you been to the computers?' And he tipped me a wink"* (Momaday, Scott N., "The Testament of Allan Houser" in: Truman T. Lowe (ed.), *Native Modernism. The Art of George Morrison and Allan Houser.* Seattle and London 2004/2005: 75).

While progress has doubtlessly been made with regard to the issue of self-assertiveness, we need to keep in mind that the current situation of the Native Americans is the result of a situation of cultural oppression. This is addressed by David W. Penney in his monograph *North American Indian Art*: *"The creation of a 'Native American' identity was forced historically by the circumstances of North America's conquest. It is now common to speak of Native American culture, Native American art, or even a Native American perception of the world. My point is that this very human construct stems from a long and difficult history.*

And the implications of this history need some clarification because not everybody means the same thing
when they speak of things 'Native American.'
The modern nations of the United States and Canada have invested a great deal of their cultural identities in
the concept of 'Native Americans' [...]
So who are Native Americans? Ultimately, the identity of Native Americans stems from countless local cultures
that, historically, have found themselves and their descendants bound together in the situation of contending
with the consequences of conquest and colonial repression [...]
The encounter and its historical consequences established the framework of difference on such a broad scale.
The entire enterprise of cross-cultural reflection, us looking at them looking back at us, stems from a long his-
tory of such encounters and their consequences" (Penney, David W., *North American Indian Art*. New York
2004: 13, 14).

As soon as the question of ethnic identity is settled, another question poses itself: is it mandatory for Na-
tive American art, including its contemporary manifestations, to establish a relationship with the past,
that is, with Native American history?
"Some Native Americans today criticize museum exhibits, popular media, and books like this one, because they
often situate American Indian culture in a historical past, as if there is no Native American culture today. This
failure to frame the past from the standpoint of the present is particularly unfortunate when considering Na-
tive American arts, since indigenous artists have always been, and still are now, among those who most ac-
tively reconcile the traditions of the past with the circumstances of the present. Art is, and has been, one of the
principal strategies of Native American 'survivance,' to use writer Gerald Vizenor's term. While the word 'sur-
vival' summons up images of last-gasp tenacity, the term 'survivance' refers more to the wisdom of memory
and adaptability, and the strategies of resistance, accommodation, and transformation. Histories of survivance
connect the present with the past, linking the experiences of the aforementioned artists active today with those
of countless forebears, the generations of Native American artists whose creations are the subject of this book"
(Penney 2004: 10).

Truman H. Lowe, a Ho-Chunk curator and writer, unconditionally agrees with Penney:
"[...] it is necessary to consider the history of Native American art in the early twentieth century, for its contours
do not conform to those delineated in histories of Euro-American art. In fact, the history of Native American art
is more closely intertwined with the broader, changing history of United States federal policies toward Ameri-
can Indians. In the early twentieth century, policies of forced assimilation prevailed. Children, sent to boarding
schools, were separated from their families and communities and trained in the dominant culture's lifestyles in
an effort to obliterate Native difference, including indigenous artistic expression. Then, under pressure from
popular reform movements in the 1920s and '30s, the government reversed course. Federal policy was officially

redirected in 1933. The appointment of John Collier as Commissioner of Indian Affairs in that year was viewed as the beginning of a new era for Indians [...]

Though they lagged slightly behind a handful of unofficial educational experiments, these new policies corresponded with the efforts of patrons and teachers who already actively encouraged Indian creativity" (Lowe, Truman T. "The Emergence of Native Modernism" in: Truman T. Lowe (ed.), *Native Modernism. The Art of George Morrison and Allan Houser.* Seattle and London 2004/2005: 12).

In the exhibition *Native American Modernism. Art from North America* we have intentionally abstained from including "old" works, because historical references are already omnipresent in the permanent exhibition of Native American ethnography.

The question of whether importance ought to be attached to the ethnic affiliation of Native artists is answered in the negative by Richard West Jr., who is a member of the Cheyenne nation and founding director of the National Museum of the American Indian in Washington, D.C. According to him, the issue of ethnic affiliation has become irrelevant due to the radical changes of Modernism that have taken place in the 20th century. As examples he cites George Morrison and Allan Houser, two early representatives of Native American modern art:

"Morrison and Houser were very different, but the energy and sheer exuberance of twentieth-century Modernism is everywhere evident in their work – from Morrison's stately and stirring abstractions to the dramatic and wondrous life so tangibly salient in Houser's sculptures. But they hold our attention for another reason as well: they were Indians, and every inch so.

The English visionary William Blake wrote, 'Without Contraries is no progression,' and we must bring something of the spirit of that remark to our appreciation of Morrison and Houser. Neither wanted to be marginalized as an 'Indian artist.' Each felt fully equipped to take his rightful place among the leading artists of the day, without any confining labels. I believe they were absolutely right to feel this way. Now for the slightly contradictory part: they are, indeed, Indian artists. You can see it and sense it in the extraordinary pieces they produced. It informs the subject matter, attitude, media, and aesthetic vision characteristic of their work. I hope and believe that [...] we can now come to a conclusion that once might have seemed contradictory: it is clearly possible, as Morrison and Houser demonstrate, to be a major American artist and Indian artist at the same time" (West, Richard W. Jr., "The Art of Contradiction" in: Truman T. Lowe (ed.), *Native Modernism. The Art of George Morrison and Allan Houser.* Seattle and London 2004/2005: 8).[4]

Cree writer Alfred Young Man addresses this issue in a more casual manner:

"Everybody is just a link in the chain of time. That's all. Were Indian people who lived at Columbus' time more Indian than the Indians of the generation before me? This idea that you're more Indian than someone else just

Fig. 73 Harry Fonseca, Nisenan Maidu, *Coyote – Cigarstore Indian*,
1985. Hartje Collection, 1989. Acrylic on canvas, height 121 cm, width
81 cm. Ethnologisches Museum Berlin, Inv. No. IV B 13118.

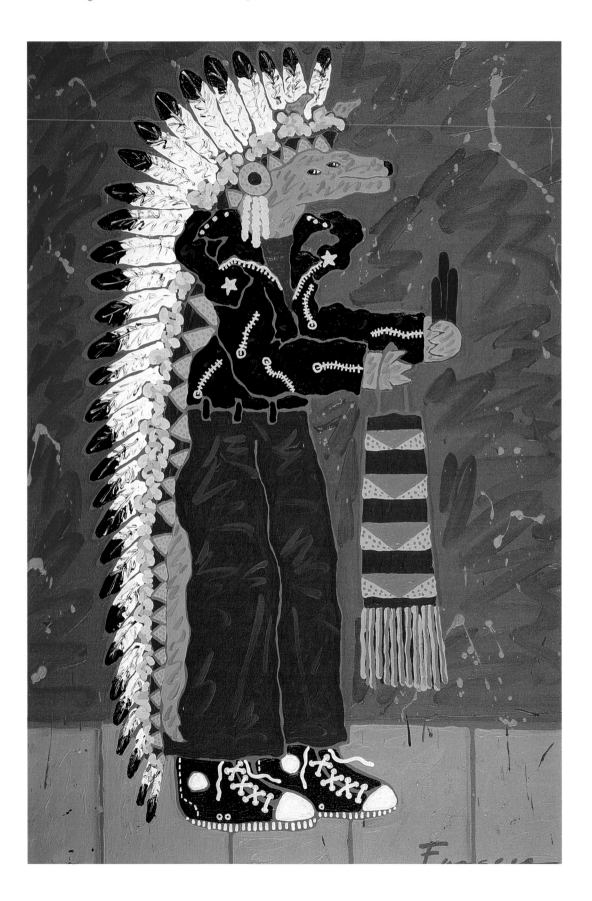

Fig. 74 Harry Fonseca, Nisenan Maidu, *Rose*, 1985. Hartje Collection, 1989. Acrylic on canvas, height 121 cm, width 81 cm. Ethnologisches Museum Berlin, Inv. No. IV B 13119.

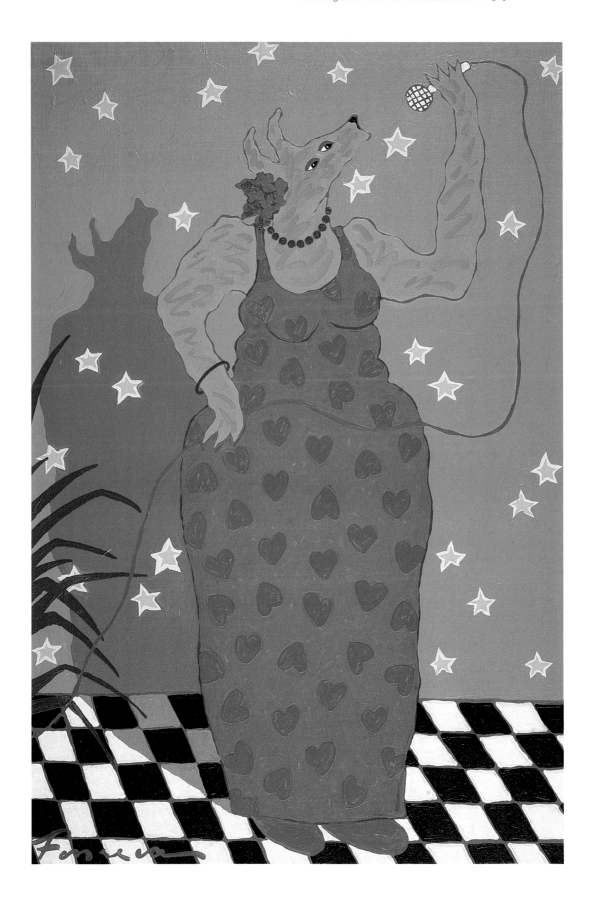

doesn't make any sense to me at all. We're all products of our own time. My children after me will be Indians in their own time in the way they find themselves. We're undergoing change all the time. The idea that there's an ethnographic-present Indian out there is a myth. There never has been and the people who are looking for one are looking for pie in the sky. I see Native people all the time and they never seem to fit those stereotypes at all, at least not from my point of view. I don't believe in the idea that I should somehow be the same type of Indian as, say, Sitting Bull in order to be an Indian. That's not the issue. Sitting Bull was a great man in his time and that time is gone now. The buffalo were there then but they're not here any more. We're finding and recreating our world the way we want it to be. That's what we're here for and that's what I'm here for.

Hey, things change. Time moves on. We need to get on with life. We can't spend our whole life looking for imag-inary Indians who aren't there any more." (*A Time of Visions*. Interviews by Larry Abbott, http://www.brite-sites.com/native_artist_interviews/aman.htm. Accessed on Feb. 4. 2012.).

Carl Beam (Ojibwa) briefly comments on his status as follows:

"I don't need the tribal bonds. I'm not saying the tribal rituals aren't useful. They are. They help people to be-long to an alienated world. There are so many forces that want a piece of your soul. But a tribal culture is only a temporary resting place" (Townsend-Gault, Charlotte, "Hot Dogs, a Ball Gown, Adobe, and Words. The Modes and Material of Identity" in: W. Jackson Rushing III (ed.), *Native American Art*. London/New York 1999: 128).

Fig. 75 George Longfish, Seneca-Tuscarora, *Everything is the Same Size Shuffles Off to Buffalo With the Three Sisters*, 1984. Seybold Collection, 2010.
Acrylic on tent canvas, height 151 cm, width 208 cm.
Ethnologisches Museum Berlin, Inv. No. IV B 13226.

Native American Involvement in World War II, and its Impact on the Postwar Period

In the biographies of Native American artists born prior to 1940, we find only few instances where they did not participate in World War II, be it in a direct or indirect way. With regard to the acceptance of Native Americans as "ordinary" citizens of the United States, their active involvement in that war generated a breakthrough.

The Prewar Period

In his introduction to a poem he wrote about the Indian cradleboard, Native American Pulitzer Prize winner M. Scott Momaday (Kiowa) once described the prewar situation, the time when early representatives of Native Modernism were born and went through childhood:

"Like most, nearly all, Indians of his generation he was born into poverty, a poverty not only of material aspect, but a poverty of morale [...]

American Indians in the early twentieth century were virtual prisoners of war. In 1900, the death rate among Indians exceeded the birth rate. In a very short time, scarcely more than a decade, the Plains Indians had lost their freedom, their economy, their religion, and, very nearly, their spirit. They were a defeated people, severely wounded in their hearts and minds [...]

I imagine that Allan and my father were placed in Indian cradles after birth. And I imagine that the cradles were beautiful and unique works of art, made with great care and infinite love. I have come to think of the Indian cradle as a relic of recovery, a symbol of simple survival, an ancient faith in the continuity of generations.

In the latter part of the nineteenth century, when the old way of life and hope itself were lost, the old women, the grandmothers, began to make cradles. They made them for children yet unborn. They invested their souls in the making of the cradles. They were gifts to those, beyond their own time, who would live or die, who would bear and determine the future, who would restore their world, if their world could be restored" (Momaday in Truman T. Lowe (ed.), 2004/2005: 75).

Chippewa artist George Morisson recalls: *"As I look back on my childhood, it was a time of transition. Indians had lost the best of the old world and could not fully cope with the new one. White civilization was encroaching on our lives. We attended white schools and were taught to imitate white people's ways. Our old mystical rites were no longer performed because they conflicted with church teachings. Our people viewed the church, I think, as a substitute of what they'd lost"* (quoted from Anthes, Bill, *Native Moderns. American Indian Painting 1940–1960*. Durham/London 2006: 103).

Prior to the war, the Native Americans on the reservations and those in the Pueblos of the Southwest lived completely isolated from the rest of U.S. society. This situation changed abruptly due to World War II.

Native Americans in World War II

"It is estimated that more than 12,000 American Indians served in the United States military in World War I [...] The outbreak of World War II brought American Indian warriors back to the battlefield in defense of their home-land. Although now eligible for the draft by virtue of the Snyder Act, which gave citizenship to American Indians in 1924, conscription alone does not account for the disproportionate number of Indians who joined the armed services. More than 44,000 American Indians, out of a total Native American population of less than 350,000, served with distinction between 1941 and 1945 in both European and Pacific theaters of war. Native American men and women on the home front also showed an intense desire to serve their country, and were an integral part of the war effort. More than 40,000 Indian people left their reservations to work in ordnance de-pots, factories, and other war industries. American Indians also invested more than $50 million in war bonds, and contributed generously to the Red Cross and the Army and Navy Relief societies.

Battle-experienced American Indian troops from World War II were joined by newly recruited Native Americans to fight Communist aggression during the Korean conflict. The Native American's strong sense of patriotism and courage emerged once again during the Vietnam era. More than 42,000 Native Americans, more than 90 percent of them volunteers, fought in Vietnam. Native American contributions in United States military combat continued in the 1980s and 1990s as they saw duty in Grenada, Panama, Somalia, and the Persian Gulf

[...] As the 20th century comes to a close, there are nearly 190,000 Native American military veterans. It is well recognized that, historically, Native Americans have the highest record of service per capita when compared to other ethnic groups. The reasons behind this disproportionate contribution are complex and deeply rooted in traditional American Indian culture. In many respects, Native Americans are no different from others who vol-unteer for military service. They do, however, have distinctive cultural values which drive them to serve their country. One such value is their proud warrior tradition.

In part, the warrior tradition is a willingness to engage the enemy in battle. This characteristic has been clearly demonstrated by the courageous deeds of Native Americans in combat. However, the warrior tradition is best exem-plified by the following qualities said to be inherent to most if not all Native American societies: strength, honor, pride, devotion, and wisdom. These qualities make a perfect fit with military tradition" (quoted from: Naval History & Tradition. Native Americans and the U.S. Military. http://www.history.navy.mil. Accessed on Feb. 4, 2012.).

If we consider the situation of Native Americans on the reservations, however, and the poverty, hardships, discrimination and social marginalization they suffered, we reach a different conclusion in regard to Native American participation in the 20th century U.S. wars than that given in the above quote. By joining the armed forces and fighting in America's wars, they earned a living and could climb up the social ladder. Nevertheless, this was by no means unproblematic because:

Fig. 76 George Longfish, Seneca-Tuscarora: *Ralph Lauren's Polo*
War Shirt, 1988/89. Nuzinger Collection, 1994.
Acrylic and mixed media on cardboard,
height 38 cm, width 102 cm.
Ethnologisches Museum Berlin, Inv. No. IV B 13130.

"On the eve of the entry of the United States into the Second World War, Native American culture and identity were called upon to play a central role in a new pluralist self-imagining. However, Americanism – and especially the unity demanded as the nation geared up for war – could not tolerate Indian political autonomy and sovereignty" (Anthes 2006: 21).

Since that time, Native Americans were deemed fit to be full-fledged members of U.S. society with equal rights – provided, however, that they relinquished their special political status, that is, their partial sovereignty within the United States. Their identity as Indians was supposed to be expressed in cultural terms only. This attitude did not meet with unanimous approval on the part of the Native Americans. The postwar period was thus marked by Native American activism and at times militant protest, as they called on the U.S. government to abide by the old treaties and to preserve the rights granted Native Americans – such as the use of reservation lands.

The Second Relocation, Pan-Indianism, and Militant Native American Movements

In the 1950s, a new government program once again resulted in far-reaching changes in American Indian life:
"In the 1950s, the federal policies instated in the 1930s regarding Native Americans were once again reversed. The government initiated programs to relocate Indians from reservations to urban centers, and to terminate tribal status. The implementation of these policies spawned a grassroots movement that united American Indians across tribal affiliation and across the nation over a period that coincided roughly with the wider Civil Rights movement" (Lowe in: Truman T. Lowe (ed.) 2004/2005: 18).

What was the agenda underlying these measures? Bill Anthes explains:
"The notion of Indian Removal was based on the idea that the best way to protect Native Americans was to segregate them from whites. Postwar Relocation had the similar effect of displacing Indians, but for altogether separate reasons. In keeping with the language of inclusion and civil rights, federal officials described Reloca-

tion with many of the same euphemisms used to justify termination: withdrawal, readjustment, assimilation, liberation and desegregation" (Anthes 2006: 27).

The integration of Native Americans into American society failed, however, many of them, along with African Americans and Puerto Ricans, lived in poor conditions in urban enclaves. This gave rise to the Pan-Indian movement, and the 1960s and 1970s witnessed the formation of militant Native movements, particularly the American Indian Movement (AIM) which was founded in Minneapolis in 1968. For the first time in the history of the North American Indians there was a Pan-Indian sense of solidarity that overcame tribal barriers. People identified first and foremost as Native Americans and only in the second place as members of a specific ethnic group. The development of Native American art was undergoing changes as well, and the "traditional style" that had been propagated by white patrons in prewar times came to be viewed as outdated. Specifically addressing younger artists, Navajo artist R.C. Gorman stated:
"Traditional painting is a bore if that's what one becomes stuck with. It becomes meaningless after a while. Stale. Overstated. Pretty. Glimmicky. Dumb. Lazy. I say, and I'm speaking to young artists, leave traditional Indian painting to those who brought it to full blossom" (quoted after Anthes 2006: 29).

Other well-known artists, such as George Morrison, Patrick DesJarlait and Allan Houser did not view themselves as political activists. As N. Scott Momaday expressed it:
"Allan Houser was an American Indian. His spirit was that of a people, and it informed his whole being. He was not a political man; he was not a spokesman for the Indian; he was the Indian" (Momaday in: Truman T. Lowe (ed.) 2004/2005: 69).

Being teachers, these artists became nevertheless involved in the political events of that time, that is the 1970s struggle for rights and self-determination.

Native American Art and North American Primitivism in Postwar America

Due to the exodus of European artists to the U.S. (particularly to New York) since the 1930s, North America became exposed to Primitivism. This encounter spawned a distinct local development that left its mark on Native American art as well.

"Primitivism has been central to the cultural history of twentieth-century culture [...]

While the primal scenes of modernist Primitivism date to the turn of the century in the Parisian studios of Picasso, Henri Matisse, and Maurice de Vlaminck are focused on artifacts from Africa and the South Pacific, a distinctly American modernist Primitivism – focused on Native American Art and culture – thrived in the United States [...]

In laying claim to an indigenous, Native American tradition, Primitivism served as a powerful platform for American artists seeking to differentiate their work from their European contemporaries" (Anthes 2006: 61).

Where exactly did Native American art position itself within that postwar American Primitivism scene? Was there really a dialogue among equals? Bill Anthes uses the term "third space," which has been introduced by Homi Bhaba, to describe the ambivalence of the situation:

"To be sure, the Native American artworks that were brought into the horizon of American modernism defined Primitivism as a cultural dialogue, even if the terms were unequal. Thus, although accusations of cultural appropriation carry some obvious moral authority, twentieth-century Primitivism should not be seen as merely an oppressive act of cultural theft [...]

This third space – resulting from the aesthetic blending of modernist and indigenous forms – was a cultural arena for the representation of cultural and spiritual practices that remained persecuted and repressed in the real social and political world where Indians and whites interacted. Such a space provided a platform from which Native and non-Native artists asserted the value of cultural difference. Primitivism thus enabled American artists to reconstruct a universal modernist culture while, conversely, it opened up an aesthetic space for Native artists to claim a modernist subjectivity. To be sure, however, the space opened by modernist Primitivism was modest and conflicted" (Anthes 2006: 87, 88).

Native American Art and the North American Art Market

North America is the world's largest stronghold of what may be called capitalism by conviction. Hence, one of the reasons why the production of Native American crafts – so-called "curios" – and, at a later time, Native American art was economically successful. From the very beginning they accommodated specific national demands of the white society's art market. World War II and its aftereffects also played a decisive role in this context. Objects of leather and fabric were made on the American East Coast at least as early as the time of contact with Europeans in the 17th century, and their decoration showed Native American as well as English, French, and Belgian influences. The manufacture of local crafts products, particularly small sculptures, was encouraged in the Russian colony that encompassed the American Northwest Coast, Alaska, and the Aleut Islands since the mid 18th century, and these objects were imported to Russia. Even at that early time Native American and Inuit carving showed European influence. The miniature carvings made of ivory are an example of this; as they were easily to transport, they were particularly popular and are found in large quantities in ethnographic museums today. In the 19th century, Northwest Coast arts and crafts boomed due to Anglo-American influence. At the beginning of the 20th century, the Southwest witnessed a tremendous increase in tourism that would have been unimaginable without the production of arts and crafts by Native Americans.

Prior to World War II there had been attempts to upgrade the status of Native American crafts or ethnologically interesting objects by declaring them works of art, yet this did not meet with any lasting success. After the war Native American veterans did not necessarily return to their old life ways on the reservations. They had received training in various trades, technical professions and administration during military service, and consequently demanded the same career chances as white American citizens. This was fostered by the discovery of regional American art traditions in the postwar era, which in the 1950s came to include Native American art. The upgrade of the production of Native American crafts opened up new chances for many veterans who became both producers and dealers. The ensuing boom of the markets in the 1970s was also due to other reasons, as is explained by Bruce Bernstein with reference to the national context:

"An intense period of nationalism followed the United States' victory in World War II. And while the 1950s were reflexive, celebratory years dominated by the American dream, the 1960s began a turbulent era in which the American ideal of equality and representation for all Americans was severely tested through civil unrest and the Vietnam War.

One reaction to this disillusionment was the 1960s counterculture typified by the hippies who began searching for alternative modes of thought and living [...]

Many discovered the religions of American Indians and interpreted them in terms of a highly ecological consciousness [...]

Fig. 77 Jaune Quick-To-See Smith, Flathead-Cree-Shoshone, *Big Green*, 1992. Nuzinger Collection, 2003. Mixed media and collage on paper, height 106 cm, width 75 cm. Ethnologisches Museum Berlin, Inv. No. IV B 13161.

The intellectual and social climate in the United States was ripe for 'discovering' and embracing Indian cultures [...]

American Indians retained a semblance of their traditional lifestyles. American society looked to Indian cultures for a means of recapturing a genuine American Heritage" (Bernstein, Bruce, "The Indian Art World in the 1960s and 1970s" in: W. Jackson Rushing III (ed.), *Native American Art*. London/New York 1999: 59).

In the 1970s, Native American Art History became established as an academic discipline of its own, and was thus granted equal rank with the other traditions of world art (Rushing 1999: 58). A number of art museums in the U.S. began to organize exhibitions of Native American art, for example, the Whitney Museum New York in 1971. Besides "ancient" art – that is, prehistoric and historic works – art galleries now offered contemporary arts and crafts for sale.

Since the 1960s and 1970s, "Indians" have been captivating the imagination of many people in Europe as well, including the younger generations. This is particularly true for Germany due to the very popular Wild-West books by 19th century novelist Karl May. Books and movies about Native Americans thus found a ready market. Europeans, including the first long-distance air tourists, became prospective buyers of Native American crafts, particularly pottery, rugs, and silver and turquoise jewelry from the Southwest.

The *American Indian Art Magazine*, which was launched in 1973 and is still published today, is explicitly *not* intended as an ethnological journal (Bernstein 1999: 61). Be this as it may, it is likely that ethnological museums, and laypeople interested in Native American cultures, are the only subscribers to this magazine in Germany, because the *American Indian Art Magazine* does feature contributions by authors who have built up a reputation as anthropologists. Coverage focuses particularly on ethnological exhibitions, and even though the contributions do not treat the works of art as curios, the excessive, lavish advertisements of art galleries are quasi identical with those in the curio trade. The 37-year existence of the *American Indian Art Magazine* is likely owed to this editorial compromise.

The Definition of Native American Art, and the Concept of Art in North American Literature

The very broad concept of art applied by North American scholars and curators to Native American art is basically all-inclusive, comprising art, crafts, graphic works, and even tourist art provided it has aesthetic qualities. Of course, there exist varying opinions about this concept in North America; yet we need to accept the fact that in North America the output of Native American creative endeavors is referred to as art, in the broadest sense of the term.

As ethnologists and cultural anthropologists, we document and describe this phenomenon; as curators, we do not reject any Native artist who is recognized in North America nor do we refuse to buy his artwork for the museum just because European art historians turn up their noses at such art. We are only marginally interested in the question of whether this is accepted art according to international definitions. We are interested in why this art is recognized and accepted in North America; our main focus, however, is on the motivation of the Native artists and the various contexts of their work: on the one hand, their traditional roots; on the other, their participation in global art.[5] Cree artist and writer Alfred Young Man comments on this as follows:

"Following the Native perspective there is something called 'Native art.' Although 'Native art' might not be the best way to describe it, it is, nevertheless, the only way we can describe this thing. It's not so much in opposition as it just is. It's a given. People ask me what the Native perspective is. I respond this way: What is the Western perspective? Academics refer to Western man, Western history, Western society, but they've never bothered to really define it. If you were to ask what Western Society is, what a Western man is, what would be the answer? In fact, Jimmie Durham, the radical artist, went so far as to say there is no Western culture. And I think he's probably right. There's a power structure that is in place that tends to be considered Western culture. But you can't really define it. It's made up of a series of interlocking facets that go on and on. I see the Native perspective in the same fashion. You can't ultimately describe it because it comes out of a very long history and it's going into an infinite future. There's no way you can describe something that is still alive, that's still growing and viable. Most of the professionals that I know, Native professionals and others, disagree over how to describe Native art. So I don't bother myself too much with trying to define it or worry too much about whether or not it is in opposition to this or that. To me it's a sovereign idea, and so much the better" (A Time of Visions, Interviews by Larry Abbott, http://www.britesites.com/native_artist_interviews/aman.htm. Accessed on Feb. 4, 2012.).

"Art and Aesthetics" is the heading given by Penney to a chapter of his book where he explicitly advocates a broad, almost arbitrary concept of art which he places in a political context:

"Readers [...] may be unaccustomed to thinking of art as a 'strategy,' which implies a social and political intention. We may be more accustomed to regarding art as a personal expression of an artist's creativity. Some may be comfortable with the notion of art as a collective expression of a worldview, particularly when considering religious symbols or the ritual role of art in religious ceremony. The term 'art,' as it will be used here, encompasses all these things. The artistic object is created within a cultural system of aesthetics. There is no single

and universal system of aesthetics. There is no privileged standard for what can or cannot be called art, 'Art' is a word used to name certain kinds of things and its definition changes all the time. Aesthetic expression, on the other hand, seems to be a human universal. Human beings all over the world express values about what is good or bad, appropriate or inappropriate, beautiful or ugly, holy or profane, through a system of aesthetic valuation. Aesthetics shape the qualitative and ethical perceptions of social life. As such, aesthetics permeate the political, religious, and economic realms of every society.

Aesthetic systems are culture-bound. Cultural misunderstandings and conflict can stem from contesting aesthetic and ethical systems [...]

Aesthetic systems change. They are permeable and easily absorb new ideas, attitudes, and shifting valuations. They are not always internally consistent. They are at once reenacted and reinvented by individuals, who [...] are artists and their audiences. For example, attitudes about media and design can change easily. In the eighteenth century women of the Great Lakes region quickly understood the aesthetic opportunities offered by trade goods such as cotton cloth, silk ribbon, and glass beads. They adopted new techniques to use these kinds of materials when decorating formal clothing. More impervious to change were the underlying ideas that valued formal clothing and its display during public events as an expression of self-worth [...]

So at any particular time, aesthetic systems reach simultaneously back into the past and forward to the future. Some aspects of an aesthetic system respond to the topical and contemporary, others draw from the traditions of generations past. This perspective reveals to us the continuities and innovations visible in the many thousands of years of Native American art" (Penney 2004: 10, 11, 12).

The pathos used by Penney in an attempt to underscore his position may be exaggerated, but his attitude is doubtlessly consistent with that of many specialists in Native American art in North America.

Lawrence Abbot gives a more matter-of-fact description of that art in the introduction to his "Contemporary Native Art Bibliography":

"The art of twentieth century Native and First Nations peoples has been a visual record of both change and continuity. Although the 'look' of the art has obviously undergone transformations in imagery, and artists have availed themselves of newer materials and techniques, contemporary painters, sculptors, printmakers, carvers, photographers, filmmakers, and videographers maintain what is perhaps the central tradition, the 'tradition of creativity'. [...] Native visual arts, like Native cultures generally, have evolved through the course of the twentieth century. From paintings of daily life, to depictions of ceremonial events, to the visualizations of myth, to meditations on nature, to self-reflection, to political analyses; from figuration to abstraction, to installation and performance, the development of Native art is a record of tribal histories and communities filtered through the alembic of individual perception" (Abbott, Lawrence, "Contemporary Native Art: a Bibliography" in: *American Indian Quarterly*, Volume: 18. Issue: 3. 1994: 383).

Some problems may arise from the self-concept of individual artists; these problems are not a recent phenomenon, and relate to artists' willingness to have their works collected and exhibited by ethnological museums. However, no artist anywhere has ever been able to dictate the whereabouts of his works once he has let them out of his hands. He inevitably loses control over their temporary or permanent placement at some art museum, gallery, or private collection. Usually, he is not in a position to raise any objections to the context in which his works are exhibited. As a rule, Native American art still finds its way into some ethnological museums, where it shares the same fate as works by artists from Africa, Australia, or Oceania.[6]

In Bruce Bernstein's opinion it does not matter where Native American works of art are kept and presented:

"Regardless of the remarkable changes during this century, quality American Indian art does not change depending on whether its objects are displayed in an art gallery or anthropological exhibition. An object is as beautiful in the anthropology museum as in the art gallery. It remains a fallacy of the post-1970s period of American Indian art studies that objects in art galleries will be automatically transformed into art" (Bernstein in: W. Jackson Rushing III (ed.) 1999: 68).

Gerald MacMaster even cites the example of an artist – Edward Poitras (Metis) who, by the way, in 1995 was the first Native American ever to be represented in the Venice Biennial – who explicitly favors ethnological museums:

"The remarks and work of Edward Poitras frequently cross boundaries. When I asked how he felt about having his work collected by ethnographic museums, he replied: 'Having my works here, I feel at home with my ancestors. In the National Gallery, they would look out of place.' Not only was this statement a leap of faith at a time when artists were seeking approval from the mainstream, but it gave further endorsement to those more interested in tradition. He did not object to the notion that his work might be regarded as 'ethnographic' because it was in the museum, rather, he dismissed the arbitrariness of such categorization in the first place. He saw new meaning in his inclusion in the museum and exclusion from the National Gallery. Even though ethnographic museums are frequently attacked for containing remnants of salvaged cultures, he saw other connections. It was as though he were rejecting inclusion into the mainstream. (Incidentally, he was selected by the National Gallery in 1989 to take part in a national exhibition)" (MacMaster, Gerald, "Towards an Aboriginal Art History" in: W. Jackson Rushing III, (ed.), *Native American Art*. London/New York 1999: 89).

Penney does not only call for an inclusion of Native American art in North American reflections on art and culture (on the basis of his broad concept of Native American art), but also for consideration of the specific

Fig. 78 Rick Bartow, Yurok, *Give Away*, 1993.
Peiper-Riegraf Collection, 2008. Pastel, coal, and
graphite on paper, height 66 cm, width 101 cm.
Ethnologisches Museum Berlin, Inv. No. IV B 13170.

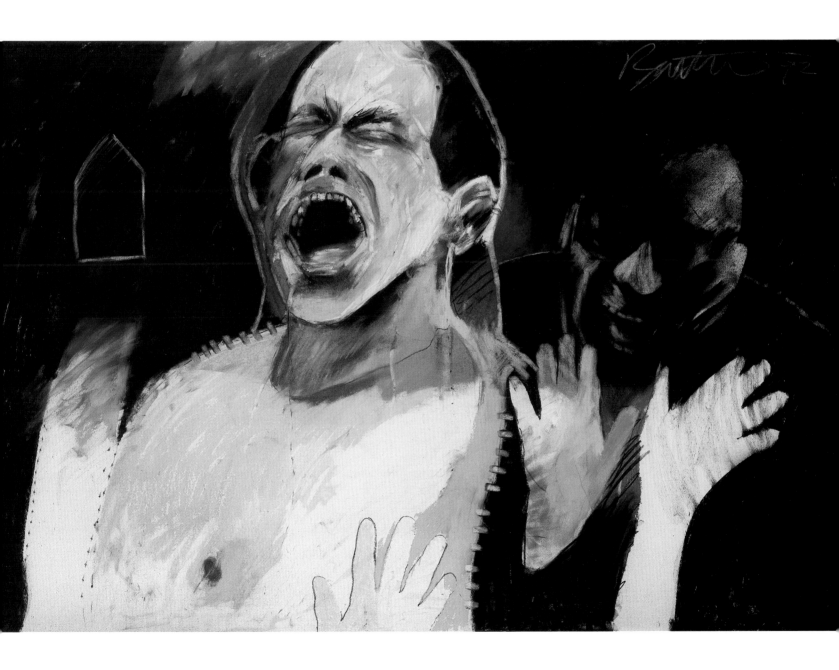

situation of Native Americans in North American society, and recognition of their potentials that arise from that situation:

"Native artists active at the beginning of the twenty-first century, working in a broad range of practices, have seized the apparatus of larger cultural discourse, the studio, the university, the gallery, the museum, and the verbal and written media that support them. But they are still represented primarily by museums specializing in Native American art. The larger histories of American art and American culture for the most part excludes them. The larger, far-from-resolved issues of cultural representation, sovereignty, land, and treaty rights persist with palpable consequences for Native people every day, yet they remain on the margins of a larger American consciousness at best. Of key importance […] is an understanding that these issues and the art of Native America yesterday, today, and tomorrow, are inextricably linked. Whether personal or cultural expression, or both, whether in the past or in the future, Native artists vitalize their thought and our perception through their ability to create powerful objects and images" (Penney 2004: 212).

Bill Anthes addresses the complex problems inherent in the application of terms like "traditional" and "modern," which have their origin in European art history, to Native American art:

"It is important to remember, that distinctions between 'traditional' and 'modern,' to the extent that they can be made at all, are extremely complex for Native American artists. Abstraction and the adoption of Western pictorial styles have been identified – perhaps to a fault – as markers of modernity in Native American art. However, this formulation runs the risk of reifying a particular mode of painting as being 'modern.' If abstract painting becomes the key marker of modernism in Native American painting, then it would follow that those artists who adopted such styles would be more fully denizens of the twentieth century than were the artists working in a style identified as 'traditional.' Indeed the definition of the modern is as artificial as the definition of the traditional […]

Such a distinction merely reproduces the stereotype that Native American artists are primitives, a people without a history until they embrace Western notions and progress.

Indeed, Native American artists in the twentieth century, regardless of style, have been the coauthors of a shared modernity, even if the terms of their involvement have been, at times, egregiously unequal. While some artists have claimed an aesthetic and cultural authority based on their connections to 'tradition,' they found themselves living in a world transformed by modernity and, in response, sought to find a place in it" (Anthes 2006: 29).

In addition, Bill Anthes discerns several "Modernisms":

"The transformative work of these Native American artists should be recognized as one of many modernisms in a multicultural America […]

I argue that Native American modernist art embodied a consciously constructed response to cross-cultural encounter, clash, and accommodation as well as to the patterns and processes of social modernization that swept Indian country in the twentieth century" (Anthes 2006: xiii, xviii).

However, even the broadest concept of art cannot answer the essential issues raised by Native American art:

"For the non-Indian or outsider looking in, the term 'art' is a convenient classification to make sense of a dynamic and integral component of the Native American worldview, to make the Indian world intelligible in terms of Euro-American experience. Indian art is the sense of motion and creation expressed symbolically in objects and is to be understood as a way of living. Indian arts have always been dynamic, challenging conventions and adapting, reinterpreting, an improvising. Indian art reflects a particular community's aesthetic that is firmly rooted within the daily lives of the people and their religion, along with cars, fast food, and mass media. Tradition is constantly changing and it needs creativity in order to remain alive because creativity breaks apart old thoughts in order to reassemble the parts into new thoughts. But we must ask ourselves what happens when art is controlled by a hermetic world of scholarship and art markets and the artists themselves begin to fall victim to the chimera of a Romanticized Past" (Bernstein in: W. Jackson Rushing III, (ed.), 1999: 68).

Arts versus Crafts? –
Attempts at Establishing Positions

"One of the challenges involved in defining 'modern' Native American art is the place of so-called traditional work [...]

Histories of modern Native American art of the rest of the century tend to isolate the histories of fine arts genres and those of other mediums, internalizing the mainstream hierarchy and separation of genres [...] The twentieth century witnessed the emergence of celebrity craftspeople such as the Pueblo potters Maria Martinez and Lucy Lewis (Acoma), but their work has not usually been integrated into the narrative of 'Native moderns.' While they have been reluctant to dismiss the value of traditional work, Indian intellectuals have contributed to this problem of genre hierarchies" (Epilogue in: Hutchinson, Elizabeth, *The Indian Craze. Primitivism, Modernism, and Transculturation in American Art, 1890–1915.* Durham, London 2009: 232).

For a long time, there was no consensus about the differentiation between arts and crafts, neither among white ethnologists, art historians, and collectors, nor among Native American artists and intellectuals. It was not until recently that the artificial distinction between art = highly valued and crafts = lowly valued was exposed as being no less inappropriate than categories of "individual" = modern, mainstream-oriented and "traditional" = ethnic, communal, backward-oriented.

"At the convocation of American Indian scholars at Princeton in 1970, Frank La Pena's question of the place of 'the so-called traditional arts' in the 'new Indian art' spurred a discussion revealing the panelists' anxiety about broaching the boundaries between painting and other mediums [...]

In his review of the 1991 exhibition Our Land/Ourselves: American Indian Contemporary Artists, *W. Jackson Rushing pointed out the flawed assumptions behind privileging painting and sculpture in discussions of modern Native American art: 'The subliminal message being sent here, albeit unintentionally, is that weaving, pottery, basketry, woodcarving, embroidery, and other 'pre-Modern' forms are less able to speak meaningfully to a 'contemporary' art audience.' Fortunately, curators and artists are beginning to undermine this assumption. Institutions such as the National Museum of the American Indian's Gustav Heye Center in New York continually stage exhibitions that put innovative work in traditional mediums on view at the same time as cutting-edge works in more mainstream genres, and New York's Museum of Art and Design has organized a three-part exhibition devoted to contemporary Native work in clay, glass, fiber, jewelry, metal, and wood. At the same time, Native artists operating within the mainstream gallery system are increasingly referencing traditional materials and techniques. Examples of artists working in this vein range from Nora Naranjo-Morse to Jolene Rickard and Brian Jungen. While each of these works in mediums and practices that are fully integrated into the contemporary art world (primarily installation and photography), their work draws viewers' attention to the complex historical frames needed to understand their work.*

It may be that the current openness demonstrated by the mainstream art world in this moment of 'postmedium' practice has helped these artists break a boundary that was vexing to their forebears a generation ago" (Hutchinson 2009: 232, 233).

It is certainly no coincidence that it was mostly female authors who addressed this issue. The Canadian art historian Ruth B. Philips points to its larger context:

"The decontextualization of the visual object for purely aesthetic contemplation and the hierarchical classification of the objects as art or craft according to criteria of media or use are especially problematic to most Native American concepts of the made object. The general raising of consciousness about such issues promoted by new (and especially by feminist) art history promised to encourage the more integrated and holistic study of the object demanded by Native American and many other art forms [...] Under the pressure of these new paradigms, art history, like those other disciplines, moved away from set canons of great works organized into narratives of the progressive rise of western culture. In their place are being inserted plural histories of art traditions belonging to particular communities and considered as parallel, contemporary and interactive with those of the mainstream culture" (Philipps, Ruth B., "Art History and the Native-Made Object" in: W. Jackson Rushing III (ed.), *Native American Art*. London/New York 1999: 99).

Native American Modernism, the Function of Space and Landscape in Native American Art, and the Renunciation of Monovisual (Ocularcentric) Art

The outworn and hackneyed question of "art or context?" can be rephrased into "modernism or context?" This implies the issue of classifying an artist as an individualist or as a member of his group/community/culture, as well as the option to be both at once. Above all, however, it implies the problems inherent in the dissociation of the visual arts from their context:

"The notion of 'scopic regimes' has proved a powerful tool in the hands of post-colonial artists. Yet [...] the anti-ocularcentristic critique does not resolve some of the major issues being raised by Native critics about the ways that the visual bias of western art discourses destroy the integrity of Native objects [...] When applied cross-culturally to objects originating in societies where the (also aesthetic) expressive forms of ritual, story-telling, music or dance are of equal or greater importance, the western inscription of its art and culture system operates as a continuing colonial legacy" (Philipps, 1999: 100).

Native American artists, on the other hand, attach importance to the complete referential context of any object (work of art): the object's materiality, the meaning of shape and motifs – for example, as linguistic metaphors – the individual and collective memory with regard to the oral traditions, as well as its embeddedness in emotional community networks.

In addition, Native American Modernists have always viewed the inclusion of their geographical "home," that is, some specific landscape, as an indispensable element of their art, even though this was in visible contradiction with the Euro-American Modernists who had recently turned away from the American regionalism of the 1930s:

"This tendency to maintain connections to the local distinguishes the art of DesJarlait and Morrison from the mainstream of modernist art in the twentieth century [...]

The new modernist art would be focused on itself, exploring the universal visual language of abstraction [...]

But DesJarlait and Morrison did continue to imagine that their art could embody a deeply felt connection to traditional homelands. Significantly, this was an active process [...]

After a period of displacement or absence, they experienced a renewed sense of being rooted in specific and significant geography. While DesJarlait and Morrison worked in nontraditional, Modernist styles, and would never, unlike younger Ojibwe artists such as Norval Morrisseau, violate traditional proscriptions against the represen-

tation of sacred imagery, each developed deeply felt personal and cultural connections to a homeland that defined their work as Ojibwe. (Anthes 2006: 114, 115).

The case of the abovementioned Woodland School – of which Norval Morrisseau, who is represented in the Berlin collection, was a central figure – does not only illustrate the internal contradictions among Native American artists, but also differences between the generations and their responses to the reception of their work by non-Native consumers (fig. 42):

"During the 1990s a group of Anishnabe artists in Canada have mounted a critique of mainstream art institutions and discourses […] The artists, who share an artistic orientation usually referred to as Woodland School, take as their subjects traditional Anishnabe spirituality and worldview. Working with a set of graphic conventions derived from pre-contact rock art, incised birchbark medicine scrolls, and other visual forms, the artists seek understandings of orally transmitted traditional knowledge and explore the relevance of these teachings for such contemporary concerns as personal empowerment, the unity of the family, and the preservation of the environment. During the 1960s, when two of the most important innovators of this art, Norval Morrisseau and Daphne Ogjig, came to prominence, and during the 1970s, when a host of younger artists were inspired to follow their model, Anishnabe painting found a ready collector's market and was regularly shown in public art galleries – though not generally by the most prestigious. Since the late 1980s, however, as postmodernism has gained dominance Anishnabe art has been largely excluded from display by the large urban museums that have been showing the work of art-school trained artists working in more current mainstream modes. Discouraged by the falling off of market and public attention, many of the artists have stopped painting" (Philipps in: W. Jackson Rushing III, (ed.), 1999: 106).

Something has changed, though: today's "Post-Modern" contemporary young Anishnabe artists are more self-confident and defend their art as a political message. Thus, they do not only gain independence from the current behavior of markets, but also from the exclusion criterion of salability of their works.

Native American Art Histories

Plains Cree artist and writer Gerald MacMaster has engaged himself with the issue of an "Aboriginal Art History," or rather various (art) histories. MacMaster contrasts these with the western discourse of *one* art history, equated by him with the "mainstream." According to him, however, the discourse of this mainstream is only one among many (art) histories (McMaster 1999: 84, 85). In his opinion, defining the right strategy is the most promising approach for the future:

"We know now that the modernist project has come apart and is exposed to pluralistic environments, which create new possibilities where boundaries disappear. The events of the world since the late 1960's have perhaps given us a collective optimism that seemed only the claim of a few in the past. This new vision and thinking has been described as postmodern. The former modernist ideology suggested a one-way movement and progress, a colonization into the space of the Other, whereas in postmodernism it is barriers – intellectual, symbolic, and physical – that are being re-examined, offering new possibilities for understanding 'identities' in demonstrating that these boundaries are permeable from both sides.

The resistance to universal ideology of the West by aboriginal people has been in progress for some time, creating in turn insularity; it will take time before the two sides become engaged on equitable basis [...]

The field has to accommodate conflicting, negotiating, interrogating histories, traditions, and identities. The conjoining of these histories leads inevitably to a situation where no one history is more important than the other, and everyone now maneuvers strategically for a new position [...]

To bring the focus closer to home, let us note that strident efforts by aboriginal peoples to retain local cultural identities can be shortsighted in the face of rapid 'pluralistic globalization.' There are also potential contradictions in this situation. As aboriginal people struggle to reclaim land and to hold on their present land, do their cultural identities remain stable? When aboriginal self-government becomes a reality, how will the local cultural identities act as centers for nomadic subjects, and how will artists function therein?" (MacMaster, in W. Jackson Rushing III (ed.), 1999: 84, 85).

The intellectual discourse on plural art histories, which has arisen from the call for a "politically correct" consideration of the specific historical and sociopolitical backgrounds of Native Americans, is a quite recent and still unresolved issue. Referring to this particular situation, Margaret Dubin calls for:

"a history of Native American art that is politically informed, and a criticism of contemporary Native American fine arts that is historically founded [...]

The first historians of Native American art faced a task of mammoth proportions: a people formerly thought to be dead, or dying, were now producing arts that were somehow connected to an ancient but unwritten history" (Dubin, Margret, "Sanctioned Scribes" in: W. Jackson Rushing III, (ed.), *Native American Art*. London/New York 1999: 149, 150).

Fig. 79 David Bradley, Chippewa, *Indian Market Manifesto*, 1997. Peiper-Riegraf Collection, 2008. Acrylic on canvas, height 152 cm, width 122 cm. Ethnologisches Museum Berlin, Inv. No. IV B 13168.

However, it was not until 1971 that a PhD thesis, which addressed a then unusual topic, called attention to this problem:

"The 1971 publication of Indian Painters and white Patrons *by J. J. Brody marked a critical turning point [...] Brody's book was the first serious attempt to contextualize the artistic renaissance of the 1920s and 1930s within the social and political dynamics of an emerging (and imperialist) art world [...]*

What intrigued him most was the apparently easy coexistence of new and old forms, and, within the medium of painting, what he perceived as the emphasis on stylistic conformity over quality [...]

Brody decided to write his dissertation on the genealogy of American Indian "easel" painting. Was this increasingly popular form the extension of an ancient tradition, as early art historians described it, or was it new, an "invented tradition" encouraged by Euro-Americans within the patronizing dynamic of colonialism? The topic raised some eyebrows in the art history department" (Dubin 1999: 151).

Brody was the first to raise the issue of quality:

"The ultimate goal of Indian Painters and White Patrons *was not to moralize, but to analyze an art form, to develop a strategy for distinguishing 'good' paintings from 'bad.' In the long run, Brody concludes, the patronage system produced paintings that were bad, 'timid' in their reluctance to confront the circumstances of their genesis and 'sterile' in their blunt commercialism.*

Body's strategy of interweaving aesthetic and socio-political histories was radical, prescient of the concerns of the 'new' art historians. But while no one could deny the impact of colonial history and Euro-American desire in Native American art, other art historians were slow to incorporate Brody's politically informed narrative into their own writing" (Dubin 1999: 153).

By this time, however, the artists themselves had long been responding to these problems. David Bradley and others used aesthetical means to address the political events and the Native American protest movement, and to transpose them into art (Fig. 79, 81).

"At the same time, it became increasingly difficult to connect contemporary to historic forms. Western art writers are encouraged to understand the avant-garde in terms of its engagement with and rupture from historical precedent. In the Native American art world, however, old and new forms exist simultaneously and self-consciously. Parodies of the old share space with studied recreations and radical innovations. The simultaneous production of disparate forms, which I conceptualize as a hybridization that blurs tribal and chronological boundaries, is impossible to reconcile with the Western concept of aesthetic evolution" (Dubin 1999: 154).

The artists are descendants of more than 500 different ethnic groups, which furthermore have become culturally mixed due to intermarriage with Europeans. As a result, it is no longer possible to invoke a "precontact intertribal aesthetic;" rather, the shared historical, social, and political experience of exposure to the Europeans is the unifying pan-Indian factor.

"But because criticism is expected to build on the foundation laid by art history, and because so much of Native American art history has been Romantic and apolitical, critics tend to interpret contemporary abstract works as extensions of an ancient, pan-Indian, symbol-laden aesthetic" (Dubin 1999: 155).

According to Rushing and others, it is thus mandatory that expert scholarly critics and art historians assess Native American art:

"It is not my intention here to assess the value of criticism or the necessity of cultural context for the interpretation of art objects, but to acknowledge that criticism influences the market, and that many contemporary Native American artists feel they are denied the attention of professional critics. Artists who wish to engage with the mainstream contemporary art world, in particular, dismiss the typical coverage of their work as amateur and full of clichés characterizing the disjuncture of an Indian-in-the white-man's-world" (Dubin 1999: 156).

Yet, there is also a lack of experts – that is, scholarly critics – who are familiar with Native American cultures, art history, and the training of Native American artists. And even if such expert critics did exist, we could always expect some Native artists to reject negative criticism for reasons pointed out by Native artist Emmy Whitehorse in 1996:

"The artist will say, 'That's easy for [the critic] to say that, because he's a white person. He has no business telling me how to paint.' It's like being Native American gives him an excuse to do bad art and get away with it" (quoted after Dubin 1999: 157).

According to Alfred Young Man (Cree), who holds a doctorate, there is a particular scarcity of Native American experts:
"So I went to do a doctorate at Rutgers so that I could write a piece on Native art. At that time there were no Ph.D.'s in Native Art; in fact, there were no Ph.D.'s in Native Studies. Since I went to Rutgers a few have opened up. But the doctorates in Native Art are few and far between, and even fewer Native artists, Native people, do these things" (*A Time of Visions*, Interviews by Larry Abbott, http://www.britesites.com/native_artist_interviews/aman.htm. Accessed on Feb. 4, 2012.).

Even though it is permissible and even necessary to criticize art, we are still facing the dilemma of how to approach art that is different, foreign, and unfamiliar. Dubin cautions us against confusing such art with the foreign ("exotic") elements integrated by European artists for purposes of innovation:
"What keeps Western art history distinct from other art histories, and allows it to progress in a linear fashion, is the persistence of a socially or culturally bounded group of producers. Western artists do 'borrow' elements from the aesthetic repertoires of other cultures, but this is usually interpreted not as ethnic mutiny, but as a temporary and incidental cross fertilization inspired by specific historic conditions" (Dubin 1999: 158, 159).

Conversely, new interpretations of elements and styles from Western/European art by Native American artists are seen as simple imitations rather than as intelligent responses and creative advancements in the development of a stylistic vocabulary of their own:
"Given the persistent focus on authenticity over quality, it is not surprising that there is very little criticism – in the sense of this-is-good, this-is-bad – of Native American art. In the absence of an accepted strategy for evaluation, the overwhelming majority of writing is concerned not with judgment, but with the maintenance and reconciliation of difference. Like the process of collecting, the process of writing has been framed by the tension between sameness and otherness, haunted by the conflicting desires to reconcile difference and exoticize. This is manifested in the rhetorical moves that establish alterity, then reduce it by the invocation of familiar stereotypes" (Dubin 1999: 159).

The maintenance of two separate worlds – that is, a "Native American" and a "modern" world – has also been propagated by some Native Americans, as it provided a certain degree of protection. On the other hand, it reinforced the prejudice that the Native world is static, past-oriented, un-dynamic, and averse to change, and that Native Americans were unwilling to take up the challenge and confront the changes of

Fig. 80 David Bradley, Chippewa,
Pueblo Feast Day 2005, 2005.
Peiper-Riegraf Collection, 2008.
Acrylic on canvas, height 150 cm,
width 206 cm. Ethnologisches
Museum Berlin,
Inv. No. IV B 13169.

the present. However, this attitude is definitely not typical of present-day Native American artists. White American critics, in turn, have an issue with political art even though there are obvious reasons for its existence, as is aptly pointed out by Cree artist, writer, and professor Alfred Young Man:

"I don't feel I'm a political artist at all. I feel that we were and are victims of politics so we have to respond to it. We are essentially aboriginal people who have lived on the land for thousands of years. We were invaded, we didn't invade anybody, so our reaction is to address the invasion, and politics is part of this invasion. The imagery of the modern world we live in is part of this invasion. That imagery was never here before, so naturally we address it, and when we address it those people who live within that sphere look at us as being political artists" (A Time of Visions, Interviews by Larry Abbott, http://www.britesites.com/native_artist_interviews/ aman.htm. Accessed on Feb. 4, 2012.).

Thirteen years have passed since Dubin published her article, but her summary is as relevant as ever:

"The challenge in writing about Native American art is to recognize areas of difference, as well as areas of merging social and cultural practices, as they coexist within and influence the nature of our shared modernity. The goal, as I see it, is the normalization of the relationship between Native and non-Native arts, a move made all the more urgent by multiculturalism's entrenchment of Native American minority status [...]
As long as Western eyes are guiding the decisions of both institutional and individual collectors, Indian artists deserve fair and sophisticated treatment according to Western aesthetic standards [...]
Many elite art institutions excuse their exclusion of Native American art on the basis of inferior quality. If artists excluded from important exhibits fare well at the hands of critics who know to evaluate Native American Art, continued exclusion on the basis of quality will be difficult to sustain" (Dubin 1999: 161, 162).

Alfred Young Man pinpoints the challenges as follows:

"Right now we're trying to organize a show at the National Gallery of Canada, which is equivalent to the National Gallery in Washington, D.C. They both refuse to acknowledge Native art. There are people out there who simply refuse to recognize Native people as a reality and as far as I'm concerned that works in our favor because it just gives us more ammunition if we need it to throw at them. When we stop meeting a force out there then our job is probably finished, but that won't happen for several generations" (A Time of Visions, Interviews by Larry Abbott, http://www.britesites.com/native_artist_interviews/aman.htm. Accessed on Feb. 4, 2012.).

We may add that it would be a pity if artists and art historians didn't discover the collection of the Ethnological Museum Berlin until 100 years from now, and if people had to wait until then to learn which works are the masterpieces.

Native American Modernism and its Artists

With the exception of a few artists who were born in the first decades of the 20th century and count among the first generation of Native American Modernism, the artists represented in the collection of the Ethnological Museum were born from the 1930s to 1950s and thus belong to the second generation.

The beginnings of Native American Modernism and the acceptance it gained, at least at the national North American level, have been summarized by the Native American author Gail Tremblay, using the outstanding example of artists Allan Houser (Chiricahua Apache, 1914–1994) and George Morrison (1919–2000), (Fig. 3):

"During their long and productive lives, Allan Houser and George Morrison were seminal figures in an art movement that has redefined the way art by citizens of indigenous nations in the United States is viewed and understood. Both of these artists were born into a world where the discourse about the aesthetic work of indigenous people was either an anthropological one about 'artifacts' in cultural context, or an art historical discourse about 'primitivism' with its counterposed notions of 'the tribal' and 'the civilized,' the 'traditional' and the 'modern.' By virtue of the power of the artwork they created, these two men helped cause a paradigm shift that forced the larger art community to define their work as fine art related to major international movements in twentieth-century art" (Tremblay, Gail, "Different Paths. Tracks Worth Following" in: Truman T. Lowe ed., *Native Modernism. The Art of George Morrison and Allan Houser*. Seattle and London 2004/2005: 78).

Beginning 1949, Houser was awarded several scholarships and prizes in the U.S. and France, and embarked on a career as a teacher and professor. In 1962 he returned to Santa Fe to join the staff at the newly founded Institute of American Indian Art in Santa Fe where he resumed his work as an artist in cooperation with a group of talented young Native American artists such as Fritz Scholder. Even though Houser had been trained as a Native artist at Indian schools and preferred themes from Native culture in general and Apache culture in particular, it was important to him to transcend these narrow limits:

"I am continuing to utilize traditional Indian themes, but I want to be free to inquire in a contemporary way, like Noguchi or Henry Moore or Barbara Hepworth, all of whom I admire very much. I want my work to reflect the heritage I am proud of, but I also want my work to reflect the full range of what I'm capable of doing. It has always been my hope that my work would be acceptable all over the world, not as the work of an Indian artist, but of a contemporary American sculptor" (quoted from Tremblay 2004/2005: 87).

In 1982 Houser remarked:

"I believe I am past the stage where I have to be confined to what people call 'Indian' art [...] I use the name Allan Houser, and I just want to be Allan Houser, the sculptor" (quoted from Lowe 2004/2005: 19).

Tremblay describes the essential features of Houser's work, which draws not only on his Native heritage but also on Western Modernism, as follows:

"Clearly, as one examines the use of shape, line, texture, and mass in Houser's startlingly diverse body of work, one can see the way in which modernist aesthetics shape many of the most exciting examples of his art [...] Houser creates works that dance on the edge between figuration and abstraction in ways that are richly magical. At the same time, one can see the absolute pride and appreciation for the culture he has inherited [...] One cannot help but be struck by the simplification of bodies so that the details of clothing at times disappear and form becomes absolutely timeless, neither historical nor contemporary, but rather an eternal essence of an indigenous presence moving gracefully across the earth, something that could have happened a thousand years ago or might happen next week [...]

Houser was a master of many media. He carved in marble, limestone, slate, and wood; cast in bronze; and fabricated things in a variety of metals. While most of his work is figurative, some works [...] are clearly abstract and totally escape the restraints of realism to explore the possibilities of pure form. His drawings and paintings travel two roads. There are the Santa Fe-style drawings of dancers and ceremonies – Indian life as his father described it and as Allan lived it as a young man. These works are his most conventional, perhaps his most romantic, and yet the way that they celebrate the survival of things Apache, of things Indian both in the world and in the imagination, speaks of the need of indigenous people of his generation to escape the racist constructs – the pressures to assimilate. The need to see indigenous culture survive that fueled the works of so many early painters of the Oklahoma and Santa Fe Schools gives those works an importance that few non-Native art critics will ever understand" (Tremblay 2004/2005: 87, 88).

From the very beginning of his creative work, George Morrison was involved with the New York art scene in which he was active as an artist. He witnessed the emergence of Abstract Expressionism and was close friends with Willem de Kooning, Franz Kline, and Jackson Pollock. Influenced by the Cubists and Surrealists, he developed a distinct abstract style of his own and studied in France, among other places. His works found their way into well-known "mainstream museums" such as the Whitney. In light of this it comes as no surprise that his works are not likely to be represented in the collections of ethnological museums.

Many sources mention that curators have refused to include his works in exhibitions of Native American art, on the grounds that his paintings feature neither Native themes of "tribal art" nor were they made in the traditional manner of his forebears (cf. Lowe 2004/2005: 16). He shared this fate with other contemporary artists such as Oscar Howe; this was due to non-Native critics' and jurors' desire to exert control on the positioning of Native American art:

"The efforts of Oscar Howe and Joe Herrera in the 1950s (and later), for example, to recast and resituate Native art were met with responses that questioned their legitimacy as 'Indian artists.' The desire to define what con-

stitutes 'authentic' Indian art really comes down to a need to control the imagery and vision of Indian artists" (Abbott, Lawrence, "Contemporary Native Art: a Bibliography" in: *American Indian Quarterly*, Volume: 18. Issue: 3. 1994: 383).

Oscar Howe (Yanktonai Sioux) brought forth arguments against such assessments:
"Who ever said [...] that my paintings are not in traditional Indian style has poor knowledge of Indian art indeed. There is much more to Indian art than pretty, stylized pictures [...] every bit in my paintings is a true studied fact of Indian painting" (quoted from Anthes 2006: xi, xii).

Morrison's ambivalent attitude becomes apparent in the following quotes from an essay by Gerald Vizenor, who is a writer and literary critic and, like Morrison (and David Bradley), a member of the Chippewa (Anishinaabe) nation:
"I never played the role of being an Indian artist. I always just stated the fact that I was a painter, and I happened to be Indian. I wasn't exploiting the idea of being Indian at all, or using Indian themes [...] But as my work became better known, some critics would pick up on my Indian background, and they'd make something of it. I guess they were looking for a way to understand my work" (Vizenor, George "Anishinaabe Expressions at Red Rock" in: Truman T. Lowe (ed.), *Native Modernism. The Art of George Morrison and Allan Houser*. Seattle and London 2004/2005: 44).

However, Morrison also stated:
"I wanted to come back to the Indian connection, to Minnesota and my family [...] I felt an inner need to come back, not realizing the consequences of what I was doing. I felt the need to put certain Indian values into my work" (Vizenor 2004/2005: 58).

While the Berlin collection does not include any work by Morrison, his influence on the next generation of artists – David Bradley, Frank Bigbear, Kent Smith, and many others – has been so profound that his life, the immediate experience of being influenced by Modernism, deserves some consideration in the present publication. The "discovery" of Primitivism by artists like Picasso had an effect on Morrison's way of thinking and working:
"Entering the international art scene during the mid-twentieth century, Morrison found a world where artists used decontextualized images by indigenous artists in order to escape from the limitations of realism. These artists had learned to create complex compositions that explored startling possibilities of color and form – almost endless possibilities" (Tremblay 2004/2005: 98).
"When he died on April 17, 2000, at the age of eighty, he left behind a substantial body of work that has helped define the direction not just of twentieth-century American art but also of contemporary American Indian art.

George Morrison is a Chippewa artist the way that Picasso is a Catalonian artist, Cezanne a French artist, Modigliani an Italian artist, Tamayo a Mexican artist, Hepworth a British artist, or Pollock a Euro-American artist from the United States. Artists are born into peoples and nations, and with their visions they shape the art and culture of those nations. They work to invent the art movements that influence the century they inhabit. Morrison brought the mainstream American art scene home and let a whole generation of contemporary artists from indigenous nations across the United States know that they too could help shape and define movements in American art. He made the generation of Indian artists that followed him aware that it was possible to free oneself from the need to make art about being Indian. He made them aware that whatever they made, it would be indigenous art because they made it. That lesson has been an incredibly powerful one" (Tremblay 2004/2005: 102).

This comment by Gail Tremblay, who is a contemporary Native American artist and poet and a member of Onondaga and Mi'kmaq decent, can be complemented by a statement by Truman T. Lowe: "Compelling artists, their stories enrich and complicate the standard histories of modernism […] Morrison and Houser stand at the beginning of a particularly vibrant era in contemporary Native American art – one that is characterized by individualism and diversity. But indigenous creativity has always been diverse and vital, and this is the real message I hope Native Modernism communicates. In my mind, it will be successful if it inspires a desire to learn more, and stimulates dialogue and discussion about the scope and complexity of the American Indian art experience" (Lowe 2004/2005:37).

However, Morrison's training as a Native artist in direct contact with representatives of Euro-American Modernism was an exception.

Allan Houser and other Native artists were trained at the Indian School Studio in Santa Fe, where political activism related to issues of Native American land rights, the preservation of cultural traditions such as freedom of religion, and the struggle against Native American poverty had been a part of Native everyday life since the 1920s. Beginning in the 1960s, however, radical measures were taken at the IAIA:

"The establishment in Santa Fe in 1962 of the Institute of American Indian Arts (IAIA) also had profound effect on Indian arts by training new artists, bringing together an esteemed faculty of Indian art instructors, and providing new media and venues for making, selling, and displaying their work [...]
'Traditional' art instructors [...] were removed from their teaching posts since it was widely believed that the style of painting that had been taught at the Santa Fe Indian School Studio, since its inception by Dorothy Dunn in 1932, was creatively drained [...]
In reaction to long-held perceptions about 'Indian art' and in order to break from the Santa Fe painting tradition and move into a modern era, the IAIA's teaching emphasis was on all types of arts, rooting its training in the broader contexts of world art history [...] The faculty included artists such as the painter Fritz Scholder, the sculptor Allan Houser, the jeweller Charles Loloma, and, as Art Director, Lloyd New, a designer and art educator [...]
Individualism was an important aspect of the Institute's training, in direct contrast to the communal nature of many Native American societies. The IAIA did not expect homogeneity on the part of the predominantly Indian student body, but rather encouraged students to find themselves as artists of the world on a purely personal basis" (Bernstein in: W. Jackson Rushing III (ed.), 1999: 66, 67).

The well-known Luiseño artist Fritz Scholder, who is also represented in the Berlin collection, was one of the first teachers at the IAIA who looked into European modernism and non-Native contemporary art, and created a new type of painting based on both Native and European traditions. He was also one of the first to come forth with a critical and subjective discourse on Native American identity (Fig. 71, 72).
"The influential teaching faculty at the new institute included [...] Luiseño painter Fritz Scholder (1937–2005), who was [...] conspicuous for not having been trained in Indian schools [...] Already an established artist by the early 1960s, Scholder had participated in the Southwest Indian Art Projects in Tucson as a student [...] Convinced that popular images of Indians were completely at odds with the experience of modern (often urban) Native Americans, Scholder's paintings of Indians mediated the gap between romantic stereotypes that had been foisted upon Indian artists and the realities of modern, urban Native life. Frustrated that his Native students at IAIA were still beholden to cliché and were unable to 'master ... their Indian subject,' Scholder turned to the image of the Indian in 1965 [...] Scholder reappropriated the hackneyed images of Native Americans [...] In doing so, Scholder insisted that history and images had cultural power, with which contemporary Natives must come to terms. Moreover, Scholder painted in an expressionistic style that borrowed from the modernist main-

stream [...] The art of Scholder and the IAIA artist was modern, to be sure, and the IAIA is often cited as the be-ginning of modern Native American art. Indeed, it was the first organized and programmatic effort to make a Native American modernist art. But, as we have seen, Native American artists were already moderns" (Anthes 2006: 178, 180, 181).

Cree artist Alfred Young Man recalls:
"After a couple of months we discovered that there was a new school opening in Santa Fe called the Institute of American Indian Arts. So they bussed us to New Mexico and we were enrolled there as students, and I spent the next five years there, from '63 to '68. I was fortunate enough to have been in the original crop of students. I didn't know anything about art, of course. I was just a young kid and I didn't know that I was an artist. But like all Native children I was told that I had some kind of a special talent, some kind of artistic Aboriginal artistic chromosome. As it turned out that was the right thing for me to do" (A Time of Visions, Interviews by Larry Ab-bott, http://www.britesites.com/native_artist_interviews/aman.htm. Accessed on Feb. 4, 2012.).

Outside the IAIA, Native artists also developed a type of art that was influenced by the first generation of Native American Modernism. With regard to the Flathead-Kootenai artist Jaune Quick-To-See Smith, whose work is represented in the Berlin collection, the already quoted Onondaga/Micmac artist, poet, writer, and professor Gail Tremblay writes (Fig. 77):
"As Quick-to-See established a national and then international reputation as an artist, she also worked to raise funds for scholarships and library books for the college on her reservation. She organized art symposia there, and brought indigenous artists from Montana together with contemporary Native American artists from other regions of the country. Quick-to-See Smith worked steadily to promote the artwork of American Indian artists by organizing artist collectives, curating exhibits, and giving hundreds of lectures, panels, talks, and work-shops on the work of native artists at museums, universities, galleries, conferences, and other venues across the country [...] Quick-to-See Smith is one of the most creative and prolific of the American Indian artists whose work explores Native American aesthetic traditions in a modern and post-modern art context. Over the years she has worked in many media, using an impressive vocabulary of techniques including painting, printmaking, lush pastels, and richly layered mixed media works. Few artists working today are as sensitive to the effects of texts on images, or as skilled at creating and appropriating texts that capture the paradigms of American society in ways that reveal its implications. Quick-to-See Smith embeds her texts in a rich environment of images she creates and images she takes from a variety of sources. By doing this, she creates complex juxtapositions that recontextualize the way viewers understand not only relationships between Euro-American and indigenous American culture, but how she, as an artist of Flathead descent, views issues in both these cultures. Her works are thoughtful and thought provoking and can raise questions that explode stereotypes and myths about in-digenous people" (Essay © Gail Tremblay / Commissioned by the Missoula Art Museum with support from

Fig. 83 Bob Haozous, Apache, *Landscape*, 1989.
Peiper-Riegraf Collection, 2010. Corroded and painted
steel, height 74 cm, width 89 cm.
Ethnologisches Museum Berlin, Inv. No. IV B 13194.

the National Endowment for the Arts and the Montana Cultural Trust for Montana Connections. www.mis-soulaartmuseum.org > The Collection. O.D. Accessed on Feb. 4, 2012.)

Like Quick-To-See Smith, the Postmodern Ojibwa artist Carl Beam uses various media to express his concerns:

"His technique is to retrieve photographic images, old, faded, defaced by Beam himself or by anonymous forces, and to reassemble them to bring out another way of looking at the images and thus of the history they purport to tell. Beam's critique of the post-Columbus invasion focuses on the arrogance of power. He seeks to counter it by pointing out the powers of Native ways of calculating value which were not calculations or measurements at all [...] In works that combine images and texts from multiple sources he decries the suppression of the narrative mode; the mis-perception 'that information equals knowledge equals good;' grids, linear thinking, and plexiglass boxes; and the classifying, categorizing impulse of a legal system that favors property over people. Positive points of identification for Beam's work would be his ability to think through images, his dialectical juxtaposing of words and images, and a multiple-point perspective. The polymorphous attributes which might characterize Beam's work as postmodern inevitably recall Robert Rauschenberg, which is not to say that his work is like Rauschenberg's" (Townsend-Gault in: W. Jackson Rushing III (ed.), 1999: 128).

In contrast, IAIA graduate David Bradley (Chippewa/Anishinaabe) uses parody and persiflage as a central means of artistic expression. He turns stereotypes upside down, portrays figures who are well-known from other contexts, and one of his specialties is the imitation of European artists and their works. Thus, he baffles the beholders; even those who have no intimate knowledge of the facts and circumstances feel that Bradley holds up a mirror not only to Native American society, but also to America's white and multiethnic society. This is illustrated by the following biographical sketch written by the curator Bradley Pecore (Menomini):

"The over thirty-year career of multifaceted artist David Bradley encompasses a rich social critique that interrogates the sociopolitical landscape of contemporary Native art [...] Bradley's Peace Corps service profoundly inspired his social consciousness and greatly influenced his use of color. While residing in Central America and the Caribbean, he gathered inspiration from Mexican muralists and the broad palette of Guatemalan folk artists.
In the 1990s Bradley actively founded and organized campaigns to promote Native American and Chicano arts. Bradley considers himself a 'socially responsible world citizen.' His activism became focused and highly politicized around concerns of fraud in the Indian arts and crafts business. As a lobbyist for the passage of the 1990 Indian Arts and Crafts Act, he became recognized nationally for questioning the exploitation of culture for commodity.

Noted for his political paintings, Bradley infuses Western pop cultural icons with stereotypical Native motifs in his complex visual narratives. His work goes beyond conventional boundaries of what is deemed authentically Native through his incorporation of modernist elements and post-modern constructions" (David Bradley by Bradley Pecore, Museum of Contemporaray Native Arts, Santa Fe, http://www.iaia.edu/museum/vision-project/artists/david-bradley/).

Bradley's work is typified by his panoramic paintings in which he bewilders the viewers by confronting them with alienated figures not only from the local Santa Fe scene, but also from history and popular culture. For example, he has his Native American colleagues communicate with deceased celebrities from history (Fig. 80).

"The modernist metanarrative of Western art history is interrupted [...] what may be perceived as chaos and play is at once a strategic placement of intersecting art worlds. In this sense, the viewer witnesses the theatrics of conversations between artists representing both the so-called dominant and subversive art discourses. Bradley's projections reformulate latent Native American stereotypes with complex interconnected cognitive images reinvigorating the history of art as intersecting webs [...] Bradley brings forth congruence with a co-mingling of voices, recalling history and placing the Native presence in a contemporary setting. In this way, we bear witness to a menagerie of counter appropriations and cultural borrowing implicit in both dominant and subversive contexts.
Bradley urges viewers to emancipate themselves from previously perceived notions of the Native while being lured into a world of satire infused with multiple systems at play. Through illustrative robust images, he reinvigorates Native American art history and proclaims stewardship while painting us all into his window of Indigenous cultural maintenance and critique" (David Bradley by Bradley Pecore, Museum of Contemporaray Native Arts, Santa Fe, http://www.iaia.edu/museum/vision-project/artists/david-bradley/. Accessed on Feb. 4, 2012.).

Like Bradley's work, that of Harry Fonseca is characterized by a considerable measure of humor and irony combined with socio-critical messages directed at the beholder. Fonseca has travelled widely, always returning home with new impressions. His work is thus inspired by the scenery of his Californian homeland, ancient rock paintings, and Native American mythology. He once said about his career as an artist:
"[...] when I was 11 years old, I knew I was an artist. I already knew that at a real, deep level. So, when I went to college, I felt that I could already do what I had to do. It may not be done the way the instructor might have wanted it to be, but it was going to be done the way I wanted it to be. My work is that way now. It has a certain energy about it. It has a certain emotional impact about it that is not taught. Another thing is: why do I do this? I do it because I love to do it [...] Let's see, my background, in terms of art education, I started in high

school, but probably more important than doing actual painting — I remember painting with oils and how awkward that was, painting sail boats and that kind of thing — was the teacher I had. He would show us slides because he was educated in Italy, so he had tons of slides of the Renaissance. That was a really stimulating time to see all these images, so-called 'fine art.' Then, by the time I got to college, Abstract Expressionism was still popular, and I remember Robert Motherwell, seeing some of his work. I fell in love with that and started to really move paint around and drip paint and have a great time. But not really with any direction, it was almost art for art's sake.

The paint was just a going and a going. Then, I found out more about my Native American background, and became involved with the dances and the whole traditional base. That really gave me a foundation, not only for me but for my art work as well. It's still here. It's still very, very strong. It has a great deal of meaning to me, even when I am not doing a petroglyph, or a coyote or something, there's still something there" (*Times of Visions*. Interviews by Larry Abott, http://www.britesites.com/native_artist_interviews/hfonseca.htm. Accessed on Feb. 4, 2012.).

Abby Wasserman sketches one aspect of Fonseca's creative work, the transformations of Coyote, of which there is an example in the Berlin collection (Abb. 73, 74):

"If Coyote, the ancient trickster and changer of Native American mythology, were to walk into a room today, he might resemble Harry Fonseca, who is tall and slim with an alert, intelligent face and watchful eyes. Coyote is, after all, a spirit who can change form at will. In legend, he is variously described as an animal with tail and pointy snout, and a man – old and ugly or young and handsome.

Coyote is a magical figure who can bridge worlds and transcend time. He is the most powerful, yet the most 'human' of the Native American gods and demigods. Virtuous and deceitful, mortal and immortal, ordinary and extraordinary, Coyote personifies deeply conflicting impulses. He is a symbol of survival, adaptability and balance.

Harry Fonseca has been making images of Coyote for more than a decade. His earliest drawings were dancers in traditional regalia and coyote headdress, the 'spirit impersonators' of Maidu ritual. Then he catapulted Coyote into contemporary times to fashion a modern myth of Coyote in the city. The images are full of humor, yet speak directly to the challenges of our time. Ever-resourceful, ever alert, Fonseca's Coyote leaves the reservation. He hangs out in the city in a black, metal-studded leather jacket and high-tops. He poses as a tobacco store Indian in full eagle headdress and Levi's outside a Hollywood studio. With his female coyote counterpart, Rose, he dances a pas de deux from Swan Lake, or sells pottery, jewelry and kachina figures at Indian Market" (quoted from Wasserman, Abby, "Coyote and the Myth-Maker" in: The Museum of California Magazine, Oakland Museum of California. 1987, http://www.abbywasserman.com/harry-fonseca.html. Accessed on Feb. 4, 2012.).

Animals – the powerful clan animals such as eagle, raven, bear, and whale – figure prominently in the art of America's Pacific Northwest Coast as well. During the 18th century, and in part due to Russian influence, this region began to witness a distinct artistic development that transcended today's border between the U.S. and Canada. Although Charlotte Townsend-Gault falsely asserts that this was owed to comparatively late contact with the Europeans – ignoring the pre-Canadian history of encounters with Spaniards, Russians, British, and Yankees – she is nevertheless successful in describing contemporary developments and problems, and in doing so uses the example of the internationally renowned artist Robert Davidson, whose work can also be found in the Berlin collection. The collection includes a considerable number of Northwest Coast artists, and Davidson's work can be viewed as being fairly representative (Fig. 43):

"Townsend-Gault is based on the Northwest Coast […] Using a slippery story built on the visual kenning of a hot dog as the Northwest Coast's ovoid-formline, she poses a troubling and, given the market value of neo-tra-ditional art (c.f., Davidson, Dempsey Bob), critically important question: can conflicts over what we might call aesthetic correctness be separated from Native identity, land rights, and demands for sovereignty? With the 'materials and modes of identity' as a unifying structure, she notes that disparate artists are conjoined (and not always comfortably) in their determination to resist assimilation by 'maintaining a defining tradition or by showing that tradition is un-constraining.' For example, in discussing why the visual codes of Northwest Coast art lent themselves to Claude Lévi-Strauss's structural analysis, Townsend-Gault documents Davidson's desire to 're-articulate a relationship with an ancient set of codes.'" (Rushing III, Jackson W., Editor's Introduction to Part II in: W. Jackson Rushing III (ed.), *Native American Art*. London/New York 1999: 78).

Unlike some "critical" postmodern artists, Davidson has never categorically dismissed museums as "Na-tive American morgues." They rather became important sources of information and inspiration for him – after all, they display an abundance of objects and works of art made by his ancestors. In addition, David-son culled important impulses from other artists and writers:
*"The artist Bill Reid, who had already done much to discover his own Haida heritage, was important to David-son at this time. He also learned from the scholar Bill Holm whose research unlocked the logic of the formline, ovoid and U-form, in his 'Northwest Coast Indian Art: An Analysis of Form.' Although the book is not uncontro-versial, for Holm is non-Native and concern over cultural appropriation became inseparable from the identity politics of the 1980s, it is described by Davidson as a 'Bible.' It amounted to the technical grammar of a visual language, guiding him in the trial and error through which any language student must go […]
But it also helped to reduce the visual expression of the cultures to a design style. Comparable laws govern, for example, the design of Greek vases and their visual periodicities, […] It has been an important part of David-son's project to re-articulate a relationship with an ancient set of rules"* (Townsend-Gault in: W. Jackson Rush-ing III (ed.), 1999: 116, 117).

Building on this canon of rules – or grammar – for the visual language of the Northwest Coast, Davidson developed a distinct style of his own. He is not only active as a sculptor in the tradition of three-dimensional woodcarving, but has also initiated the transposition of the formline motif onto flat surfaces. When he made his first silk-screen prints, he did not even sign them. It was not until the 1970s that he began to produce serigraphs in limited, signed editions. Numerous artists followed in his footsteps, but Davidson's art is still unsurpassed. He broke new ground as a sculptor as well, as did his ancestors: thanks to their knowledge of European metal tools and commercial colors, they applied new artistic methods in the 19th century; their innovation met with success because their works found acceptance both in their own Native culture and European society. Townsend-Gault explains this using the example of the sculpture "Nanasimget and the Killer Whale":

"Davidson positions himself as heir to this tradition of innovation. It is a narrative sculpture telling the Haida legend of a wife captured by a killer whale. Liberated from the familiar formats of screen, pole, or staff, the emblematic characters of Nanasimget's story – a dorsal fin with hands and eyes locked in struggle around it – determine the forms. Sculpture would be an appropriate term now that the informing criteria are its own elements and not the demands of a given form" (Townsend-Gault in: W. Jackson Rushing III (ed.), 1999: 117).

The sons and nephews of Robert Davidson, Dempsey Bob, Nathan Johnson, and other internationally known artists have already successfully stepped out of their famous forebears' footprints; they have developed their own styles and create unusual, innovative works. Closely related to the environment that surrounds them, their art is a reception of Modernism and Post-Modernism, and features the characteristic combination of irony, humor, and criticism. In 2012 the Ethnological Museum Berlin bought two videos by the young Tlingit artist Nicholas Galanin – the first contemporary work of art by a representative of the third generation of Native American Modernism to be included in the collection.

Native American conferences – such as the meetings of the Native American Art Studies Association – have been held since the beginning of the 20th century, though at large intervals. At these conventions, Native artists and intellectuals discuss the issue of positioning Native American art within North American society. How were "traditional" and "contemporary" Native American art supposed to relate to the mainstream world of art? What could be done about Anglo-American control over the art market and exhibition venues? Was institutional support conductive to the advancement of Native American art? Did Native artists bear particular responsibility towards their ethnic groups and traditions? How could the liberty to combine traditional and mainstream art be translated into practice? Hutchinson sums this up: *"Making these connections allows us to see the persistent linkage between Native American art and Indian welfare, the difficulty both Indians and non-Indians face in defining Native American art as indigenous and mod-*

Fig. 84 Bob Haozous, Apache, *Apfelbaum – Sacred Images*
(No. 8 out of a series of 11), 1992. Peiper-Riegraf Collection,
2010. Corroded and painted steel, axe with wooden handle,
height 86 cm, length 138 cm, width 60.5 cm.
Ethnologisches Museum Berlin, Inv. No. IV B 13193.

ern at the same time, and the general ambivalence about the aesthetic status of handicrafts" (Hutchinson
2009: 222, 223).

The linkage with state-run welfare programs for Native Americans is not the only major problem faced by
indigenous artists today. Despite all efforts by Native American artists to get an education that at least
theoretically enables them to establish themselves in the global art scene, Native tourist "art" is still pro-
duced on a huge scale. The majority of buyers do not care too much about the existence of the 1990 Indian
Arts and Crafts Act and the Indian Arts and Crafts Enforcement Act passed in 2000 – both of which can be
hardly enforced anyway. Due to the competition with fake merchandise from Bali (Indonesia), which is
incredibly cheap in comparison to genuine Native American products, it is possible that only excellent,
innovative Native American artists and artisans who are both creative and technically perfect will survive
in their profession.

Artists Represented in the Berlin Collection: Statements, Opinions, Convictions

This collage concludes with a number of statements by the artists represented in the Berlin collection. Not all artists have their say, and the order of quotes is arbitrary. In the beginning there are brief statements followed by longer quotes in which the artists characterize their work and motivation.[7]

Kevin Red Star, the great inspirer whose pictures and protagonists seem to be alive, and whose works are omnipresent in museums and galleries Fig. 38, 39, 40, 41):
"Even before you prepare a canvas the thought and idea is there. Today I feel like horses. Should they be in a meadow, in the hills or with a beautiful mountain backdrop. Every day is exciting for new ideas" (http://vis-itmt.com/montana-stories/kevin-red-star/).

George Longfish, himself a professor, curator, and writer, whose political message is wrapped in pop art: Fig. 75, 76):
"The images I create are meant to question the stereotypical romantic image of Native People so often portrayed in past as well as current media" (*New Art of the West* at the Eiteljorg Museum, Indianapolis, in: May 6 – Aug. 7, 2000, http://www.tfaoi.com/aa/1aa/1aa533.htm. Accessed on Feb. 4, 2012.).

Virginia Stroud, who has won fame in the traditionally male artistic field of ledger painting (Fig. 34):
"I paint for my people. Art is a way for our culture to survive, perhaps the only way. More than anything, I want to become an orator, to share with others the oldest of Indian traditions. I want people to look back at my work just as we are today looking back at the ledger drawings. I'm working one hundred years after those people, saying, this is how we still do it. We still have our traditions" (http://www.dwyerogrady.com/stroud.html. Accessed on Feb. 4, 2012.).

David Bradley, whose paintings expose stereotypes and clichés about Native Americans, and who is bold enough to even use the Mona Lisa for that purpose (Fig.79, 80, 81):
"I do use repeatedly certain symbols which you could call popular cultural iconography like the 'American Gothic,' 'Mona Lisa,' 'Whistlers Mother' [...] as archetypical images everyone can relate to. Then you take it from that point of the familiar into the new and unfamiliar and you involve it in humorous or more complicated situations. I juxtapose things and just fit all these symbols, archetypical things, clichés in amongst my own creations" (interview with Dorothee Peiper-Riegraf, March 1989, http://www.peiper-riegraf-collection.com/. Accessed on Feb. 4, 2012.).

Fritz Scholder, who also picked out the romanticizing stereotypes and clichés about Native Americans as a theme for his painting (Fig. 71, 72):
"When I first came to Santa Fe, I vowed to myself that I would not paint Indians. Then I saw the numerous over-romanticized paintings of the 'noble savage' looking into the sunset and decided that someone should paint the Indian in a different context. My concern therefore includes depicting the strange paradox created in the

transition to the 20th century; the quiet humor of the nature-oriented person; the faces that show the imposi-
tion of the non-Indian and the tenacity for holding onto an identity; the monstrous metamorphosis that at
times makes the Indian his own worst enemy; the contemporary Indian/cowboy with a can of beer in his hand
[...] In the final analysis, however, the Indian Series is an optimistic reaction to a new era of the emerging Amer-
ican Indian" (quoted after Anthes 2006: 181).

Rudolph Carl Gorman, who enjoyed being a Native American artist and a Navajo, and who loved to paint
women, as they are the ones who set the tone in Navajo culture (Fig. 29):
"I deal with the common woman who smells of the fields and maize. She lives and breathes [...] My women
work and walk on the land. They need to be strong to survive. They have big hands, strong feet. They are soft
and strong like my grandmother who gave me life [...]
My women are remote, withdrawn in their silence. They don't look out, but glance inward in the Indian way.
You know their faces, but not a thing about their thoughts. They do not reveal whether they are looking at us or
not [...] I like to think that my women represent a universal woman. They don't have to be from the reservation.
They could be from Scottsdale or Africa. They're composites of many women I've known" (Native American Art,
http://nativeamerican-art.com/painting-gorman.html. Accessed on Feb. 4, 2012.).

Tarrance Talaswaima, who is deeply rooted in Hopi tradition and the ritual cycle of Pueblo culture (Fig. 14):
"As Hopi artists, we sense beauty and meaning in every aspect of our lives. We believe that we are a part of a
great living force, which began hundreds of years ago. We do not accept the popular theory which says that all
people came to this land from across the Bering Strait. Our concept is that we came from the Third World of the
Hopi and that, now, we are in the Fourth World. We emerged from underground somewhere in the Grand
Canyon [...] That is our concept. As Hopi artists we share it. We live the artistic, aesthetic way; we must develop
the talents given to us. We have the responsibility to communicate to others, Hopi and non-Hopi peoples,
through our art, the spiritual images of Hopi life" (Honvantewa (Terrance Talaswaima), "The Hopi Way: Art as
Life, Symbol, and Ceremony" in: *Hopi Nation: Essays on Indigenous Art, Culture, History, and Law.* University
of Nebraska, Lincoln 9-29-2008: 68).

Jaune Quick-To-See Smith, who had to realize that Native American Modernism is also a field dominated
by men (Fig. 77):
"The year that professor told me that I could not be an artist was 1958. My art classes were all men receiving the
GI Bill from the Korean War and the instructor told me that I could draw better than the men, but that women
could not be artists. He said I could be a teacher. So eventually I did earn an art education degree. But through
hard work I began showing and selling my work while in grad school. I didn't look back at what that male instruc-
tor said, I just kept working [...] We can't predict where we're going in life, but we can have goals and stay focused.

So you have to do what you believe in. Do what makes you feel whole and happy. Do what keeps your life in balance" (Jaune Quick-To-See Smith, Salish/Kootenai, Interview by Shilo George, Winter 2011. Contemporary North American Indigenous Artists, http://contemporarynativeartists.tumblr.com/. Accessed on Feb. 4, 2012.).

Harry Fonseca, the "master of transformation" who always continued to look for new sources of inspiration (Fig. 73, 74):
"In many cases Coyote reminds me of a human psyche, or humans in general [...] Like him, we are capable of such creativity and such destruction. Coyote is a survivor and a trickster [...] but in some cases, he is also a 'stripper.' He can give you the world and strip you of many things at the same time [...] Coyote survives because of his adaptability, but there is always a risk to change [...] You gain and lose something. You have to weigh those gains and losses, and make changes with awareness and clarity. Coyote just responds. He doesn't take time to reflect. As human beings, we also respond too quickly to things [...] Besides teaching how to get through situations, what to be aware of, and how to increase our awareness [...] Coyote also teaches us to have a good time [...] That' what I understand about my coyotes. They are yin-yang, black-white, negative-positive. After a while there's no separation; the shades of gray come. My coyotes are always gray. I have tried to make them brown, but they come out gray. Actually, coyotes are many colors – usually like a tattered old coat. Coyote is a hard figure to pinpoint. He's in flux constantly" (quoted after Wasserman 1987).

Rick Bartow, who says that his role models are the European expressionists, Horst Janssen, Maori art from New Zealand, mythology, and – most importantly – Native American stories of transformation, and who wants to capture the essence of nature in his paintings (Fig. 78):
"I want to get some information there that makes you think salmon or bass if I'm doing that. If it's a fish, I want you to get a sense of its moving in the water. And it's more gestural, like I had a wonderful term, gestural configuration. It's great! And Expressionism. When Joe Feddersen and Lillian Pitt started introducing me to the art circles, people compared me to Expressionists, neo-Expressionists, the German Kirchner, and those guys. Years later I got a book on Expressionism. I could see that and that was fair. But one of my all-time heroes too was Fritz Scholder, looking as a mixed blood, the kind of fire he walked in. He laid some ground. He did something really strong. [...] What I'm after are the things that come through, that I could draw if I were blind. What I'm looking for are images with emotion and power. I can't create that. I can't do that on call. [...] You have to draw an incredible amount to make people cry, or to make a crying person laugh, but that's what I want to do, and I've been able to do that, I think, [...] The really powerful ones are so strange, so wonderfully strange, and the way that they affect people gives me an indication that something's going on that's greater than the parts. A friend of mine tells me to just do the work, don't bother with explanations, don't bother quizzing yourself. Somebody someday will explain it all" (Times of Visions. Interviews by Larry Abott, http://www.britesites.com/native_artist_interviews/rbartow.htm. Accessed on Feb. 4, 2012.).

Bob Haozous, who wants to use his art to make political statements about the environment and about the situation faced by Native Americans (Fig. 83, 84):

"In most of the galleries, you see an image of Indians that's untrue. It doesn't include who we really are, and in a lot of ways, very unhealthy: alcoholism, violence, poverty, suicide, political problems, loss of land, religion, and language [...] I've always considered humor to be more than just making somebody laugh or entertaining somebody. I think that humor is a very serious tool [...] I try to use humor to get past barriers. All people have humor but I also am most familiar with Native American humor and I realize it's one of the many ways of reflecting a culture. For most people, if you say, 'a political Indian artist,' they'll turn around and walk away [...] So I use humor to draw them in and I make basically the same statement. If you can get people's attention by making them have a bitter, bloody laugh, it's much better, and much more fun for me, too [...] I've been fighting this concept of individualism, uniqueness, universalism, those concepts that are totally contrary to tribalism. Individualism immediately denies a future or a past awareness. You claim it, you own it, but you're not a part of it" (*Times of Visions*. Interviews by Larry Abott, http://www.britesites.com/native_artist_interviews/bhaozous.htm. Accessed on Feb. 4, 2012.).

Notes

1 As of 2019, the Ethnological Museum will give up its current location in Berlin Dahlem and move to the Humboldt-Forum in the reconstructed City Palace (*Stadtschloss*) in the heart of Berlin.

2 Exceptions to this are Abbott 1994 and Rushing III 1999.

3 See, for example, http://www.comanchelodge.com/cherokee-blood.html. Accessed on Feb. 4, 2012.

4 Richard W. West, Jr. was a Southern Cheyenne and a member of the Cheyenne and Arapaho Tribes. He was founding director of the National Museum of the American Indian in Washington, D.C. (1990–2007).

5 The degree to which the assessment of non-western art production is subject to constant changes becomes apparent from the manner in which ethnographic collections were used over the past decades. Objects formerly dismissed as "ethno-kitsch" are now being reassessed by art historians on the basis of aesthetic criteria, and serve as a source of inspiration for contemporary artists.

6 Museums of Asian art, which have a long tradition in the western metropolises, are an exception to this. With regard to Latin America the situation is complex due to the fact that *mestizaje* is a dominant feature there.

7 It is worthwhile to look for more statements and interviews on the Internet, where information is continually updated; this keeps the reader up-to-date on the development of the "state of the art."

Centers of Modern North American Indian Art

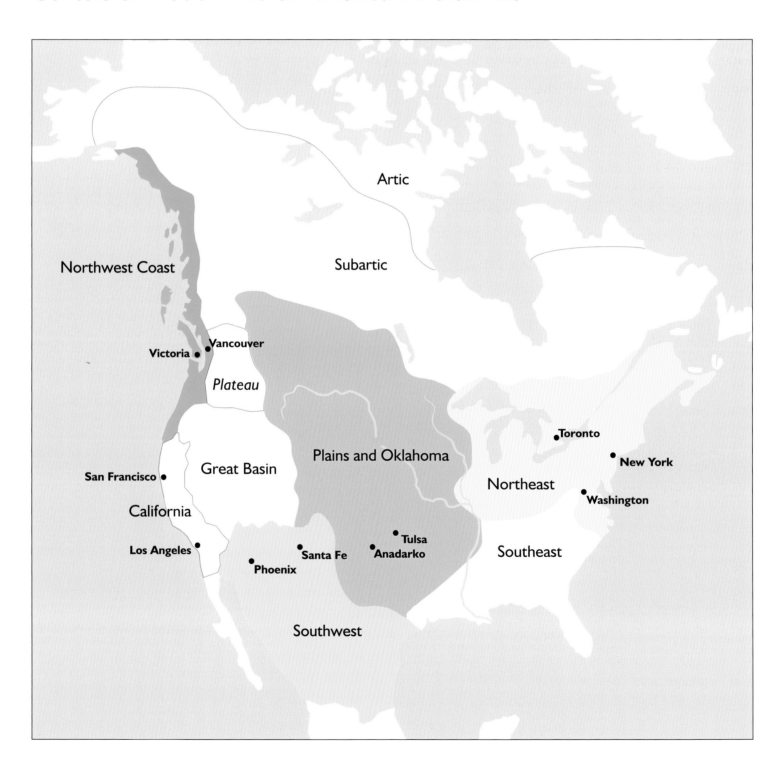

Artic

Subartic

Northwest Coast

Victoria • • Vancouver

Plateau

San Francisco •

Great Basin

California

Plains and Oklahoma

Toronto •

• New York

Northeast

• Washington

Los Angeles •

• Tulsa
Santa Fe • • Anadarko

Phoenix •

Southeast

Southwest

APPENDIX
Chronology: Milestones of Modern Native American Art

Prehistoric and early historic times: rock paintings, painted pottery, ceremonial wall paintings, painting on leather, painted house walls, drawings incised on birch bark, sand paintings.

1875 "Invention" of ledger art (color drawings in ledger books) in Fort Marion, Florida, by Native American captives deported from Oklahoma.

1890 Anthropologist Jesse Walter Fewkes commissions three Hopi Indians to make color drawings of kachina dancers.

1910 Emergence of a school of painting in San Ildefonso Pueblo, New Mexico.

1918 A group of Kiowa painters is "discovered" by Susie Peters at the Kiowa Agency, Oklahoma.

1928 The artist group Kiowa Five from Oklahoma takes part in the International Art Congress held in Prague.

1932 Art educator Dorothy Dunn founds a studio for Indian painting at the Santa Fe Indian School in Santa Fe, New Mexico.

1960 Establishment of the Southwestern Indian Art Project in Tucson, Arizona.

1962 Foundation of the Institute of American Indian Arts in Santa Fe, New Mexico, a governmental academy of arts dedicated to training and supporting Native American artists.

 First exhibition of Norval Morrisseau, the founder of the Woodland School (also called "legend painting"), at a gallery in Toronto, Canada.

1964 Luiseño artist Fritz Scholder begins to teach at the Institute of American Indian Arts in Santa Fe.

1968 Establishment of the Kitanmax School of Northwest Coast Indian Art in 'Ksan, British Columbia.

1969 Kwakiutl artist Tony Hunt opens his Arts of the Raven Gallery in Victoria, British Columbia.

1973 Five Hopi painters found the group Artist Hopid.

 Foundation of the Carl N. Gorman Museum, which is managed by Native Americans, at the University of California in Davis.

 Indianische Malerei in Nordamerika (*Indian Painting in North America*) exhibition at the Linden-Museum Stuttgart.

1975 First purchase of modern Native American art for the Ethnologisches Museum Berlin.

1981 *Native American Arts '81* exhibition at the Philbrook Art Center in Tulsa, Oklahoma.

1985 Travelling *Indianische Kunst im 20. Jahrhundert* (*20th Century Indian Art*) exhibition in Germany and Switzerland.

1990 Passing of the American Indian Arts and Crafts Act, according to which only members of federally recognized Native American communities are allowed to offer their artworks for sale as "Indian-made."

1999 Opening of the *Indianer Nordamerikas – vom Mythos zur Moderne* (*North American Indians – from Myth to Modernity*) permanent exhibition, which includes a permanent presentation of modern Native American art, at the Ethnologisches Museum Berlin.

2004 Opening of the National Museum of the American Indian in Washington, with a concurrent special exhibition on Native Modernism.

Claudia Roch

Biographies of the Artists

Eugene Alfred *1970
Northern Tutchone/Tlingit
Northern Tutchone/Tlingit artist Eugene Alfred was born in the village of Mayo in the Canadian Yukon Province in 1970. He was trained as an artist at the Kitanmax School of Northwest Coast Indian Arts near Hazelton, British Columbia, where he studied under the well-known artist Ken Mowatt. Alfred has been represented in many exhibitions; his most significant works were shown at the exhibition *Touch the Earth*, which was organized by the Society of Yukon Arts of Native Ancestry (SYANA). Alfred's works are found in many private collections, as well as in Canada's National Art Center in Ottawa.

Rick Bartow *1946
Wiyot/Yurok
Wiyot/Yurok artist Rick Bartow was born in Newport, Oregon, in 1946. He studied art at the Western Oregon University and subsequently served 13 months in the Vietnam War as a teletype operator and musician at a military hospital. His creative work comprises sculptures, prints, etchings, pottery, and paintings. Bartow's works have found their way into the collections of many museums. In 2003, his artwork was exhibited at the George Gustav Heye Center in New York. Bartow says that his art is influenced by his Native heritage and his work among the Maori, as well as by European artists such as Marc Chagall, Francis Bacon, Odilon Redon, and Horst Janssen. He is also a guitar player and singer in his own band.

David Bradley *1954
Chippewa
David Bradley was born in 1954 in Eureka, California, the son of a Norwegian father and a Native American mother. He spent the largest part of his childhood in Minneapolis on the White Earth Ojibwe Reservation in Chippewa, Minnesota. He became interested in drawing when he was still a schoolboy. Bradley interrupted his studies at the University of St. Thomas in Minnesota to spend two years as a development aid worker in Guatemala. After his return home he felt drawn to the Southwest. He enrolled at the Institute of American Indian Arts (IAIA) in Santa Fe where he studied jewelry making, pottery, sculpture, painting, and graphic art. In the early 1990s he returned to the IAIA as a guest lecturer and artist-in-residence. He has also studied at the University of Arizona and at the College of Santa Fe. Bradley's works often feature political messages, and he loves to parody the Mona Lisa and other icons of popular culture and art history. In the course of his career, Bradley has been awarded numerous prizes and his works are internationally exhibited.

Benjamin (Ben) Buffalo 1948–1994
Cheyenne
Cheyenne artist Benjamin Buffalo was born in Clinton, Oklahoma, in 1948. He has studied at the Institute of American Indian Arts, the San Francisco Art Institute, and the University of Oklahoma in Norman, among others. In the late 1970s he moved to Santa Fe. While his early paintings were very abstract, he later changed his style radically: with photographic precision he painted realistic pictures, thus becoming the most notable Native American representative of photorealism. His premature death kept him from continuing to develop his style, and only few of his paintings found their way into public collections.

Cecil Calmingtewa
Hopi
Regrettably, no biographical information is available on this artist.

Roy Calnimtewa (Bevasiviya)
Hopi
Regrettably, no biographical information is available on this artist.

Grey Cohoe 1944–1991
Navajo
Navajo artist Grey Cohoe was born in 1944 in Tocito, New Mexico. He received his first formal art training at the Institute of American Indian Arts in Santa Fe. In the late 1960s, he studied at the University of Arizona. Cohoe is primarily known for his prints. He has worked with a multitude of materials, ranging from zinc, copper and aluminum used for his etchings to watercolor, oil, and acrylic. Cohoe is also a well-known writer of prose and poetry.

Neil David *1944
Hopi/Tewa
Neil David is one of the four Hopi artists who formed the group Artist Hopid. His father was from the Hopi village of Walpi, his mother's ancestors were Tewa people who had come to settle among the Hopi in the wake of the big Pueblo uprising against the Spaniards in 1680. David has been awarded numerous prizes for his work; his artwork has been widely exhibited and published. Hopi ceremonial life is the source of inspiration for his paintings. He has also achieved considerable renown as a bronze artist, and created inventive prints and lithographs. David is currently best known for his woodcarvings of kachina figures.

Reg Davidson *1954
Haida
Reg Davidson was born in 1954 in the village of Masset on the northern coast of the Queen Charlotte Islands. In 1972, he began to create sculptures from argillite. He became apprentice to his elder brother Robert Davidson when both of them were jointly working on the Charles Edenshaw Memorial Longhouse in 1977 and 1978. He is also an accomplished dancer and singer in the Rainbow Creek Dancers, a Haida dance group founded by him and his brother Robert in 1980.

Robert Davidson *1946
Haida
Robert Davidson is one of the most outstanding Native artists in Canada, and one of the leading figures in the renaissance of Haida art and culture. Born in Hydaberg, Alaska, he grew up in the village of Masset on the Queen Charlotte Islands. At age thirteen he began to learn carving from his father Claude and his grandfather Robert Davidson, Sr. His great-grandfather was the famous Haida carver Charles Edenshaw. In 1966, he met Haida artist Bill Reid and became the latter's apprentice. In 1967, Davidson attended the Vancouver School of Art where he studied painting, graphic arts, carving, as well as gold and silver working. In 1969 he raised a totem pole on the Queen Charlotte Islands – the first such pole made in about 90 years. His works are represented in many private and public collections. In 1995 he was given the National Achievement Award in appreciation of his contribution to Native American art and culture. In addition, he has been awarded honorary doctorates by several universities. He was decorated with the Order of British Columbia, and became a member of the Order of Canada in 1996.

Frances Dick *1959
Kwakiutl (Kwakwaka'wakw)
Kwakwaka'wakw artist Frances Dick was born in 1959 in Alert Bay (Vancouver Island, British Columbia). She is a member of the Musgamakw Dzawadaenutw Band of Kingcome Inlet. Most of her works feature depictions of the mythical wolf Kawadelekala who is viewed as the ancestor of the Kingcome people. As a young woman she embarked on a career as a social worker but soon realized that her real interest was in the sphere of art. While paintings, prints, and song are her primary forms of artistic expression, she also works with gold, silver, and wood. She created woodcarvings in Alert Bay for several years, working together with her cousin Beau Dick, Bruce Alfred, and Fah Ambers. Frances Dick has written and produced a ceremonial performance entitled *Wiwoma: Honouring the Spirit of Women*,

which premiered at the Newcome Theatre in Victoria in 1992. In October 1994 she was initiated into the highest-ranking ceremonial society of her tribe, the Hamatsa. Dick currently lives in Victoria, British Columbia.

Harry Fonseca 1946–2006
Maidu

Harry Fonseca was born in 1946 in Sacramento, California. His ancestors included Nisenan Maidu, Hawaiians, and Portuguese. He studied at Sacramento City College and under Frank LaPena at California State University in Sacramento before dropping out of university to follow his own vision. While Fonseca's work underwent a number of transformations in the course of his career, his openness to new influences and sources of inspiration always remained a constant. In 1979 he began to work on his famous Coyote series, portraying the trickster in contemporary locations and modern clothing such as sneakers and biker jackets. In 2004, Fonseca was presented with the Allan Houser Memorial Award by New Mexico's governor Bill Richardson. In 2005, the Eiteljorg Museum in Indianapolis awarded him the Eiteljorg Fellowship for Native American Fine Arts. Fonseca moved to Santa Fe in 1990 and remained living there until his death in 2006.

Nicholas Galanin *1979
Tlingit/Aleut

Nicholas Galanin was born in Sitka, Alaska, in 1979. He was apprentice to his father Dave Galanin, his uncle Will Burkhardt, and other traditional Northwest Coast artists. From 2000 to 2003 he attended the London Guildhall University where he specialized in jewelry design and silversmithing. Shortly afterwards he came across a study program that suited his artistic interests even better: from 2004 to 2007, he studied Indigenous Visual Arts at Massey University in New Zealand. Afterwards he returned to Sitka. Galanin uses various media, ranging from sculpture to video art. His works are represented in numerous American museums. Galanin is also involved in the music scene. He is co-founder of the popular Home Skillet Music Festival in Sitka and recently released *It's Glimmering Now*, his second CD.

R.C. Gorman 1933–2005
Navajo

Rudolph Carl (R.C.) Gorman is one of the most famous and successful Native American artists to date. He was born in Chinle, Arizona, in 1933. His father, Carl Gorman, was his first art teacher. He subsequently studied at Mexico City College, Northern Arizona University in Flagstaff, and San Francisco State College. He used various media and techniques, including oil, polymers, ink, lithography, sand, as well as wood- and linocuts. While Gorman followed modern trends in using these media, his subjects always reflected his Navajo background: they range from rug motifs and sand paintings to portraits of his tribespeople. Gorman was influenced by Orozco, Siqueiros and – with regard to lithography – José Sánchez. In 1968 he opened his own art gallery in Taos, New Mexico. Gorman's works have been exhibited all over the western United States, particularly in San Francisco and other Californian cities. His artwork has won numerous prizes.

Bob Haozous *1943
Apache/Navajo

Bob Haozous was born in Los Angeles, California, in 1943. He is the son of the famous Chiricahua Apache artist Allan Houser. After serving a four-year term in the Navy he became a student at the California College of Arts and Crafts in Oakland. Haozous is principally known for his sculptures; he also creates jewelry, watercolors, prints, and smaller three-dimensional objects. The materials he uses range from metal and wood to marble. His artwork is often humorous and outspoken in its political message. Haozous' subject matters include his Apache heritage, environmental problems – especially climate change – and racism.

Allan Houser 1914–1994
Chiricahua Apache

Allan Houser (Allan C. Haozous) is doubtlessly one of the best-known and influential 20th century Native American artists. He was born in Apache, Oklahoma, in 1914. His parents and his great-granduncle, who was none less than the famous Apache leader Geronimo, had been held prisoners of war at Fort Sill, Oklahoma, until 1913. In the early 1930s, Houser attended the Santa Fe Indian School where he studied under Dorothy Dunn. He made his debut as a professional artist in 1939 when his work was exhibited in San Francisco and at the World Fair in New York. In 1940, the Ministry of the Interior in Washington commissioned him to create a large mural, which was his first assignment in

this type. The Norwegian muralist Olle Nordmark, who was Houser's teacher at the Indian Art Center in Oklahoma, encouraged him to become a sculptor. In 1962 Houser became a teacher at the Institute of American Indian Arts in Santa Fe, where he was head of the department of sculpture from 1971 to 1975. In 1975 he stopped teaching in order to focus completely on his own sculptural art. Sculptures by Allan Houser are found in many renowned museums in America and Europe. He was awarded numerous prizes, including two Guggenheim Fellowships and the Palmes Académiques, which were bestowed on him by the French government in recognition of his outstanding role in the advancement of Native American art.

Calvin Hunt *1956
Kwakiutl (Kwakwaka'wakw)
Kwakwaka'wakw artist Calvin Hunt, who was born in 1956, is a descendant of the famous Tlingit anthropologist George Hunt and a grandson of the renowned woodcarver Mungo Martin. He creates woodcarvings (including canoes), silk-screen prints, gold and silver jewelry, and stonemasonry. He began to carve at age twelve and was apprentice to his grand-cousin Tony Hunt, Sr. from 1972 to 1981. In 1981 he returned home, moving to Fort Rupert where he and his wife, Marie, opened the carvers' workshop The Copper Maker. This was followed by the opening of the Kwakiutl Art of the Copper Maker Gallery in 1989. In 2009 Hunt was the recipient of the British Columbia Creative Achievement Award for Aboriginal Art.

Tony Hunt *1942
Kwakiutl (Kwakwaka'wakw)
Tony Hunt was born in Alert Bay in 1942. His first carving teacher was his grandfather Mungo Martin, who also taught him to dance. In 1962 he became assistant carver at Thunderbird Park, working under his father Henry Hunt. In 1969 Tony Hunt opened The Arts of the Raven Gallery in Victoria. This enterprise contributed greatly to the revival of traditional carving skills and made fine quality carving available for the first time for purchase. Tony Hunt has a strong connection with his Kwakiutl heritage and has erected memorial poles in honor of his grandfathers, Jonathan Hunt and Mungo Martin. His dual role as artist and hereditary chief has given him a unique vision of the place of native artists in our evolving world.

Jerry Ingram *1941
Choctaw/Cherokee
Jerry Ingram is the son of a Choctaw mother and a Cherokee father and was born in Battiest, Oklahoma. Initially, he wanted to follow in his father's footsteps and become a lumberman. His passion for painting and drawing prevailed, however, and he attended the Institute of American Indian Arts and Oklahoma State Tech. Ingram specialized in advertising graphic and worked in that trade for 20 years. He is currently a freelance wax carver and creates bead and quillwork. Ingram's works are represented in various museum and private collections. He was awarded the Smithsonian's Native Artist Fellowship in 2002 and won the Southwestern Association for Native American Arts Fellowship Award in 2004. Following a prolonged break he resumed painting in 2009 and now lives in Ilfeld, a town situated east of Santa Fe.

Peter B. Jones *1947
Onondaga Iroquois
Peter B. Jones was born in 1947 on the Cattaraugus Reservation in the northwestern part of the state of New York to a Seneca father and an Onondaga mother. At age 16 he went to Santa Fe to enroll at the newly established Institute of American Indian Arts (IAIA) where he was strongly influenced by Otellie Loloma, an acclaimed Hopi potter who taught him how to blend traditional and western techniques. After doing his military service, Jones moved to Anadarko, Oklahoma, where he taught pottery at the Indian City USA Cultural Center through an on-the-job training program sponsored by the Bureau of Indian Affairs. In 1977 he returned to the Cattaraugus Reservation. Jones' ceramic works are found in museums and private collections within and without the USA.

Michael (Mike) Kabotie (Lomawywesa) 1942–2009
Hopi
Michael Kabotie was the son of the famous Hopi artist Fred Kabotie. He was born in 1942 on the Hopi reservation in northeastern Arizona, and grew up in the village of Shungopovi. When he attended the Oraibi High School, his father became his first art teacher. Kabotie later studied at the University of Arizona in Tucson and at age 17 participated in

the Southwest Indian Art Project. While his works were based on the graphic traditions of his ancestors, he made use of the visual vocabulary of abstract art. Many of his pieces feature humorous and sociopolitical comments. In 1973 Kabotie was one of the co-founders of the group Artist Hopid. He also made silver jewelry, wrote poems and essays, and taught in the USA, New Zealand, Germany, and Switzerland. His works are represented in museums all over the world.

D. Kopelva
Hopi
Regrettably, no biographical information is available on this artist.

Frank LaPena *1937
Maidu/Wintu
Frank LaPena, an internationally renowned painter and poet, was born in 1937 in San Francisco. Like many Native children of his generation he was sent to a state-run boarding school at an early age. As a young man he became interested in the songs, dances, and ceremonial traditions of his people. He is one of the founding members of the Maidu Dancers and Traditionalists. LaPena is best known for his paintings that allude to Maidu and Wintu ceremonies. Since 1960, his works have been shown in many exhibitions in the United States, Europe, Middle and South America, Australia, and New Zealand. LaPena is a professor emeritus at the California State University where he taught art at the Native American Studies Department for 30 years. In addition, he has been a consultant to various museums in the U.S. Beside his painting he has also published several volumes of poetry. He lives in Sacramento and continues to be active in ceremonial life as a singer and dance leader.

John Livingston *1951
Kwakiutl (Kwakwaka'wakw), adopted
John Livingston was born in Vancouver in 1951 and moved to Victoria at a young age. Due to his close friendship with the Hunt family, he began to carve in the Thunderbird Park of the Royal British Columbia Museum in 1961. Henry and Tony Hunt were the head woodcarvers at that museum at that time. After graduating from high school, John Livingstone became apprentice to Tony Hunt. Livingston is an expert carver and has cooperated with Tony and Calvin Hunt on numerous large commissions for the creation of totem poles. In recent times he has carved several large totem poles and other sculptures by himself. While wood is his primary medium, he is also a versed painter and has created more than fifty limited prints since the early 1970s. He is a multi-talented artist and has cooperated with Haida, Salish, and Nuu-chah-nulth artists in major projects.

Milland Lomakema, Sr. (Dawakema) *1941
Hopi
Milland Lomakema is a self-taught artist and writer. He was born in Shungopovi on the Hopi reservation in 1941. His traditional Hopi name is Dawakema. In the course of his eventful career he has been a private eye, police officer, and manager of the Hopi Arts and Crafts Cooperative. He was one of the founding members of the group Artist Hopid. Lomakema's favorite media are acrylics and watercolors. His subjects are inspired by Hopi life, with a special focus on kachinas and symbolic design. In the 1970s he turned to a mostly abstract style of painting. His works have been exhibited all over the United States.

George Longfish *1942
Seneca/Tuscarora
Seneca/Tuscarora artist George Longfish was born in Oshweken, Oklahoma, in 1942, and currently lives in South Berwick, Maine. He was trained as an artist at the School of the Art Institute of Chicago. Longfish's early paintings were strongly influenced by abstract expressionism. In 1972 he established the graduate studies program in American Indian Arts at the University of Montana and became head of that program. From 1973 to 2003 he was a professor at the Department of Native American Studies at the University of California in Davis. From 1974 to 1996 he was also director of the Carl N. Gorman Museum. He works with oil colors, acrylics, pencils, ink, and typographic media. Many of his paintings feature humorous and tongue-in-cheek allusions to issues of Native American identity.

Clarence S. Mills *1958
Haida
Haida artist Clarence Mills was born in 1958 in the village of Skidegate on the Queen Charlotte Islands. At age eighteen, Mills began to study traditional Haida art under his uncle Doug Wilson, who is a well-established Haida artist and writer. Over the past twenty years, Mills has been working with a broad range of media. He has made carvings from argillite, wood, and ivory, as well as gold and silver jewelry, serigraphs, and – most recently – monumental totem poles. One of his major projects involved the creation of a totem pole for Christian Faure, the chief architect of the Louvre. This pole now stands in front of the President's Palace in Paris. Mills currently lives on Granville Island near Vancouver, where he moved a couple of years ago.

Geronima Cruz Montoya (P'o-tsunu) *1915
San Juan Pueblo
Geronima Cruz Montoya looks back to a long and impressive career as an artist and teacher. She was an early student of Dorothy Dunn's at the Studio of the Santa Fe Indian School (SFIS) and pursued higher education at the University of New Mexico, Claremont College, and St. Joseph's College in Albuquerque. From 1937 to 1961 she headed the art program at SFIS. Montoya is a staunch and famous proponent of the two-dimensional Studio Style; this has earned her both praise and ridicule. When Fritz Scholder's abstract style began to eclipse Geronima Montoya's traditionalist manner of painting, she became an early casualty of revolution in the world of Native American art: she was not allowed to teach at the Institute of American Indian Arts which had replaced the art program at the Indian School. Montoya continued to work in adult education at San Juan Pueblo, where she also founded the first Pueblo artisans' cooperative, O'ke Oweenge Crafts. In 1994, Geronima Montoya was presented with the first National Museum of the American Indian Art and Cultural Achievement Award. She has been on the board of the Southwest Association of Indian Arts (SWAI), and has participated in the Santa Fe Indian Market since 1962.

Norval Morrisseau 1932–2007
Ojibwa
Norval Morrisseau is regarded as Canada's best-known First Nations artist. Dubbed "Picasso of the North", he was the most prominent member of the Indian Group of Seven. As the founder of the Woodland School of Art, he has inspired three generations of artists. Morisseau was born in 1932 on the Sand Point Reservation in northwestern Ontario. He was raised by his grandparents. His grandfather, Moses Potan Nanakonagos, was a shaman and taught him the traditions of his people. Morrisseau was a self-educated artist. He developed his own techniques and art vocabulary, which captured ancient myths and images that came to him in visions and dreams. He was initially criticized by the Native community for disclosing traditional spiritual knowledge in his pictures. An early supporter of Morrisseau's was Selwyn Dewdny, an anthropologist intrigued by the artist's profound knowledge of indigenous culture and mythology. Jack Pollock, a Toronto-based art dealer, introduced Morrisseau's art to a wider public in the 1960s. The two of them met in 1962 when Pollock was teaching a painting workshop in Beadmore. Impressed by Morrisseau's art, Pollock immediately organized an exhibition of the latter's works at his gallery in Toronto. Morrisseau's paintings were so well received that he sold all of them at the opening. His vivid paintings, which feature bright colors and pronounced black contour lines, were signed "Copper Thunderbird" in Cree syllabic writing. This was the name given him in his youth by a medicine woman to cure a severe sickness that had befallen him. One of his early commissions was for a large mural in the Canadian pavilion at the *Expo 67*; the mural expressed the frustration of the Canadian First Nations people with their social and political situation. In 1972, Morrisseau was almost killed in a fire at a hotel in Vancouver. He eventually recovered from his burns and was able to resume painting. At about that time he converted to Christianity, and his belief in the Christian Savior is reflected in a number of his paintings from the 1970s. In 1976 he converted once more, this time to a New-Age religion called Eckankar, and began to capture its mystical beliefs on canvas. Morrisseau had many solo exhibitions in Canada and the U.S. His works are represented in prestigious museums in Canada and around the world. He was made a member of the Order of Canada in 1978, and awarded honorary doctorates by the McGill University and McMaster University in 1980. In 1989, Morrisseau was the only Canadian artist to be invited to present his work at the Centre Georges Pompidou on the occasion of the 200th anniversary of the French Revolution. In 2005, he was elected into the ranks of the Royal Society of Canada. In the final months of his life the artist was wheelchair-bound and lived in Nanaimo, British Columbia. Due to his bad health he was no longer able to paint. He died of cardiac arrest due to complications arising from Parkinson's disease on December 4, 2007 at Toronto General Hospital.

Raymond Naha 1933–1975
Hopi/Tewa
Hopi/Tewa artist Raymond Naha was born in 1933 in Polacca, Arizona. He attended Fred Kabotie's painting classes at the Oraibi High School for one year. Kabotie noticed Naha's potential and encouraged him to continue his art studies. Naha then attended the Phoenix Indian School, the Intermountain Indian School, and subsequently the Connecticut Art School in Westport where he studied under Norman Rockwell. Like many Native artists of his generation he fought in World War II, serving a four-year term in the army. His paintings show Hopi and Zuni ceremonial life in a dynamic, colorful style. Since the early 1960s Naha has been represented in all important exhibitions in the Southwest, and won numerous prizes and awards.

Lawrence B. Paul (Yuxweluptun) *1957
Coast Salish
Cowichan Coast Salish artist Lawrence Paul was born in Kamloops, British Columbia, in 1957. He spent the largest part of his youth in the Vancouver region where he also went to school. From 1978 to 1983 he studied at the Emily Carr College of Art, with a focus on painting. Paul's keen interest in the latest developments in all spheres of Native American/First Nations life has probably been spawned by his parents' membership in organizations such as the North American Brotherhood. Many of his works deal with current social and political problems faced by Native Americans. His large-format acrylics combine Coast Salish cosmology and motifs from traditional Northwest Coast art with the western tradition of surrealism. In 1998 he was the recipient of the Vancouver Institute for the Visual Arts Award (VIVA).

Susan A. Point *1952
Coast Salish
Susan A. Point is from the Musqueam Indian Reserve near Vancouver. Her career as an artist began in 1981 when she became active as a jewelry designer. Point's work is inspired by the art traditions of her ancestors. She has done thorough research in museums to gain a better understanding of Coast Salish art. Many of her designs are modeled after the large wooden whorls used to spin the wool of mountain goats. In 1983, she began to mix colors in her silk-screen prints, which prompted some critics to dismiss her color schemes as non-traditional. In the 1990s, Susan Point began to create three-dimensional works of art, using glass, bronze, wood, concrete, polymer, stainless steel, and cast iron. She loves to experiment with new media and large-size formats. She has been commissioned to create numerous works of public art which adorn the Vancouver International Airport, the University of British Columbia's Museum of Anthropology, and the Victoria Conference Centre, to name just a few.

Mark Preston (Tenna Tsa The) *1960
Tlingit
Mark Preston (Tenna Tsa The) was born in 1960 in Dawson City in the Canadian Yukon Province. He is of Tlingit and Irish descent and currently lives in Vancouver. While his study of art was initially inspired by the work of European masters such as Leonardo da Vinci, he later became aware of the existence of other distinguished masters right in his Northwest Coast homeland: First Nations artists Bill Reid, Robert Davidson, and Roy Vickers. Preston has worked with various materials including paper, fabric, metal, stone, silver, and most recently glass.

Jaune Quick-To-See Smith *1940
Flathead/Cree/Shoshone
Jaune Quick-To-See Smith is one of the most acclaimed contemporary Native American artists. She was born in 1940 on the Confederated Salish and Kootenai Reservation in Montana. Smith studied art education at Framingham State College, Massachusetts, and art at the University of New Mexico in Albuquerque, where she earned a Master's degree. Since the 1970s she has been creating complex, abstract paintings and lithographs that feature outspoken sociopolitical messages, addressing issues such as environmental destruction and the oppression of Native American cultures by the government. Inspired by Pablo Picasso, Paul Klee, and Robert Rauschenberg among others on the one hand and by traditional Native American art on the other, Smith views herself as a mediator between Native and western art. During the past 35 years her work has been presented at more than 100 solo exhibitions. She has also curated numerous exhibitions and been a guest lecturer at universities, museums, and conferences all over the world. Her works are found in many private and public international collections. Among other honors she has received the Joan Mitchell Foundation Painters Grant, the Lifetime Achievement Award of the Women's Caucus for the Arts, the College

Art Association's Committee on Women in the Arts Award, the New Mexico Governor's Outstanding Woman's Award, and the New Mexico Governor's Award for Excellence in the Arts (Allan Houser Award). In addition, Smith has been awarded four honorary doctorates – from the Minneapolis College of Art and Design, the Pennsylvania Academy of the Arts, the Massachusetts College of Art, and the University of New Mexico.

Kevin Red Star *1943
Crow

Kevin Red Star enjoys international renown for being both a pioneer of modern Native American art and an ambassador of Crow culture. He was born in 1943 in Lodge Grass on the Crow Indian Reservation. His parents were very supportive of their children's artistic talents. From 1962 to 1965, Red Star attended the Institute of American Indian Arts in Santa Fe where he was a student of Fritz Scholder's. After that, he received a two-year-scholarship to the San Francisco Art Institute. His cultural heritage is a never-failing source of inspiration for his work. While his favorite media are acrylic, crayon, and ink on watercolor paper, he also makes collages and lithographs. His works have been shown in exhibitions all over the world, including France, Belgium, Germany, China, and Japan. In 1995, he participated in a cultural exchange program with the Russian Academy of Art. He has been awarded honorary doctorates by the Rocky Mountain College in Billings, Montana, and the IAIA. Kevin Red Star now lives and works in Roberts, Montana.

José D. Roybal (Oquwa) 1922–1978
San Ildefonso Pueblo

José D. (J.D.) Roybal, whose Tewa name was Oquwa ('Rain God'), was born in San Ildefonso, New Mexico, in 1922. He was a nephew of Alfonso Roybal and began to paint at school in San Ildefonso when he was only eight years old. It was not until the 1950s, however, that he became known as a painter, and he reached the zenith of his productive phase in the 1960s and '70s. Roybal's paintings focus on the depiction of ceremonial dances. His favorite subject matter was the Tewa clowns who are known as Koshare or Koosa. Throughout his career, he worked with watercolors. Roybal was awarded several prizes – for example, in Scottsdale, Arizona (1968), Gallup, New Mexico (1969), and Pine Ridge, South Dakota (1971). In the last two decades of his life, J.D. Roybal was the best-known and most successful artist in San Ildefonso.

Percy Tsisete Sandy (Kai Sa) 1918–1974
Zuni

Kai Sa (Red Moon) was born in 1918 at Zuni Pueblo and received his training as an artist at the Indian School in Santa Fe. Due to internal conflicts in Zuni over his depiction of sensitive religious subjects, he later moved to Taos where he died in 1974.

Fritz Scholder 1937–2005
Luiseño

Fritz Scholder was one of the most famous 20th century Native American artists. He was born in Breckenridge, Minnesota, in 1937 and spent his childhood in North and South Dakota. While Scholder's ancestry was mostly German, one of his grandmothers was a Luiseño from California. Scholder used to refer to himself as a "non-Indian Indian artist". When he was a high school student in Pierre, South Dakota, his teacher was the famous Sioux Artist Oscar Howe. In 1957, Scholder's family moved to Sacramento, California, where Scholder studied under the acclaimed artist Wayne Thiebaud who introduced him to abstract expressionism and gave him his first opportunity to exhibit his works. In 1961 he participated in the Rockefeller Indian Art Project at the University of Arizona. He turned to Native American subject matters in 1964 when he joined the staff at the Institute of American Indian Arts. As soon as his new series of paintings on the American Indian was presented to the public in 1967, it stirred a heated dispute because Scholder portrayed Indians with American flags, beer cans, and cones of ice cream. Due to the vehement protest on the part of traditionally oriented critics, who accused him of sullying the dignity of Native Americans, Scholder became one of the most controversial characters in the Native American art scene. In the course of his career, Scholder was the recipient of several scholarships and awards – from the Whitney Foundation, the Rockefeller Foundation, the Ford Foundation, and the Academy of Arts and Letters. In addition, he was awarded five honorary doctorates. Scholder's work has been exhibited all over the world.

Virginia Stroud *1951
Cherokee/Creek
Cherokee/Creek painter Virginia Stroud was born in 1951 in Madera, California. Following her mother's death she moved to live with her sister in Muskogee, Oklahoma. Later on she was adopted into a Kiowa family. From 1968 to 1970, Stroud attended the Bacone College and studied art education at the University of Oklahoma. Her teacher, Cheyenne artist Richard West, encouraged her to become a painter. She sold her first painting when she was only fourteen, and was the youngest artist ever to win the first prize at the annual Indian Artists Exhibition at the Philbrook Art Center in Tulsa, Oklahoma. In 1971, she was crowned Miss Indian America. In 1982, the Indian Arts and Crafts Association honored her as Artist of the Year. Stroud has also written and illustrated several children's books.

Terrance Talaswaima *1939
Hopi
Terrance Talaswaima was born on Hopi Second Mesa in 1939. He attended primary and secondary school on the Hopi reservation, where one of his teachers was Fred Kabotie, who strongly influenced him. Together with Mike Kabotie, Talaswaima was among the founders of the group Artist Hopid. He spent part of his high school years in Tucson. In 1960, he participated in the Indian Art Project of the University of Arizona and continued his formal training by taking regular classes at that university during the 1960s. His primary medium is watercolors, but he will sometimes also use crayons. His works deal with Native American subject matters, his favorite theme being kachinas. Besides his realistic depictions, Talaswaima has also experimented with an abstract or semi-abstract style. While he has been exhibited to a lesser extent than other Hopi artists, he has nevertheless won first prizes at both the Arizona State Fair (1959) and the Navajo Fair (1964).

Art Thompson 1948–2003
Nootka (Nuu-chah-nulth)
Art Thompson was born in the village of Whyac on Vancouver Island. As a child he received his first art lessons in the traditional Northwest Coast style of the Nootka from his father and both his grandfathers. He then studied acrylic oil painting and the art of serigraphy at the Vancouver School of Art and the Camosun College in Victoria. Later, when cooperating and discussing with other artists such as Ron Hamilton and Joe David, he developed a modern style which maintained its roots in Nootka traditions. The imagery of his prints reflects various aspects of life on the west coast of Vancouver Island: the whale hunt, the sea, and potlatch feasts. Besides serigraphs, Thompson has also created works from wood and silver, which were often distinguished by an innovative use of the two-dimensional Northwest Coast design.

Beatien Yazz (Little No Shirt, Jimmy Toddy) *1928
Navajo
Beatien Yazz, who was born on the Navajo Indian Reservation in 1928, showed promise as an artist early on. While still a boy, he met Sally and Bill Lippencott who ran the Wide Ruins Trading Post; the couple supplied him with paper and other materials so he could practice painting in color. At age twelve he had his first exhibition at the Illinois State Museum. In 1942, writer Alberta Hannum visited Wide Ruins and wrote two books about Yazz which he illustrated. Yazz studied for one year under Geronima Cruz Montoya at the Santa Fe Indian School. In World War II, he served in the Navy and was one of the famous Navajo Code Talkers. After the war he returned to the reservation and embarked on a career as a full-time artist. Up until the late 1980s, when severe eye problems forced him to quit painting, Yazz created an abundance of paintings, prints, and illustrations. He was specialized in subject matters familiar to him from his everyday life on the reservation, which included the use of Peyote during the rituals of the Native American Church.

List of Works on Exhibit

Fig. 1 Bull Head, Brulé Sioux, *War Scenes*, ca. 1880. Wyman Collection, 1905. Color pencils on cotton cloth, height 84 cm, width 90 cm. Ethnologisches Museum Berlin, Inv. No. IV B 7623.
Lit.: Hartmann 1973 Nr. 149; Rochard 1993, 60.

Fig. 2 Running Antelope, Hunkpapa Sioux, *War Scene*, ca. 1880. Hoffman Collection, 1889. Watercolor on paper, height 23 cm, width 31 cm. Ethnologisches Museum Berlin, Inv. No. IV B 1979.
Lit.: Hartmann 1973 Nr. 150.

Fig. 3 Allan Houser (Haozous), Chiricahua Apache, *Chiricahua Medicine Man*, 1982. Hartmann Collection, 1983. Bronze sculpture on wooden base, height 26 cm. Ethnologisches Museum Berlin, Inv. No. IV B 13104.
Lit.: König 2003, 83.

Fig. 4 Beatien Yazz (Jimmy Toddy), Navajo, *Navajo Couple*, ca. 1970. Hartmann Collection, 1975. Watercolor on cardboard, height 51 cm, width 38 cm. Ethnologisches Museum Berlin, Inv. No. IV B 12905.

Fig. 5 Beatien Yazz (Jimmy Toddy), Navajo, *Two Dancers at a Fire*, ca. 1970. Seybold Collection, 2010. Tempera on black cardboard, height ca. 48 cm, width ca. 58 cm. Ethnologisches Museum Berlin, Inv. No. IV B 13229.

Fig. 6 Beatien Yazz (Jimmy Toddy), Navajo, *Peyote Princess*, ca. 1975. Hartmann Collection, 1980. Casein on canvas cardboard, height 62 cm, width 51.5 cm. Ethnologisches Museum Berlin, Inv. No. IV B 113064.

Fig. 7 J.D. Roybal, San Indefonso Pueblo, *Corn Dance,* ca. 1970. Hartmann Collection, 1975. Watercolor on paper, height 40 cm, width 57 cm. Ethnologisches Museum Berlin, Inv. No. IV B 12904.
Lit.: Bolz and Sanner 1999, 223.

Fig. 8 Percy Sandy (Kai Sa = Red Moon), Zuni, *Longhair and Mate* (Zuni Rain Dancer), ca. 1970. Hartmann Collection, 1980. Watercolor on cardboard, height 34 cm, width 26 cm. Ethnologisches Museum Berlin, Inv. No. IV B 13066.

Fig 9 Geronima Cruz Montoya (P'o-tsunu), San Juan Pueblo, *Underworld Ghost*, 1979. Malotki Collection, 1979. Gouache on colored paper, height 33 cm, width 26.5 cm.
Ethnologisches Museum Berlin, Inv. No. IV B 12999.

Fig. 10 Raymond Naha, Hopi, *Mixed Kachina Dance*, ca. 1970. Hartmann Collection, 1975. Gouache on brown cardboard, height 38.5 cm, width 51.5 cm. Ethnologisches Museum Berlin, Inv. No. IV B 12906.
Lit.: Hartmann 1978, 5.

Fig. 11 Roy Calnimtewa (Bevasiviya), Hopi, *Kooninkatsina*, ca. 1975. Malotki Collection, 1975. Watercolor on cardboard, height 51 cm, width 40.6 cm. Ethnologisches Museum Berlin, Inv. No. IV B 12998.

Fig. 12 Kopelva, Hopi, *Corn Dancer, Ka-e Kachina*, ca. 1975. Hartmann Collection, 1980. Watercolor on cardboard, height 30.6 cm, width 23.3 cm. Ethnologisches Museum Berlin, Inv. No. IV B 13056.

Fig. 13 Cecil Calmingtewa, Hopi, *Hummingbird Kachina*, ca. 1975. Hartmann Collection, 1980. Gouache on brown cardboard, height 51 cm, width 41 cm. Ethnologisches Museum Berlin, Inv. No. IV B 13055.

Fig. 14 Terrance Talaswaima (Honvantewa), Hopi, *Hunter Spirits*, 1978. Hartmann Collection, 1980. Watercolor and ink on brown cardboard, height 28.5 cm, width 21 cm.
Ethnologisches Museum Berlin, Inv. No. IV B 13057.

Fig. 15 Neil David, Hopi, *Hé'e'e, Hopi Warrior Maiden Kachina*, 1973. Malotki Collection, 1984. Crayon on black cardboard, height ca. 52 cm, width ca. 40 cm. Ethnologisches Museum Berlin, Inv. No. IV B 13105.
Lit.: Bolz and Sanner 1999, 229.

Fig. 16 Neil David, Hopi, *Hopi Clowns*, 1975. Malotki Collection, 1982. Acrylic on canvas cardboard, height 45.5 cm, width 61 cm. Ethnologisches Museum Berlin, Inv. No. IV B 13085.

Fig. 17 Neil David, Hopi, *Pottery Mound Motif # 2*, 1976. Malotki Collection, 1982. Acrylic on canvas cardboard, height 50.5 cm, width 40.5 cm. Ethnologisches Museum Berlin, Inv. No. IV B 13086.

Fig. 18 Neil David, Hopi, *Kachina Spirits*, 1977. Hartmann collection, 1980. Gouache on cardboard, height ca. 45 cm, width ca. 40 cm. Ethnologisches Museum Berlin, Inv. No. IV B 13065.

Fig. 19 Neil David, Hopi, *Longhair with Maid* (*Angaktsina with Angaktsinmana*), 1978. Malotki Collection, 1979. Pen-and-ink drawing on cardboard, height ca. 32 cm, width ca. 27 cm.
Ethnologisches Museum Berlin, Inv. No. IV B 12997.

Fig. 20 Michael (Mike) Kabotie (Lomawywesa), Hopi, *From Zuni They Came*, 1978. Seybold Collection, 2010. Acrylic on canvas, height 91.5 cm, width 91.5 cm. Ethnologisches Museum Berlin, Inv. No. IV B 13235.
Lit.: Hoffmann 1985, 250.

Fig. 21 Michael (Mike) Kabotie (Lomawywesa), Hopi, *Kachina Coming*, 1979. Malotki Collection, 1979. Tempera on cardboard, height 40.5 cm, width 51 cm. Ethnologisches Museum Berlin, Inv. No. IV B 12996.
Lit.: König 2003, 84–85.

Fig. 22 Michael (Mike) Kabotie (Lomawywesa), Hopi, *Kachina Song Blessing*, 1986. Nuzinger Collection, 1991. Lithograph printed in seven colors with additional hand coloring (edition number 46/75), height 39 cm, width 56 cm. Ethnologisches Museum Berlin, Inv. No. IV B 13127.
Lit.: Bolz and Sanner 1999, 230.

Fig. 23 Milland Lomakema (Dawakema), Hopi, *Warrior with Shield*, 1976. Seybold Collection, 2011. Acrylic on canvas cardboard, height ca. 92 cm, width ca. 72 cm. Ethnologisches Museum Berlin, Inv. No. IV B 13236.
Lit.: Kunze 1988, 190.

Fig. 24 Milland Lomakema (Dawakema), Hopi, *Warrior God*, 1977. Seybold Collection, 2010. Acrylic on canvas, height 104 cm, width 112 cm. Ethnologisches Museum Berlin, Inv. No. IV B 13237.
Lit.: Kunze 1988, 196.

Fig. 25 Milland Lomakema (Dawakema), Hopi, *Symbols of Big Horn and Maiden*, 1977. Hartmann Collection, 1980. Gouache on cardboard, height 51 cm, width 40.5 cm.
Ethnologisches Museum Berlin, Inv. No. IV B 13058.

Fig. 26 Milland Lomakema (Dawakema), Hopi, *The Whippers*, 1978. Malotki Collection, 1984. Acrylic on canvas cardboard, height 61 cm, width 45.5 cm. Ethnologisches Museum Berlin, Inv. No. IV B 13106.

Fig. 27 Milland Lomakema (Dawakema), Hopi, *Symbols of War Society*, 1979. Malotki Collection, 1984. Acrylic on canvas cardboard, height 51 cm, width 60.5 cm. Ethnologisches Museum Berlin, Inv. No. IV B 13107.

Fig. 28 Grey Cohoe, Navajo, *Rite for Autumn Harvest*, 1983. Seybold Collection, 2011. Acrylic on canvas, height 102.5 cm, width 127 cm. Ethnologisches Museum Berlin, Inv. No. IV B 13238.
Lit.: Hoffmann 1985, 294.

Fig. 29 R. C. Gorman, Navajo, *Taos Traders*, 1989. Nuzinger Collection, 1991. Lithograph in 46 colors (edition number 197/224), height 66 cm, width 92 cm. Ethnologisches Museum Berlin, Inv. No. IV B 13126.

Fig. 30 Frank LaPena, Wintu, *Red Cap*, 1989. Nuzinger Collection, 1994. Acrylic on canvas, height 122 cm, width 91 cm.
Ethnologisches Museum Berlin, Inv. No. IV B 13131.
Lit.: Bolz and Sanner 1999, 225.

Fig. 31 Benjamin (Ben) Buffalo, Cheyenne, *Sun Dancer* (*The Medicine Man*), 1978. Seybold Collection, 2010. Acrylic on canvas, height 183 cm, width 112 cm. Ethnologisches Museum Berlin, Inv. No. IV B 13228.
Lit.: Highwater 1980, 59.

Fig. 32 Benjamin (Ben) Buffalo, Cheyenne, *Girl in Elk Tooth Dress*, 1978. Seybold Collection, 2010. Acrylic on canvas, height 125.5 cm, width 66 cm. Ethnologisches Museum Berlin, Inv. No. IV B 13227.
Lit.: Hoffmann 1985, 288.

Fig. 33 Benjamin (Ben) Buffalo, Cheyenne, *Daughter of the Native American Revolution*, 1982. Seybold Collection, 2011. Acrylic on canvas, height 61 cm, width 76 cm. Ethnologisches Museum Berlin, Inv. No. IV B 13233.

Fig. 34 Virginia Stroud, Cherokee-Creek, *Outside the Tipi*, 1984. Seybold Collection, 2011. Tempera on cardboard, height ca. 28 cm, width ca. 38 cm. Ethnologisches Museum Berlin, Inv. No. IV B 13234.

Fig. 35 Jerry Ingram, Choctaw-Cherokee (Oklahoma), *Personal Strength* (*Personal Medicine*), 1982. Seybold Collection, 2011. Acrylic on canvas, height 76 cm, width 61 cm.
Ethnologisches Museum Berlin, Inv. No. IV B 13231.
Lit.: Hoffmann 1985, 266, and cover.

Fig. 36 Jerry Ingram, Choctaw-Cherokee (Oklahoma), *Hunter's Song*, 1981. Hartje Collection, 1989. Acrylic on canvas, height 61 cm, width 91.5 cm. Ethnologisches Museum Berlin, Inv. No. IV B 13115.
Lit.: Hartje 1984, 77; Rochard 1993, 198.

Fig. 37 Jerry Ingram, Choctaw-Cherokee (Oklahoma), *With the Bear as His Medicine* (*Bear as Medicine Man*), 1982. Hartje Collection, 1989. Acrylic on canvas, height 81 cm, width 102 cm. Ethnologisches Museum Berlin, Inv. No. IV B 13114.
Lit.: Hartje 1984, 76.

Fig. 38 Kevin Red Star, Crow, *Walks Long* (*Walks Along*), 1981. Hartje Collection, 1989. Acrylic on canvas, height 71.5 cm, width 61 cm. Ethnologisches Museum Berlin, Inv. No. IV B 13116.
Lit.: Hartje 1984, 86; Bolz and Sanner 1999, 224.

Fig. 39 Kevin Red Star, Crow, *Painted Crow Wolf*, 1982. Hartje Collection, 1989. Acrylic on canvas, height 89 cm, width 74 cm. Ethnologisches Museum Berlin, Inv. No. IV B 13117.
Lit.: Hartje 1984, 87; Rochard 1993, 197; König 2003, 84.

Fig. 40 Kevin Red Star, Crow, *Rainbow Woman*, 1983. Seybold Collection, 2011. Acrylic on canvas, height 112.5 cm, width 86.5 cm. Ethnologisches Museum Berlin, Inv. No. IV B 13232.
Lit.: Hoffmann 1985, 292.

Fig. 41 Kevin Red Star, Crow, *Full Moon Riders*, 1986. Peiper-Riegraf Collection, 2008. Serigraph (edition number 39/275), height 76.5 cm, width 57 cm. Ethnologisches Museum Berlin, Inv. No. IV B 13171.

Fig. 42 Norval Morrisseau (Copper Thunderbird), Ojibwa, *Hunting*, 1980. Antonitsch Collection, 1999. Acrylic on canvas, height 51 cm, width 61 cm. Ethnologisches Museum Berlin, Inv. No. IV B 13155.
Lit.: Bolz and Sanner 1999, 228.

Fig. 43 Norval Morrisseau (Copper Thunderbird), Ojibwa, *Thunderbird, Shaman, and Earth Mother*, ca. 1985. Seybold Collection, 2011. Acrylic on canvas, height 122 cm, width 101.5 cm.
Ethnologisches Museum Berlin, Inv. No. IV B 13230.

Fig. 44 Robert Davidson, Haida, *Beaver*, 1972. Gift of the artist, 1976. Serigraph (without edition number), height 29.5 cm, width 27 cm.
Ethnologisches Museum Berlin, Inv. No. IV A 9518.

Fig. 45 Robert Davidson, Haida, *Raven*, 1973. Gift of the artist, 1976. Serigraph (edition number 73/150), height 32.5 cm, width 28.5 cm.
Ethnologisches Museum Berlin, Inv. No. IV A 9520.

Fig. 46 Reg Davidson, Haida, *Raven Stealing Moon*, 1981. Larink Collection, 2003. Serigraph (edition number 92/229), height 27.8 cm, width 55.8 cm. Ethnologisches Museum Berlin, Inv. No. IV A 9572.

Fig. 47 Reg Davidson, Haida, *Shark*, 1984. Larink Collection, 2007. Serigraph (edition number 139/193), height 24,9 cm, width 55,9 cm. Ethnologisches Museum Berlin, Inv. No. IV A 9632.

Fig. 48 Clarence S. Mills, Haida, *Haida Moon*, 1993. Larink Collection, 2000. Serigraph (without edition number), height 38 cm, width 33 cm. Ethnologisches Museum Berlin, Inv. No. IV A 9544.

Fig. 49 Clarence S. Mills, Haida, *Haida Raven and Moon Totem*, 1996. Larink Collection, 2006. Serigraph (edition number 50/199), height 71 cm, width 45.7 cm. Ethnologisches Museum Berlin, Inv. No. IV A 9627.

Fig. 50 Clarence S. Mills, Haida, *Raven, Moon and Frog*, 2000. Larink Collection, 2007. Serigraph (Artist's Proof), height 37.8 cm, width 40.7 cm. Ethnologisches Museum Berlin, Inv. No. IV A 9641.

Fig. 51 Tony Hunt, Kwakiutl, *Transformation Mural IV*, 1978. Larink Collection, 2002. Serigraph (artist's Proof), height 35.6 cm, width 29.1 cm. Ethnologisches Museum Berlin, Inv. No. IV A 9578.

Fig. 52 Tony Hunt, Kwakiutl, *Raven, Man and Killer Whale* (*Transformation No. 1*), 1980. Larink Collection, 2004. Serigraph (edition number 67/90), height 75.2 cm, width 55.5 cm.
Ethnologisches Museum Berlin, Inv. No. IV A 9604.
Lit.: Larink and Streum 1995, 81.

Fig. 53 Calvin Hunt, Kwakiutl, *Three Killer Whales*, 1998. Larink Collection, 2004. Serigraph (edition number 75/200), height 48.2 cm, width 60.8 cm. Ethnologisches Museum Berlin, Inv. No. IV A 9597.
Lit.: Rousselot, Müller, Larink 2004, 38.

Fig. 54 Calvin Hunt, Kwakiutl, *Namukwiyalis Memorial*, 2003. Larink Collection, 2003. Serigraph (edition number 47/200), height 24 cm, width 76.5 cm. Ethnologisches Museum Berlin, Inv. No. IV A 9590.

Fig. 55 John Livingston, Kwakiutl (adopted), *Bella Bella Chest Study, Bird Design*, 1992. Larink Collection, 2002. Serigraph (Artist's Proof), height 53.4 cm, width 73.6 cm.
Ethnologisches Museum Berlin, Inv. No. IV A 9579.

Fig. 56 Frances Dick, Kwakiutl, *Kawadelekala's House*, 1995. Larink Collection, 2005. Serigraph (edition number 9/150), height 36.4 cm, width 50.5 cm. Ethnologisches Museum Berlin, Inv. No. IV A 9611.

Fig. 57 Frances Dick, Kwakiutl, *Honoring Malidi*, 1995. Larink Collection, 2007. Serigraph (edition number 3/100), height 76.4 cm, width 38 cm. Ethnologisches Museum Berlin, Inv. No. IV A 9633.

Fig. 58 Art Thompson, Nootka, *Gambler* (*Lehac-player*), 1985. Larink Collection, 2003. Serigraph (edition number 38/100), height 61 cm, width 56 cm. Ethnologisches Museum Berlin, Inv. No. IV A 9547.

Fig. 59 Eugene Alfred, Tlingit, *Raven Stealing the Light*, 1999. Larink Collection, 2003. Serigraph (edition number 54/170), height 43 cm, width 33.3 cm. Ethnologisches Museum Berlin, Inv. No. IV A 9588.

Fig. 60 Mark Preston (Tenna Tsa The), Tlingit, *The Salmon Returns*, 1999. Larink Collection, 2005. Serigraph (edition number 22/180), height 41 cm, width 61.8 cm. Ethnologisches Museum Berlin, Inv. No. IV A 9619.
Lit.: Rousselot, Müller, Larink 2004, 32.

Fig. 61 Susan A. Point, Coast Salish, *Harmony*, 1991. Larink Collection 2007. Serigraph (edition number 43/91), height 33 cm, width 31.3 cm. Ethnologisches Museum Berlin, Inv. No. IV A 9642.

Fig. 62 Susan A. Point, Coast Salish, *Completing the Circle*, 1992. Larink Collection 2004. Serigraph (edition number 40/50), height 41.5 cm, width 41.5 cm. Ethnologisches Museum Berlin, Inv. No. IV A 9607.

Fig. 63 Susan A. Point, Coast Salish, *Sea*, 1993. Larink Collection, 2002. Intaglio print (relief print, edition number 6/30), height 76 cm, width 76 cm. Ethnologisches Museum Berlin, Inv. No. IV A 9583.

Fig. 64 Susan A. Point, Coast Salish, *Land*, 1993. Larink Collection, 2002. Intaglio print (relief print, edition number 6/30), height 76 cm, width 76 cm. Ethnologisches Museum Berlin, Inv. No. IV A 9584.

Fig. 65 Susan A. Point, Coast Salish, *Sky*, 1993. Larink Collection, 2002. Intaglio print (relief print, edition number 6/30), height 76 cm, width 76 cm. Ethnologisches Museum Berlin, Inv. No. IV A 9585.

Fig. 66 Susan A. Point, Coast Salish, *Water – The Essence of Life*, 1996. Larink Collection, 1999. Serigraph (edition number 13/ 166), height 59 cm, width 56.3 cm. Ethnologisches Museum Berlin, Inv. No. IV A 9539.

Fig. 67 Susan A. Point, Coast Salish, *Giving Voice*, 1993. Larink Collection, 2007. Glass engraving (edition number 17/25), diameter 45 cm. Ethnologisches Museum Berlin, Inv. No. IV A 9646.
Lit.: Larink and Streum 1995, 94.

Fig. 68 Lawrence B. Paul (Yuxweluptun), Coast Salish, *Native Winter Snow Fall*, 1987. Purchased from the artist, 1989. Acrylic on canvas, height 125 cm, width 184 cm.
Ethnologisches Museum Berlin, Inv. No. IV A 9509.
Lit.: Townsend-Gault 1995, 38.

Fig. 69 Lawrence B. Paul (Yuxweluptun), Coast Salish, *Downtown Vancouver*, 1988. Purchased from the artist, 1989. Acrylic on canvas, height 174 cm, width 127 cm.
Ethnologisches Museum Berlin, Inv. No. IV A 9510.
Lit.: Gerber and Katz-Lahaigue 1989, 116–117; Townsend-Gault 1995, 41; Bolz and Sanner 1999, 232.

Fig. 70 Lawrence B. Paul (Yuxweluptun), Coast Salish, *I Have a Vision that Some Day all Indigenous People Will Have Freedom and Self Government*, 1987. Purchased from the artist, 1989. Acrylic on canvas, height 174 cm, width 211 cm. Ethnologisches Museum Berlin, Inv. No. IV A 9511.
Lit.: Townsend-Gault 1995, 2; König 2003, 85.

Fig. 71 Fritz Scholder, Luiseño, *Patriotic Indian*, 1975. Nuzinger Collection, 1992. Lithography (edition number 22/50), height 57 cm, width 39 cm.
Ethnologisches Museum Berlin, Inv. No. IV B 13128.
Lit.: Adams 1975, 137; Bolz and Sanner 1999, 222. Luiseño

Fig. 72 Fritz Scholder, Luiseño, *Indian Portrait with Tomahawk*, 1975. Nuzinger Collection, 1993. Lithograph in four colors (edition number 28/75), height 77 cm, width 57 cm.
Ethnologisches Museum Berlin, Inv. No. IV B 13129.
Lit.: Taylor 1982, 83; Bolz and Sanner 1999, 224.

Fig. 73 Harry Fonseca, Nisenan Maidu: *Coyote – Cigarstore Indian*, 1985. Hartje Collection, 1989. Acrylic on canvas, height 121 cm, width 81 cm.
Ethnologisches Museum Berlin, Inv. No. IV B 13118.
Lit.: Rochard 1993, 196; Bolz and Sanner 1999, 226.

Fig. 74 Harry Fonseca, Nisenan Maidu: *Rose*, 1985. Hartje Collection, 1989. Acrylic on canvas, height 121 cm, width 81 cm.
Ethnologisches Museum Berlin, Inv. No. IV B 13119.

Fig. 75 George Longfish, Seneca-Tuscarora, *Everything is the Same Size Shuffles Off to Buffalo With the Three Sisters*, 1984. Seybold Collection, 2010. Acrylic on tent canvas, height 151 cm, width 208 cm.
Ethnologisches Museum Berlin, Inv. No. IV B 13226.
Lit.: Hoffmann 1985, 278.

Fig. 76 George Longfish, Seneca-Tuscarora: *Ralph Lauren's Polo War Shirt*, 1988/89. Nuzinger Collection, 1994. Acrylic and mixed media on cardboard, height 38 cm, width 102 cm.
Ethnologisches Museum Berlin, Inv. No. IV B 13130.
Lit.: Bolz and Sanner 1999, 227.

Fig. 77 Jaune Quick-To-See Smith, Flathead-Cree-Shoshone, *Big Green*, 1992. Nuzinger Collection, 2003. Mixed media and collage on paper, height 106 cm, width 75 cm.
Ethnologisches Museum Berlin, Inv. No. IV B 13161.
Lit.: Bolz 2003.

Fig. 78 Rick Bartow, Yurok, *Give Away*, 1993. Peiper-Riegraf Collection, 2008. Pastel, coal, and graphite on paper, height 66 cm, width 101 cm.
Ethnologisches Museum Berlin, Inv. No. IV B 13170.

Fig. 79 David Bradley, Chippewa, *Indian Market Manifesto*, 1997. Peiper-Riegraf Collection, 2008. Acrylic on canvas, height 152 cm, width 122 cm. Ethnologisches Museum Berlin, Inv. No. IV B 13168.

Fig. 80 David Bradley, Chippewa, *Pueblo Feast Day 2005*, 2005. Peiper-Riegraf Collection, 2008. Acrylic on canvas, height 150 cm, width 206 cm. Ethnologisches Museum Berlin, Inv. No. IV B 13169.

Fig. 81 David Bradley, Chippewa, *Land O' Lakes, Land O' Bucks, Land O' Fakes*, 2005. Peiper-Riegraf Collection, 2008. Acrylic on cardboard, wood, height 42 cm, width 81 cm, depth 41 cm. Ethnologisches Museum Berlin, permanent loan by Dorothee Peiper-Riegraf.

Fig. 82 Peter B. Jones, Onondaga Iroquois, *Effigy for the Last Real Indian*, 1993. Stambrau Collection, 1998.
Clay sculpture, feathers, leather, length 68 cm.
Ethnologisches Museum Berlin, Inv. No. IV B 13133.
Lit.: Kasprycki 1998, 83; König 2003, 68.

Fig. 83 Bob Haozous, Apache, *Landscape*, 1989. Peiper-Riegraf Collection, 2010. Corroded and painted steel, height 74 cm, width 89 cm. Ethnologisches Museum Berlin, Inv. No. IV B 13194.
Lit.: Peiper-Riegraf 1989, 25; Rochard 1993, 215.

Fig. 84 Bob Haozous, Apache, *Apfelbaum – Sacred Images* (no. 8 out of a series of 11), 1992. Peiper-Riegraf Collection, 2010. Corroded and painted steel, axe with wooden handle, height 86 cm, length 138 cm, width 60.5 cm. Ethnologisches Museum Berlin, Inv. No. IV B 13193.
Lit.: Hendricks 1998; Rochard 1993, 214; Sanchez 2005, 8.